D

ANN ARBOR DIST

D0935940

31621012

THE
SURREALIST
PARADE

BOOKS BY WAYNE ANDREWS

Pianos of Sympathy (1936)
(UNDER THE PSEUDONYM OF MONTAGU O'REILLY)

The Vanderbilt Legend (1941)

Battle for Chicago (1946)

Who Has Been Tampering with These Pianos? (1948)
(UNDER THE PSEUDONYM MONTAGU O'REILLY)

Architecture, Ambition and Americans (1955)
(REVISED EDITION, 1978)

Best Short Stories of Edith Wharton (1958)
(EDITOR)

Architecture in America (1960)
(REVISED EDITION, 1977)

Germaine: A Portrait of Madame de Staël (1963)

Architecture in Michigan (1967)

Architecture in Chicago and Mid-America (1967)

Architecture in New York (1968)

Siegfried's Curse:
The German Journey from Nietzsche to Hesse (1972)

Architecture in New England (1973)

American Gothic (1975)

Pride of the South:
A Social History of Southern Architecture (1979)

Voltaire (1981)

The Surrealist Parade (1990)

709.04
An

X

Wayne Andrews

THE SURREALIST PARADE

AFTERWORD BY
JAMES LAUGHLIN

A NEW DIRECTIONS BOOK

Ann Arbor Public Library JUN 1 6 1990

Copyright © 1988, 1990 by Elizabeth A. Andrews
Copyright © 1988, 1990 by James Laughlin
Copyright © 1990 by New Directions Publishing Corporation

All rights reserved. Except for brief passages quoted in a newspaper, magazine, radio, or television review, no part of this book may be reproduced in any form or by any means, electronic or mechanical, including photocopying and recording, or by any information storage and retrieval system, without permission in writing from the Publisher.

Excerpts from Chapter Four, "The Clocks Stopped at the Precise Hour; and Then . . . ," and James Laughlin's "Afterword: Montagu O'Reilly and Wayne Andrews" were first published in *New American Writing,* Fall 1988.

Book design by Sylvia Frezzolini
Manufactured in the United States of America
New Directions Books are printed on acid-free paper.
First published clothbound and as New Directions Paperbook 689 in 1990
Published simultaneously in Canada by Penguin Books Canada Limited

Library of Congress Cataloging-in-Publication Data
Andrews, Wayne. The surrealist parade / Wayne Andrews ;
afterword by James Laughlin. p. cm. Includes bibliographical references.
ISBN 0–8112–1126–6 (alk. paper).—ISBN 0–8112–1127–4 (pbk.: alk. paper)
1. Surrealism. 2. Arts, Modern—20th century. I. Title.
NX456.5.S8A53 1990 709'.04'063—dc20 89–14037 CIP

New Directions Books are published for James Laughlin
by New Directions Publishing Corporation,
80 Eighth Avenue, New York 10011

CONTENTS

FOREWORD

The menace of surrealism was so frequently advertised by impudence that any reader of this book should be allowed the impudence of demanding my credentials. Although I was never an official member of the group, I have a debt to pay which might as well be revealed.

In 1930, when I was turning seventeen, I founded with James Douglas Peck, my classmate at Lawrenceville School, *La revue de l'élite,* a mimeographed chronicle of French civilization written in the French language. For some reason this little magazine was welcomed in Paris. Jean Paulhan, the editor of *La nouvelle revue française,* had the kindness to point out that "all other magazines are too long." Paul Valéry was touched by our compliments, André Gide forwarded with his best wishes a copy of *Les caves du Vatican,* and Jean Cocteau offered us a truly charming letter. Finally, Romain Rolland, who looked askance at our title, persuaded us to rename our effort *Demain.*

So far we are far from surrealism. But on January 27, 1932, *Demain* reprinted Guillaume Apollinaire's proto-surrealist poem "Zone," in which Christ wins the world's record for

altitude. This was too much for a sad example of a Roman Catholic on the faculty, who complained to our headmaster (incidentally a direct descendant of Cotton Mather). *Demain* was suppressed for a few weeks—which vastly increased our readership once it reappeared. News of the censorship enchanted Georges Braque, who wrote us that this proved that Apollinaire was still very much alive.

No encouragement came from Somerset Maugham. "I wish I knew why you wrote me in French, which you write very well, rather than in English which you probably write better. Are you by any chance under the impression that the French language is richer than the English, or that the literature of France of today has a merit greater than that of England and the United States? If so, I venture to point out that you are quite wrong."

Ezra Pound was of another opinion. "Mesieurs mes enfants," he broke out. "I dare say you are right to print in French. Will confine circulation to those who can understand the contents. If the venerable Wm. Bill Williams"—here he was referring to a delightful letter from another of our collaborators—"thinks French poesy has had no influence on him, he dwells still deeper in the vale of the unconscious than I shd. hv. thought. His sentence merely means that the influence has reached him at second hand . . ." Pound continued in French:

Calculez, mes chers confrères, la profondeur de la merrdre ou il faut faire pousser nos fleurs. Sais pas si vous voulez encore essayer à civilizer l'Amerique ou seulement à échapper et vous vous conserver dans vos forts interieurs. En tout cas, faut penser aux moyens de faire circuler les bons livres français ou traduits.

I don't know whether you're at all in touch with the few people who are trying to organize some more satisfactory publishing system? You probably feel infinitely more kulchud, cultivated etc. than. . . . XYZ, nevertheless, you might make an effort. Swallow my crude evangelism long enough to

consider the question. H. J. has been more effective than Griffin and Merril (which don't prove anything).

500 people can have any kind of civilization they want. 500 people can have anything they like printed for them (or imported for them).

You can't work in "ideal conditions," by which I mean they don't exist (YET).

Might put it this way: When you get to my age you will find it very irritating to find an amount of opposition, obstructionism, etc. proportional to that which I still find, every time I want anything good printed in America or translated into the murkin langwidg.

Demain is a good start & a start that starts in a good way of starting. Also quite right to keep *its* objective (as distinghuished from *yours*) limited to reports on French activity.

Demain came to an end in 1933 just as Raymond Roussel was sending us a money order for 25 francs. But Pound kept on writing. "Nothing much against the Surrealists," he told us on July 21, 1934, "save that a lot of 'em are French, and therefore bone ignorant, like the English."

I believe they write, but none of 'em has ever been known to read, and it is highly doubtful the alphabet is personally known to most of them. Surrealism must not be regarded as a modern movement, ref/ Ms/ Vaticano Barzeberino Latino 3953; Guido Calvacanti Rime (Genova, Marsano anno X.); also a few poems inaccessible to the Surrealists because written in American in or about 1916.

Max Ernst is a damn fine painter. I have his clear and limpid colours before me (in concrete materiality, as I write this). Also he has burried Freud and all freudian fiction, but the Freudians haven't yet found out THAT . . .

I shall join the movement when they devise a form of assassinagram which will kill at once all bankers, editors, and presidents of colleges or universities who approach within 1000 kilometers of its manifestations.

So much for Pound on the members of my cast. I did not meet Breton until the summer of 1934 when he won my eternal loyalty by putting his stamp of approval on my prose poem "The Evocative Treason of 449 Golden Doorknobs."

(Published in *transition*, this was my first appearance in print.) Breton also introduced me to Giacometti, Éluard, and Dalí. Dalí was kind, or more than kind, paying the most flattering attention to the pianos and the heads of hair that figured in the fiction I was writing under the pseudonym of Montagu O'Reilly. The name came from a bookplate I picked up in London of an Irish admiral I suspected of being pretentious and spurious. *Pianos of Sympathy,* 1936, the first tale of O'Reilly, happened to be the first title published by New Directions. Later, in 1948, New Directions would bring out O'Reilly's collected works: *Who Has Been Tampering with These Pianos?*

One attentive reader of O'Reilly was the American surrealist Joseph Cornell, to whom I was introduced by Charles Henri Ford of *View* magazine. Cornell admitted that his celebrated Taglioni jewel casket, "although not inspired by, would remind anyone familiar with it of *Pianos of Sympathy."*

The Surrealist Parade does not pretend to be an all-inclusive history of the movement. I have had the arrogance to concentrate on the artists and writers who seemed most important to me. You are welcome to disagree.

"Beauty," proclaimed André Breton, "must be convulsive or else." This was the cry of a perpetual adolescent, who would display the most sinister patience in urging the claims of the irrational on our rational world. "Flamingoes and mustard both bite," as Lewis Carroll explained. Breton was determined that no one should forget this advice, or indeed any other saying that might ruffle our complacency. And as the founder in 1924 of the surrealist movement, he could count, such were his hypnotic powers, on the loyalty, for a curious number of years, of an exceptional number of writers, painters, and sculptors, all of whom naturally preferred the temptations of their own ambition to discipline of any kind. The solidarity, so long as it lasted, was like nothing in history.

Surrealism was to explore the ultimate recesses of the dream world, and its reach could never be restrained. One of its subversive devices was automatic writing. This could release startling images: "Beautiful like the chance meeting on a dissection table of a sewing machine and an umbrella" was one of the splendid insults the surrealists discovered in the work of Isidore Ducasse, comte de Lautréamont, who disappeared at twenty-four in 1870. But the conscious mind could also be put to perverse uses, as Salvador Dalí made plain when he set out to systematize confusion. "The only difference between me and a madman is that I am not mad," he declared, proud to be a professional paranoid. Breton could not object to this, for he recognized that advertising had its importance. "What is Christianity," he inquired, "but an advertisement for heaven?"

Breton was to turn perpetually to the Left—to the anarchist Left. This was understandable. He and his followers had lived through the First World War and the Battle of Verdun, where the French and British losses totaled 615,000, the German losses, 650,000. But Breton's glance was often anxious. He was revolted by the gospel of good hard work in Stalinist Russia and shuddered at the puerility of what passed for proletarian literature. For a time he fixed his hopes on the message of Trotsky. But his ultimate savior was the utopian socialist Charles Fourier, who died in 1837 after having, in his own words, "put an end to twenty centuries of political imbecility." Fourier was never known to laugh. Every day at high noon he kept his appointment with an unknown benefactor—who never showed up. This benefactor might have helped him realize the new world for which he prayed, a universe in which the task of all parents was to spoil their children. Women, he understood, were not naturally vicious. What was vicious was civilization.

"Whom do I haunt?" Breton was to ask himself. One of those who haunted him was Friedrich Nietzsche, and he loved

the black humor with which Nietzsche saluted the coming of his own insanity. "I was twice present at my own funeral," Nietzsche informed his friend the historian Jacob Burckhardt in 1889. "I walk around town in my old student's cape, strike people on the shoulder and ask them: *Are we happy, all of us? I am God wearing this disguise.*"

Breton would never peer at the demented with the conde-scension or horror betrayed by so many of us. All his life he suspected that the insane might be more precious than the sane. An unconventional explorer of the field of psychiatry, he was not one to neglect Freud's *Interpretation of Dreams.* Nor did he overlook Freud's reliance on the free association of ideas in treating the mentally ill. This last, after all, had something in common with his own emphasis on the blessings of automatic writing. Yet Breton found Freud a pretentious bore when he called on him in Vienna in 1921. He would put Freud's case histories to one side whenever he had the opportunity to study the revelations of famous mediums. One of his favorites was Hélène Smith, a young woman of irreproachable morals in the business world of Geneva in the 1890s. In her trances Victor Hugo would often volunteer to be her guide, and at any moment she herself might speak with the deep bass voice and Italian accent of the immortal charlatan Cagliostro. Then she would become the reincarnation of the Marie-Antoinette whom Cagliostro drew into his web. On other days she would travel to Mars as Samandini, the eleventh wife of the Hindu prince Savrouka Nayaca. They would converse in Sanskrit, which she dutifully translated into French.

If Breton tired of Hélène Smith, he could always turn to the writings of Frederic W. H. Myers. The son of the perpetual curate of Saint John's, Keswick, Myers was renowned for swimming the river beneath Niagara Falls, for his study of hallucinations, and for his crusade for women's rights in his native England. He was also one of the founders of the Society

for Psychical Research and devoted several pages of his *Human Personality and Its Survival of Bodily Death* to the "Watseka Wonder." This was the case of Mary Lurancy Vennum, a fourteen-year-old girl from Watseka, Iroquois County, Illinois, suddenly possessed by the spirit of Mary Roff, a neighbor's child who had died age eighteen years and nine months when Lurancy was only fifteen months old. Lurancy fell into fits and trances: then, passing into ecstasy declared she could see heaven and the angels. In this state, which lasted nearly four months, she was Mary Roff incarnate, recalling everything the dead girl had experienced. Four years later, after her marriage to the farmer George Binney, these fits recurred, while everyone remembered that Mary Roff had been subject to raving manias.

Breton's interests were indeed wide-ranging. Save for music, all of the arts were threatened. When it came to music, he did not venture beyond the operettas of Offenbach. However, musicians were seduced. Francis Poulenc set poems of Aragon and Éluard to music, Pierre Boulez turned to the surrealist René Char for the words of *Le marteau sans maître* and if Edgar Varèse never wrote the opera he planned to a libretto by the occasional surrealist Antonin Artaud, Olivier Messiaen was inspired by Breton himself when he composed the Turangalîla Symphony. Contagion, at least, was evident. "Naked thoughts and naked emotions are as vital as naked women," Breton argued. "It is our duty to undress them."

Although his good friend and admirer the publisher José Corti kept waiting for Breton's conversion to the Roman Catholic Church, he remained a robust atheist to the end. Yet he learned much from the Church. He established his own index of forbidden writers, including, as you might imagine, the diligent rationalist Voltaire. And like a Roman steeped in the teachings of the Holy Fathers, he called on the most provocative authors in French, English, and German literature

to bless the program he laid down. "In his better days Shakespeare was a surrealist," Breton ruled. And like a conscientious Roman finding fault with Saint Augustine, he might at any moment pull one of his secular saints off his pedestal. Lautréamont, and Lautréamont alone, was safe from discussion.

"In summer, roses are blue," Breton maintained, and his faith was apparently unshakable, even though he was to suffer a real blow with the defection of Louis Aragon and Paul Éluard to the Communist Party. Of course there were consolations. In exile in New York during the Second World War he must have been aware that his taste and that of his group were leading the American abstract expressionist painters from banality into freedom. And his disdain for reason would never be forgotten, nor his scorn for middlebrow culture.

Mistakes had been made; penalties would be paid. "I am the most unhappy man on earth," he was telling one friend on the eve of his death in 1966. There remained his pride, at which he hinted when the surrealist movement was barely beginning. "Living and ceasing to live," he announced, "are imaginary solutions. Existence lies elsewhere."

CHAPTER ONE

FAREWELL TO TINCHEBRAY

Childhood, Breton was to tell his own daughter, should be the time when children watch for those mysterious and splendid riders, dashing at dusk by the banks of nervous rivers. His own childhood was dreary, and he did not choose to dwell upon it.

The joyless village of Tinchebray in Normandy, where he was born on February 18, 1896, the only child of Louis Breton and his wife Marguerite LeGorgès, is famous only as a center for the production of garden tools and hardware. Nor is the railway center of Flers, ten miles away, in the least endearing. It specializes in the manufacture of razors and cotton goods, and no one would guess that the lovely Château d'O, promising the wonders of the Renaissance, is not far distant. When André was four, the family moved to Pantin, the industrial suburb northeast of Paris. Here he was confronted with the desolate gardens of the latest subdivisions.

His mother was a bigot: she grew sullen when he dared to buy a book or two. His father, who was anything but a success, having given up the trade of upholsterer that his forebears practiced, was for a time a policeman, then clerked in a bookstore that may have resembled a newsstand, and finally

1

sold glassware for a living. Although he might have proved a companion if he had not been under the domination of his wife, he rarely encouraged his son. He was, however, a stubborn atheist, and Breton was forever grateful for the visit they paid together to a tomb bearing the legend: *Neither God Nor Master.*

Breton's atheism was, if you will, a conviction, but it was also a burden he bore his life long. It may never be explained, but it may be understood if you remember that he was a brilliant man cursed with a dull mother and a dull father. He may have reasoned that the God who gave him such parents did not deserve to exist. In any event he came to consider that the prominent atheists of the past were so many martyrs dedicated to his own cause. All of which, of course, was not quite true. This poet, this believer in romantic love, would forget that the Marquis de Sade, no matter how curious a figure in the annals of pathology, was no friend to anyone falling in love. For the same reason he would overlook the pomposity of Freud, whose appreciation of art and literature was minimal, to say the least.

One of the rare pleasant moments of Breton's childhood came when he called on his maternal grandfather at Saint-Brieuc on the Breton coast. He was a taciturn fellow who could tell a story now and then. But the only appealing figure to emerge from the shadows was the maternal grandmother he was taken to see when she was over one hundred and near death. "When I was kissing her right hand," Breton recalled, "my dear grandmother—may she rest in the kingdom of heaven—placed her dying left hand on my head and said in a deep but distinct voice: 'You, the oldest of my grandchildren! Listen to me and remember my last wishes. As long as you live, never do anything like other people.'" He seemed puzzled by this last command, and she added in a petulant tone: "Or else

do nothing at all. Just go to school. But be sure and do nothing that anyone else is doing."

His first school was Sainte-Élisabeth, maintained by the religious of the community of Saint-Charles. His second was the public school of Pantin where a Professor Tourtoulou secured a following by retailing horror stories in class. By this time Breton was already a constant annoyance to his father and mother, who prayed that he might raise the family's standing by making a name for himself in the applied sciences or taking up mining as a career. "I was not in the least interested in the kind of life they were planning for me," Breton has told us. From ten to seventeen he attended the Collège Chaptal near the Gare Saint-Lazare, where he had the luck to run into a Professor Keim, who could not resist talking of Baudelaire and Mallarmé. Here were two poets who would haunt Breton's adolescence.

Baudelaire was long misunderstood by Anglo-Saxon critics who made too much of his apparent Satanism. "God is a scandal. A scandal that pays off," judged this exasperated and exasperating Roman Catholic. There was no limit to either his daring or his courage. "This life," he realized, "is a hospital in which every patient is tormented by the yearning to move to another bed." While he understood that serious travelers set off on their voyages only for the joy of leaving, he could also pause with anguish over the grave of a faithful family servant. Himself one of the peerless critics, he pitied all poets who were not critics: *they were incomplete.* As a critic, he was devastated by the music of Wagner, enchanted by the fashionable sketches of Constantin Guys, amazed by Manet, and pleased with Whistler. Above all he was touched by Delacroix, whose painting made him dream of a lake of blood haunted by evil angels.

As for Mallarmé, who died when Breton was two years old,

he earned his precarious living as an English teacher, despising his profession but finding his recompense in the magnificent authority he enjoyed over those who appreciated his achievement. In fact his disciple Paul Valéry was moved to paraphrase Pascal when evoking his prestige: "You would not be reading me if you had not already understood me." "Do you realize," Valéry once asked Mallarmé, "that in every city of France there is a quiet young man who would suffer almost any punishment for you and your verses?" Everything that pleases most people was expurgated from his work, Valéry explained. So he could produce very little, but that little, once tasted, corrupted the flavor of all other poetry.

Valéry believed that Mallarmé understood words as if he had invented them. This belief was shared by other writers of his generation, like André Gide and Paul Claudel, who took their places on Tuesdays in the salon he maintained in his apartment in the rue de Rome close to the Gare Saint-Lazare.

While Breton was aware of the power of images like the "ideal fault of roses" he came across in "The Afternoon of a Faun," and was certainly subject to the cerebral typographic spell of "The Casting of the Dice," he was later to question Mallarmé the scientific poet, who meant so much to Valéry. Yet there remained the authority of the magician of the rue de Rome. And his occasional impertinence. When Degas, who was anything but a casual artist, made the mistake of telling Mallarmé of the trouble he was having working up ideas for poems, he was instantly informed that poems are made of words, not ideas.

Of course Breton had other diversions in his teens than Baudelaire and Mallarmé. One of these was the hyperromantic Maurice Barrès, ultimately identified with the extreme nationalism of his later years and his cult for the dead. But Barrès, who rediscovered El Greco and did not conceal his yearning for the anemic courts of Germany, was originally something of

an anarchist, spending his passion for Spain in *Blood, Voluptuousness and Death,* whose tales and sketches made a profound impression on Breton in 1913. Not that Barrès could rank with Villiers de l'Isle-Adam, the symbolist whose drama *Axel* will always be remembered for Axel's defiant cry: "Living? The servants will do that for us." Another symbolist who cast a profound spell was Saint-Pol-Roux, the author of the still mysterious play *The Lady with the Scythe.* He was positive that a work of art was the holiest of crimes. Naturally, Breton had no time for Maupassant, whom he dismissed as vulgar.

But to Breton no one loomed larger in 1914 than Paul Valéry. "You have one great defect," Degas told Valéry. "You want to understand everything." This poet, who could claim to be Mallarmé's representative on earth, had an immaculate mind, revealed in his essay of 1919, "The Spiritual Crisis":

We civilizations, we know now that we are mortal.

We had heard of worlds that completely vanished, of empires gone down with all their men and all their engines; descending to the inexplicable depth of the centuries with their gods and their laws, their academies and their pure and applied sciences, their grammars, their dictionaries, their classics, their romantics and their symbolists, their critics and the critics of their critics. We well know that what we take to be the earth is made of ashes, and that ashes mean something. We could see through the thickness of history the phantoms of immense ships laden with wealth and intellect. We could not count them. But those shipwrecks, after all, were not our business.

Elam, Ninevah, Babylon were beautiful vague names, and the total ruin of those worlds had as little meaning for us as their very existence. But *France, England, Russia* . . . could also be beautiful names. *Lusitania* is a beautiful name. And we now see that the abyss of history is vast enough for everyone. We know that a civilization has the same fragility as a life. The circumstances that could send the works of Keats and Baudelaire to join those of Menander are not at all inconceivable: they are in the newspapers.

Valéry defined the beautiful as that which drives us to despair. Breton might have agreed. He was overcome by

Valéry's caustic essay of 1894, *The Evening with Monsieur Teste,* begun when the author was only twenty-three. "Stupidity is not my strong point," Teste insists on the first page and he rarely disappoints. "I had my suspicions about literature," he continues, "even about the rather precise efforts of poetry. The act of writing always demands a certain sacrifice of the intellect." Teste has no opinions, but is convinced that "we are only beautiful, only extraordinary in the eyes of others."

Valéry may have owed his dignity to the princely blood of his Genoese and Venetian ancestors. His anxiety, however, was his own property. "I am between myself and myself," he confessed during the ghastly night of October 4, 1892, that he spent in Genoa. He was then on the verge of renouncing a literary career. Yet he could not forget that the year before, when he was not quite twenty, Mallarmé had done more than merely acknowledge one of his poems. "Your 'Narcissus Talking' charms me," came the word. "Keep this rare tone."

The unstained fame of Valéry was not a miracle but a conscious work of art. Saving himself from the perils of journalism, he labored for twenty-two years as the confidential secretary of a lucid paralytic at the Havas News Agency. And for twenty years he refused to publish any poems. Breton was to admire this silence, ultimately broken in 1917, when he dedicated "La Jeune Parque," a hymn to one of the fates, to his good friend André Gide.

Breton, whose own first poems first appeared in the review *La phalange* on March 20, 1914, when he was barely eighteen, was then completely under the spell of Mallarmé. In that summer he was writing: "Mallarmé reigns. This is not idolatry on my part, but simply devotion to God made manifest." He could not resist asking Valéry on March 7 if he might call at the apartment near the Étoile where Valéry was living with his wife, the niece of the impressionist painter Berthe Morisot. Breton was not disappointed. "I can still see myself," he was to

recall thirty-eight years later, "invading for the first time 40, rue de Villejust, having no idea that this street would later bear his name. There were beautiful impressionist canvases stacked anywhere, blocking the mirrors. This man, he and no other, received me in the most gracious manner, and I, mounting the stairs, did my best to compose myself when face to face with his transparent blue eyes." Valéry began by making Breton ill at ease by talking of his luck in growing up in the Pantin quarter, which for him meant the perfume factories of the rue de Paris and the skirts of the cocottes. No one could say enough, Breton admitted, about either the range or the charm of Valéry's conversation. His wit was most evident when the profoundly destructive or nihilistic element of his mind came to the fore, and Breton judged that T. S. Eliot must have been delighted by this aspect of his character.

A year younger than Valéry had been when he first met Mallarmé, Breton had seen his idol and passed the test. Valéry would not only encourage his writing but become in trying years his patron.

"Valéry taught me a great deal," Breton testified. "With tireless patience, year after year, he answered all my questions. He restored me—he took all the trouble that was necessary to make me hard on myself. I owe to him the constant care I have taken to maintain a certain discipline. Provided certain demands were met, he gave me my freedom. He used to tell me: 'I am not at all anxious for my ideas to be shared. Making converts is the last thing in the world I have in mind. Everyone must have his own point of view.'"

Monsieur Teste, Breton decided, had come down from his frame. In the years to come he could hear Teste grumble like no one else. "He remains the figure that I know must be right. In my eyes Valéry had created the supreme formula: a being created by him (at least I suppose so) had really begun to move and come toward me."

The day would come, in 1927, when Valéry, in Breton's eyes, would betray Teste by taking Anatole France's seat in the Academy. Four years later he would welcome Marshal Pétain to the company of the immortals. Said Breton of Valéry: "I chose the day he entered the Academy to get rid of his letters, which a bookseller was dying to get his hands on. It is true that I had the weakness to keep copies of them but for a long time I held on to the originals as my prize possession."

In the summer of the year he met Valéry, Breton discovered Rimbaud, who would shortly remove Mallarmé from the very first rank of poets. Long dismissed by tedious professors as a vagabond, Rimbaud by now had become more than the mere rebel who died of gangrene in a Marseilles hospital in 1891. "*I* is someone else," Rimbaud had the bravery to announce on May 13, 1871, when only sixteen. "I maintain that one must be a *seer,* make of oneself a *seer.* The poet makes himself a *seer* by a long, immense and calculated *derangement of all the senses.* All the forms of love, suffering, madness: these he must search for himself—he must exhaust in himself all poisons, keeping only the quintessence." "He must undergo," he added, "ineffable torture when he is in need of all the faith, of all the superhuman strength, when he becomes the sickest man of all, the great criminal, the great accursed—and the supreme scientist—for he is touching the *unknown!* Because he has cultivated his soul, already rich, richer than that of anyone else! So he reaches the unknown, and when, having lost his mind, is on the verge of losing any comprehension of his visions, still he has seen them! Let him collapse after racing through things unheard-of and unmentionable: other horrifying toilers at the task will make their appearance, and they will set out from the horizon where the first man fell to pieces."

For Rimbaud, Baudelaire was "the first seer, the king of poets, a real God." He may have arrived at this conclusion by reading the works of the illuminist Éliphas Lévi, who argued

that "the knowledge of everything is in man, in the same way it is in God, only a heavy wall of darkness hides it from our view . . . The word became man, but it will only be when it becomes woman that the world will really be saved."

The son of an army officer who abandoned his family in the miserable town of Charleville near the Belgian border, Rimbaud was oppressed by a mother so narrow-minded that she was horrified to learn that her son was reading a book as subversive as *Les misérables.* So the anger was comprehensible that made him a marvelous poet and forced him at nineteen to abandon poetry forever.

Reading Rimbaud, Breton was paralyzed by images the like of "tips of black air," and never forgot that here was a poet who *scorned* all professions: "the hand holding a pen is the equal of the hand pushing a plow." Breton could forgive him almost anything but could not excuse the author of *Illuminations* and *Season in Hell* for surrendering to the embraces of the slovenly Paul Verlaine. On the subject of homosexuality Breton agreed with Saint Paul (Romans I: 26-27).

Breton could sympathize with almost every mile of Rimbaud's wanderings. They had led him to London, where he tried teaching French, to Hamburg, where he performed as a translator in a circus, to the Dutch army in the Far East—he promptly deserted—and eventually to Abyssinia, where he survived as slave dealer and gunrunner until a tumor developed in his right knee. His right leg was amputated. Death came after a priest administered the last rites. "Your brother has the faith," the priest told Rimbaud's sister Isabelle. "He believes. Indeed I have rarely met a faith of the quality of his." Isabelle fell into ecstasy at this communication. "What can death and life, and the whole universe, and all the happiness of the world do to me now, since his soul is saved?" she asked.

There is no way to test the sincerity of his belief. But to the dogmatic Roman Catholic Paul Claudel, all questions were

unnecessary. "I owe him everything," he wrote. "He was not of this world." This opinion was intolerable, Breton claimed.

Perhaps to calm the impatience of his parents, Breton began studying medicine in 1913, not that anything could divert him from poetry, even though, in the course of his studies, he became a prescient observer of the new science of psychiatry.

The coming of the war, which he saluted with perfect disdain, did offer him the opportunity to come into contact with many of the French specialists in the psychiatric area. Called up in the spring of 1915, he served at first in the seventeenth regiment of the artillery and was a stretcher bearer in the Meuse offensive. Far more important were the months he spent as an assistant to Dr. Raoul Leroy at the neuro-psychiatric center at Saint-Dizier. Leroy had know Charcot, and Breton appreciated his elegance, not to mention all the details he revealed of Charcot's exploration of hysteria. Later, Breton was to make the acquaintance of Dr. Joseph Babinski of the Pitié in Paris, who predicted that he might have a great medical career. Babinski had been the first to separate neurology from psychiatry, and in this atmosphere Breton began devouring the works of Freud, not yet translated into French. However, what made the most profound impression of all were the talks he had with one patient at Saint-Dizier who refused to believe in the existence of the war. For him it was only a gigantic sham—fake wounds, fake corpses, fake shells. So he seized the chance to walk out of the trenches to watch fake shells exploding.

Having failed, perhaps on purpose, to pass his examination as an auxiliary doctor in the army, Breton was released in September 1919. One of his rare moments of relief was the reading of Romain Rolland's pacifist tract *Above the Struggle*. Although he despised Rolland's ever so popular *Jean-Christophe*, the word for *Above the Struggle* was sublime.

His real consolation in the war years came from his

friendship with Guillaume Apollinaire, a poet as playful as Valéry was persuasive. The charm of Apollinaire's impertinence was eternal, which made him the close companion of Henri Rousseau, Braque, Picasso and many other modern artists touched by his affectionate essays. Picasso, he claimed, began by waiting for the muse to dictate his brushstrokes. Later he was to draw all of his inspiration from himself, becoming one of those artists created in God's image. Here was an idea that should have been refreshing to Breton, who grew worried at times when Valéry complained of not being able to tell cubist A from cubist B.

Born in Rome to Angelica de Kostrowitzky, a native of Russian Sweden (or Finland), Apollinaire had a father who has resisted exact identification. Was he a certain Francesco Flugi d'Aspermont, of an ancient Swiss family? Although Francesco's brother was abbot primate of the Black Benedictines, Francesco himself vanished without a trace in 1894. Another legend would have it that Apollinaire's father was a Kostrowitzky raised in the Vatican, who may have been the illegitimate son of the duke of Reichstadt, the only child of Napoléon I and Marie-Louise of Austria.

With Angelica for a mother, Apollinaire was saved from a comfortable childhood. When she and her latest lover, the Alsatian gambler Jules Weil, moved to Monaco in 1887, she was ordered expelled as a loose woman by the authorities. The order was somehow rescinded, and Angelica, her lover, Guillaume, and his younger brother (of indefinite parentage) kept on living in Monte Carlo, where the great gambling hall designed by Charles Garnier provided a charming backdrop for his adolescence. He went to a French school, the Collège Saint-Charles, founded by the first bishop of Monaco. This was shut down in 1895, presumably due to the misuse of funds by the director, who may have taken too many chances at the casino, and for the next two years Apollinaire commuted to

school in Nice. All this while a facade was maintained; he dutifully took his first communion and served as secretary of the Congregation of the Immaculate Conception.

By 1895, when Angelica and her lover were living with the two children in Stavelot, a spa on the Belgian seacoast, Guillaume and his brother found it convenient to walk out of their hotel without paying the bill. Weil had disappeared, and Angelica moved on to Paris. There the two boys and their mother were apprehended by the police. "I fail to understand why we should be accused of fraud," Guillaume complained to the interrogating magistrate. "It is true that we had to leave Stavelot without paying our bill. But we always supposed our mother would take care of it. We live with her. She supports us. We have no private resources." The ugly incident was soon adjusted, once Angelica testified in court that "they're nothing but children after all, and like children they must have wanted to avoid harsh treatment." The bill was found to be too high; the charges were dropped after Angelica agreed to pay something as soon as she could.

She may well have been proud of her Guillaume. His dexterity was always evident, even if he had to slave for five or six years as a bank clerk in Paris. In the meantime he was puffing the classics of pornography and doing more than his share of hackwork while searching for the inspiration of his poems. One such opportunity was provided late in the summer of 1901 when he went off to the village of Bennscheid near Bonn to be a tutor in the family of the hateful vicomtesse de Milhau, a German whose husband had just shot himself in his villa on the Norman coast. At Bennscheid he met the governess Annie Playden, the daughter of an English architect so strict that he was recognized in his own family as the "Archbishop of Canterbury." Annie failed to return his love, even though he proposed to her on the top of a dizzying mountain known as the Drachenfels or Dragon Cliff. Twice he pursued

her to London, again without forcing her to submission, but she was the subject of a few poems that will not be forgotten. Later he would adore Marie Laurencin, the "Tristouse Balle-rinette" of his comic novel *Le poète assassiné*. His ultimate choice was Jacqueline Kolb, whom he married in the spring of 1918.

A lyrical moment of a different order occurred on August 23, 1911, when the newspapers reported that the *Mona Lisa* had been stolen from the Louvre. Apollinaire had nothing to do with this theft by a mad Italian housepainter, and the picture was recovered in 1913, but the police were brought into this case when a certain Géry Pieret, a dubious Belgian posing as Apollinaire's secretary, admitted stealing two Iberian heads from the museum. These he sold to Picasso, who grew so frightened he thought of dropping them into the Seine before he had them returned. Apollinaire was sentenced to a few days in prison for befriending Pieret. This was embarrassing. So was the fact that Picasso refused to recognize him during the investigation.

Apollinaire was, however, more than the man who romped through the headlines. On March 15, 1918, two months before his wedding to the red-haired Jacqueline, he published "La jolie rousse," a poem that summarizes, as does no other, his belief that modern art, considered by some people to be too disobedient to enter the museums, was worth the battle that Picasso and the others were waging:

> You whose mouth is designed as the image of God
> Mouth the essence of order
> Be indulgent when you compare us
> To those who were the perfection of order
> We, who are always searching for adventure
> We are not your enemies
> We want to offer you vast and strange domains

Where mystery in bloom is there for whoever plucks
 the flower
There are new fires, colors never seen
To which we must give reality
We want to explore goodness, that vast and quiet land
There is also time, which can be sent away or called
 back
Have pity on us, who are always fighting at the
 frontiers
Of the limitless and of the future
Have pity on our errors, pity on our sins

It was about this time, on May 18, 1917, to be exact, that he
coined the word *surrealist* to describe a new ballet, *Parade*. The
sets were by Picasso and the music by Satie. He was ready to be
entertained, even though the idea came from Jean Cocteau,
about whose character he had grave misgivings. He did not
trouble to define the word exactly, even when he used it a little
later to catch the essence of his own new play, *The Mammary
Glands of Tiresias*. Eventually set to music by Francis Poulenc,
Tiresias was a hilarious invention, a scream rather than a hymn
to raising the French birthrate.

"I so love art that I have joined the artillery," Apollinaire
wrote a friend at the end of 1914. As a foreigner he was not
obliged to enlist, and his first application to join up had been
ignored. There were days when Breton worried over the
gaiety with which Apollinaire saluted the war. But he was ever
subject to his charm: "He was a great man . . . In any event I
have never seen his like again." Breton could not forget the
door at which he knocked at 202, boulevard Saint-Germain.
There was that Picasso of the blue period, two good Derains
and two Chiricos. And Apollinaire himself. "A few years from
now," Breton would write in 1952, "those of us who have lived
long enough to talk of other times will speak of Guillaume

Apollinaire. To have known him will pass for a rare blessing. Young people will bring up that unsophisticated phrase: *I came too late.*"

Breton, who began writing Apollinaire by the end of 1915, paid his first call in May 1916, when the poet was recovering at the Italian Hospital in Paris from a wound in his right temple caused by shell splinters. The wound proved to be more serious than first supposed: he grew dizzy and his left arm was paralyzed. The doctors ordered a trepanation to relieve the pressure on the brain. The operation was successful, but on November 9, 1918, just two days before the armistice, he died in his apartment of pneumonia. On the thirteenth a mass was said at his funeral at the Church of Saint-Thomas-d'Aquin around the corner, where he and his wife had been married a year and a half before.

The widow, remembering that Breton had been calling almost every day, presented him with Apollinaire's fountain pen. No such easy ceremony was possible after another friend, the twenty-three-year-old Jacques Vaché, was found dead of an opium overdose in a Nantes hotel on January 6, 1919. If Vaché had lived longer, he might have repeated one anecdote too many, but in 1919 he was a prince of disdain and impudence, who did his best to stop Breton from taking himself too seriously. "But for him I might have been a poet," Breton admitted.

Serving as an interpreter for the British forces, Vaché affected a monocle, which was not his only affectation. When Breton met him at the hospital in Nantes where he was getting over a slight wound in his calf, he was already denying that he had learned anything as a student at the École des Beaux-Arts. "We don't like either art or artists," he proclaimed. "Down with Apollinaire! We don't know Apollinaire any more, for we suspect him of creating art on purpose." As for Mallarmé, "we don't hate him, but he is dead." He meant what he said

about Apollinaire. Showing up at the opening night of *Tiresias* in a British uniform, he pulled out his revolver and threatened to fire on the audience. He was then rereading Saint Augustine, and one of the rare contemporaries he forgave was André Gide, for having exploited the consequences of a gratuitous crime in *The Vatican Cellars.* The Lafcadio of that novel was not only a criminal but a hero.

Another excusable writer—Vaché had nothing to do with the cult for Rimbaud—was Alfred Jarry, dead of meningitis and absinthe at thirty-four in 1907. Jarry's grandmother and his aunt had been confined for insanity, and even if he did know Valéry (who turned up at his funeral) and even if he got along with artists as famous as Gauguin, Lautrec, and Bonnard, he was not meant to pass for a solemn figure. His most "important" work was the play *Ubu Roi,* a Polish escapade remarkable for its first word: *Shit.*

The unbearable Jarry also invented the difficult Duke Haldern of the drama *Haldernablou,* who yearned to meet someone neither man nor woman, but a monster, a devoted slave who might say a word without breaking into the harmony of his sublime thoughts. And to Jarry must go the credit for citing Lautréamont before he was discovered.

Lautréamont (this pen name of Isidore Ducasse was obviously borrowed from *Latréaumont,* the title of a rather dull novel by Eugène Sue, celebrated in the Second Empire for penny dreadfuls like *The Wandering Jew*) had vanished, as we noted, in 1870 upon completing *The Songs of Maldoror,* which might well be considered the most extraordinary book of the nineteenth century. Yet it had been constantly overlooked, although Remy de Gourmont saw fit in 1896 to dismiss its author as a maniac. The first man really to emphasize Lautréamont's achievement was Valery Larbaud, the creator of the marvelous millionaire Archibaldo Olson Barnabooth, and the sure translator of James Joyce. In *La phalange* for February 20,

1914, the very issue in which Breton's first poems were published, Larbaud pointed out that the proper inscription for *Maldoror* should be: *Here the public is not admitted.* By which he meant that here was a book that could not *fit* any of the labels which the common reader insists on, for fear of being tricked or made fun of.

The six prose poems of *Maldoror* are the work of a furious adolescent, but let no one believe that this is a trivial production. If we deny the fires of adolescence, we deny the beautiful indignation that once may have been our own. "My poetry," Lautréamont insisted, "will consist only of attacks on Man, that bald beast, and the Creator, who should not have perpetrated such vermin. Volumes may pile up, one after the other, until the end of my life, but you will never discover anything but this single idea, ever present to my conscience."

In order to sow disorder in every family, Maldoror has sealed a pact with prostitution. This may or may not prepare you for the horrors to come. You may be ready for the beetles a little bigger than cows, or the hymns to lice, or the joy of chopping one's mother into shreds, but what can possibly prepare you for his humor at its most savage? Maldoror adores the ocean, even though May may be more intelligent than the ocean. He is also shattered by the beauty of mathematics. And on every page the imagery is stupefying.

For Breton, Lautréamont was a living presence, compensation for the deaths of Apollinaire and Vaché. You may then imagine his ecstasy on discovering at the Bibliothèque Nationale yet another book by Lautréamont, his *Poésies.* This slender volume he immediately transcribed. Here was the perfect refutation of *Maldoror,* a series of maxims to discredit all the heroes of romanticism. "The genuine masterpieces of French literature," the author maintains, "are the addresses delivered at the distribution of prizes in our schools—these, and the discourses pronounced in our academies." To Lautréamont it

was obvious that poetry had not progressed a millimeter since Racine. Instead it had gone backwards. Thanks to whom? Thanks, among other people, to Châteaubriand, that sad Mohican, to Gautier, that incomparable grocer, and to Byron, that hippopotamus from the jungles of hell. And what is poetry, he exclaimed, but geometry *par excellence?* Its only aim must be to reveal a practical truth. Finally, he decided that "poetry must be made by everybody. Not by one man." Having said all this, he went on to reveal that "all the water in the sea could not wash away an intellectual bloodstain." This was magnificent, and what was equally magnificent, Lautréamont had lived and died without burdening us with biographical details. All that was known was that he was born in Montevideo, the son of the one-time chancellor of the French consulate.

Breton was not entirely alone in his enjoyment. André Gide, who had already acquired a certain reputation for intelligence, confessed as early as 1912 that after reading Rimbaud and the *Sixth Song of Maldoror* he grew ashamed of his own work.

Breton would also face the world with two companions who would travel at his side much of the way.

There was Paul Éluard, who came from a family apparently as unpromising as his own. Born in 1895 in the industrial suburb of Saint-Denis, he was the son of the accountant Clément-Eugène Grindel and his wife Jeanne-Marie Cousin. Though a solid anticlerical socialist, Grindel would eventually make some money as a specialist in real estate subdivisions, at which time his wife would abandon her own career as a dressmaker. Éluard was close to both his parents but was haunted by what he had heard of the unhappy life of his maternal grandmother and so chose her family name as his *nom de plume.*

The victim all his life of tuberculosis, Éluard was a fragile man capable of superb anger. His mind was his ears, by which

is meant that he could listen like no one else and could accept with beautiful humility the inspiration of his subconscious mind. He was not so precocious as Breton. He was even guilty, in his teens, of dipping into Maupassant, and his very first poems, published in 1913, betrayed the influence of T. S. Eliot's favorite, the gently mocking Jules Laforgue.

Éluard was spitting blood as early as 1912. The next two years he spent in the tuberculosis sanatorium of Clavadel near Davos. There he met a fellow patient from Russia, Helena Dimitrovnic Diakonova. "I am your disciple!" he cried and he named her Gala. She would design his life. Called up for active service in November 1914, he performed first in the infantry and then as a military nurse. Back at the front in January 1917, he was declared unfit for active service after an attack of bronchitis and a recurrence of tuberculosis. In the meantime he met and sympathized with anarchists and pacifists. On February 21, 1917, he got three days off from the army to marry his Gala. His father was horrified that he took communion at this time and that he made Gala his bride in the Roman Catholic Church. "The fathers of the Church have no influence over me!" he reassured his family.

Éluard owed his acquaintance with Breton to Jean Paulhan, later to be the editor of *La nouvelle revue française* and an executive of the omnipotent publishing firm, founded, like the magazine, by Gaston Gallimard. But on November 24, 1918, he had already presented himself to Breton at the first performance of Apollinaire's play *The Color of Time,* mistaking him for a comrade thought killed in the war. At the moment Breton was deep in conversation with Picasso.

Louis Aragon, who specialized in insolence, may have been a more exciting companion than Éluard, although he frequently proved to be a surly spectator of the rich and the well-born. "I have never searched for anything but scandals, and I went after scandal for scandal's sake," he admitted. In 1925 in

Madrid he would announce that "we are the ones who will always hold out our hands to the Enemy." There were days when Breton wondered what public Aragon was seeking for his performances. "The only danger he runs," he commented, "is his terrible desire to please people."

Born in 1897, Aragon was the child of Marguerite Toucas, a woman reduced to painting fans for her living, even though her great-great-grandfather's brother was the respectable preacher Jean-Baptiste Massillon, a member of the French Academy. At seventeen Marguerite was seduced by the fifty-seven-year-old Louis Andrieux, an ambiguous politician with a family of his own, who had won a reputation for harshness in 1871 by suppressing the revolutionaries of Lyons sympathizing with the Commune in Paris. Marguerite's father, who had abandoned the family to look after a gambling casino in Constantinople, made it more than plain that he was on the side of the Commune.

"I was a burden for my family," Aragon confessed, "because I was not a legal child. My mother passed herself off as my sister." His ancestry was not explained until he was seventeen and Andrieux "forced my mother to tell me she was not my sister, because he did not want me to be killed without knowing that I was proof of his virility." As a little boy he was a witness to horrid quarrels between his parents. During one of these squabbles Andrieux tore off the wall a photo of the man who posed in the family as little Louis's father.

When Aragon was eleven, the story goes, one of his compositions was read out loud in the very classroom where the future novelist and playwright Henry de Montherlant was absorbing his education. But this was a rare distinguished moment. The little boy grew up in the boarding house his mother managed on the avenue Carnot near the Étoile. The surroundings may have been elegant, but the money problems were merciless. He and his mother eventually moved to

Neuilly, where she kept on struggling with her fans while putting the saucers she created on the market.

Aragon took his first and evidently his last communion at this time, compensating for this mistake by becoming a belligerent atheist. In his teens he was as passionate an admirer of Barrès as Breton himself. He also claimed to have written sixty novels before he was nine years old. This may not have been quite true, but he was a voracious reader and seems to have discovered Lautréamont a month or two ahead of Breton. In 1917 they ran across each other at Val de Grâce Hospital in Paris. Together they stuck reproductions of Picasso, Matisse, and Chagall on the hospital walls and according to Aragon realized that their encounter was one of those decisive events. Like Breton, he was a medical student. Unlike him, he won the Croix de Guerre and had the unpleasant duty of firing on German strikers during the French occupation in Saarbrücken in 1919.

Breton may have decided that the twentieth century began in 1919. This was the year he founded *Littérature,* a magazine of his own, and made his first experiments in automatic writing. He was then twenty-three and more than familiar with all the innovations of Baudelaire, Rimbaud, Lautréamont, and Apollinaire. Entertained by the arrogance of Jarry and Vaché, he also admired the calm of Mallarmé and his disciple, Valéry. To speak with their authority was his consuming ambition, although he was not meant to be respectful of anyone for too long.

Now and then an unfriendly friend might object to the manner in which Breton issued his edicts and more than once he was put down as a "pope." But his real friends realized that he was a magician. When he came on stage with his impressive, well-groomed mane, he had only to fix his eyes upon you to force you to perform: to set out upon a voyage you had not yet contemplated.

CHAPTER TWO

POETRY MUST LEAD SOMEPLACE

To the bookseller Adrienne Monnier, who attracted a sophisticated clientele to La Maison des Amis des Livres, her shop on the rue de l'Odéon, Breton in those days had the look of a handsome archangel. Angels, she pointed out in her autobiography, are graceful; archangels, serious. Angels are always smiling, she added, while archangels have great tasks to perform, like driving people out of paradise. In her presence Breton never smiled, but would laugh a sardonic laugh and, like a woman conscious of her beauty, would never change his expression.

At twenty-three Breton was, however, naive, so naive that he imagined he might find someone to replay the exact role of Jacques Vaché. He was tantalized by what he had been hearing of the dadaists in Zurich, especially by the performances of the Rumanian Sami Rosenstock, already winning a sensational reputation under the *nom de plume* of Tristan Tzara. Like Vaché, Tzara was seldom minus his monocle.

"I was just about to write you," Breton burst upon Tzara on January 22, 1919, "when a great grief dissuaded me. What I most loved in the world has vanished: my friend Jacques

Vaché is dead. It was a joy to me in recent days to think you would have appreciated him. In you he would have recognized a kindred spirit, and if we had all worked together, we could have accomplished great things."

Was Tzara the substitute for whom Breton was searching? He did know a thing or two about advertising, and proved it by his recipe for a dada poem. "Take a newspaper," he directed. "Take a pair of scissors. Choose an article as long as you are preparing to make your poem. Cut out the article. Then cut each of the words that make up the article and put them in a bag. Shake it gently. Then take out the scraps one after the other in the order in which they left the bag. Copy conscientiously. The poem will be like you. And now you are a writer, endowed with a sensibility that is charming, although beyond the understanding of the vulgar."

This sounds suspiciously like Edward Lear, but it was never Tzara's ambition to pass for a humorist: in fact he was to spend his old age in a self-conscious modern house designed by the Viennese Adolf Loos, while proclaiming at the slightest opportunity his loyalty to the principles of Stalinist Communism. What passed for his humor in the 1920s was essentially a number of clever lines repeated an unclever number of times.

Tzara was obviously enjoying the wave of despair that swept over Europe in 1919, and Zurich was not the only center of dadaist agitation. The virus spread to Cologne, Hanover, Berlin, Barcelona, and even New York. The divine disorder had to be experienced; if it were simply enjoyed there was always the danger of sentimentality, of which Breton was well aware. He plunged into dada in hopes that a concrete ambition would emerge of which he would be the master mind.

That this despair existed was apparent to Count Harry Kessler, the most perceptive German of his generation, who on December 28, 1918, jotted down in his diary his impressions of the shambles of the royal palace of Berlin. "The imperial

apartments," judged this connoisseur, whose Irish mother and Persian great-grandmother may have contributed to the distance from which he surveyed Germanity, "were such a ghastly reminder of the preferences of the lower class that you couldn't possibly rise to any indignation over the plundering that had been going on." Out of this vulgar paradise, he reasoned, came the World War, or at least William II's responsibility for the war. "His taste was sickening, his very whims were pathological, and yet he had his hand on the all-too-well-oiled machinery of the state . . . I have no pity for him, only, when I think things over, a feeling of horror and a suspicion that I too am guilty, for this world, which should have been destroyed long ago, lives on in one form or another."

Kessler was a man who got around. With the actress Elisabeth Bergner on his arm he turned up now and then at the Cabaret Voltaire in Zurich at Spiegelgasse 1, a step away from Lenin's lodgings at Spiegelgasse 6. At the cabaret, dada was invented in the spring of 1916. "What we are celebrating is a buffoonery and a requiem mass," claimed the most brilliant of all the dadaists, Hugo Ball, who had refused to do his bit in the trenches, like all of his confederates.

We should meet the other performers in this night club. Aside from Tzara there was the Rumanian painter-poet Marcel Janco, last heard from in Tel Aviv at the end of the Second World War. Then there was the able but unemotional abstract sculptor, the Alsatian Hans Arp, who would come in and out of Breton's life in later years. There was also Dr. Richard Huelsenbeck, who would ultimately practice Jungian psychiatry in New York City under the name of Dr. Charles L. Hurlbeck. He claimed to have been the first man to pronounce the word dada. The word itself, meaning hobbyhorse, was discovered in a French dictionary by Ball.*

*Or so we believe. The discovery of the word was the subject of many quarrels.

Although Ball, pale as a plaster dummy, consented to play the piano accompaniment to Huelsenbeck's slamming of a drum, while Tzara managed to make his bottom jump like the belly of an Oriental dancer, it would be wrong to dismiss Ball as just another member of the group that entertained the customers at the Cabaret Voltaire. *They* might enjoy their despair. *He* was revolted into action.

"There were signs," wrote Ball in his *Fantastic Tenderenda*, "that evil was staring at us. A head was found that shrieked *blood, blood* and its cry could not be silenced. Parsley was growing out of its cheekbones. Thermometers were flaming with blood . . . the *Watch on the Rhine* was selling at a discount in the banking houses."

Writing of his own generation, he pleaded: "When we spoke of Kandinsky and Picasso, we didn't mean painters but priests, not craftsmen but creators of new worlds, new paradises." He turned to childhood as to a new world. "The child will be the accuser on judgment day, the Crucified One will judge, the Resurrected One will pardon . . . Childhood is not at all so obvious as generally assumed. It is a world to which hardly any attention is paid, with its own laws, without whose application there is no art, and without whose religious and philosophical recognition art cannot exist or be apprehended . . . The credulous imagination of children is, however, also exposed to corruption and deformation. To surpass oneself in naiveté and childishness—that is still the best antidote." In all his ecstasies he was accompanied by his lovely wife Emmy Jennings, the cabaret singer and actress who played her own part in the Cabaret Voltaire. Like him, she was a desperate Roman Catholic.

"Faith in the material world is faith in death," Ball had written. With this, his father, a drummer from the Palitinate famous for inventing fairy stories, might have agreed. When the time came, in the summer of 1927, for Ball to die of cancer,

Emmy was at his bedside. On hearing the first stanza—"Roses are beautiful, farewell my love"—of the folk song sung by children on the hospital lawn, she seized the red and white roses in the vase by Hugo's bed and threw them as a bouquet to the children below.

"It was so good seeing you on Friday," she wrote when it was all over to their old friend Hermann Hesse, "although the road was dark, darker than ever before. It was stormy, it was raining and there was lightning, and our Hugo was spending his first night alone in the earth and not in my arms as on the last night of his life."

Ball, who founded the Cabaret Voltaire as an experiment in constructive anarchism, was irritated by the all too methodical destruction advocated by Tzara. "Language," Ball believed, "must be destroyed. No harm will be done. When communication is at an end, one dives into oneself." He must be recalled as the author of the poems without words he recited, poems later reprinted by Eugene Jolas in *transition*. "We should burn all libraries," Ball had the innocence to declare, "and allow to remain only that which everyone knows by heart. A beautiful age of the legend would then begin."

This message should have touched the heart of Breton, but rumors of Tzara the spellbinder had already reached Paris. "I say unto you," Tzara had declared in the *Dada Manifesto* of 1918, "there is no beginning and we do not tremble, we are not sentimental. We are a furious wind, tearing the dirty linen of clouds and prayers, preparing the great spectacle of disaster, fire, decomposition." To Breton's impatient friend Aragon, Tzara might well be a second Rimbaud. "A few of us," Aragon testified "waited for him in Paris as if he were that savage adolescent who swooped down on the devastated capital at the time of the Commune."

Tzara did not reach Paris until January 17, 1920, when he knocked at the door of Germaine Everling, the mistress of

Francis Picabia, the painter who insisted: "If you want to have clean ideas, change them as often as you change your shirts."

Picabia, who had been wondering for some time whether his wife or his mistress would produce his next child, was away from home at the moment, and Tzara had to discover that he had arrived at an inopportune hour: Germaine had just given birth to Lorenzo, the latest of the Picabia children. But Tzara was not to be embarrassed, not even by his approximate French: he spoke with an atrocious Rumanian accent. In any event he had been invited to share the apartment. So he stayed.

Breton may not have perceived that Tzara, in turning up in Paris, had decided to manage dada in Paris without the help of anyone, Breton included. Breton had written Tzara that "you can't imagine how much André Gide is on our side. I have noticed that he is terribly interested in the last word in painting and literature." This statement could not have made a good impression. In Tzara's eyes, Gide did not amount to much. He had no intention of excusing Gide's fondness for that "mediocre and sentimental" poet Rainer Maria Rilke. On the subject of Gide, Tzara and Picabia were as one. Said Picabia: "If you read André Gide aloud for ten minutes, your breath will stink."

Tzara, proud of pointing out that "people have always made mistakes, but the greatest mistakes of all are the poems they have written," may not have realized that Picabia was as uncomfortable a representative of the dada spirit as he himself. "A conviction is a disease," Picabia was guilty of repeating, whether in Barcelona, Paris, or New York.

The son of a rich Cuban and his French wife, Picabia did not take his painting too seriously, either in his impressionist period or in his brief attachment to the principles of cubism. By 1913 he was off for New York with his wife to inspect the Armory Show, in which two of his quasi-cubist canvases were hung. Two days after the show closed, he was given an

exhibition of his own by Alfred Stieglitz, which led him to believe that New York might be a second home. Back in France when war broke out, he was in no danger, as a Cuban national, of conscription. However, his considerate wife saw to it that he served as chauffeur to a general. This was a tactful assignment, since Picabia was the victim of a lifelong infatuation for expensive automobiles. He was even credited, by one of his admirers, with running through 127 motor cars of his own. In 1915 he was sent to New York, ostensibly on a mission to buy up Cuban molasses for the French government. The mission seems to have slipped his mind, but he did contribute to two issues of Stieglitz's magazine *291*. And when he grew depressed in Manhattan, his wife arranged for him to recover in the sunshine of Barcelona. Here he started a magazine of his own, named *391* in homage to Stieglitz, rounding up contributions from Apollinaire, Aragon, Breton, Éluard, and Tzara as well as a poem or two from Ezra Pound, including his "Ritratto" of Ambassador Lowell; he also broke into print himself under the pen name of Funny Guy. "Crocodiles are my friends," Funny Guy announced. "There are no modern crocodiles, any more than there are ancient crocodiles. I know because I am the brother of cherries and of God."

One of his trials in Barcelona—we may assume that it was a trial—was his meeting with Arthur Cravan, the stock character in so many accounts of the dada movement. Cravan, who passed for the nephew of Oscar Wilde, brutally insulted Marie Laurencin and dismissed Apollinaire, incorrectly, as a Jew. Although Jack Johnson knocked him out cold on April 29, 1916, Cravan liked to believe that he was a professional boxer, and it was in that capacity that he once called on André Gide. "I must tell you right off," he told Gide, "that I prefer boxing to literature." "Literature," Gide is said to have replied, "is however the only topic we can discuss. What have you read of mine?" "I am afraid to read you," Cravan countered. Then he

added: "How are we doing with the time?" To which Gide supposedly answered: "It's a quarter to six."

Cravan, many of whose best friends were drug addicts, was at home in all the night clubs of Berlin's Kurfürstendamm, detested Paris, and did not object to sleeping in Central Park at night. "The squirrels are my friends," he reported. "And like all my friends, I have to leave them." He was to vanish in Mexico, where he may have been murdered in a dance hall.

Picabia was to haunt New York again in 1917, where he renewed his acquaintance with Emmanuel Rudnitzky, who under the name Man Ray would become the official photographer of Breton and his allies. Thanks to his first French wife, Ray had already dipped into Rimbaud and Lautréamont. He was also making a number of friends, right and left. On the conservative side were George Bellows, never so happy as when painting prizefighters, and Robert Henri, who based his technique on masters as well established as Hals and Manet. A far more radical point of view was represented by Alfred Stieglitz, who mounted in his gallery the first exhibits of Cézanne and Picasso in the New World. Ray would dine rather frequently with Stieglitz at Mouquin's exceptional restaurant. Other remarkable friends included Edgar Varèse, not yet the composer of *Ionisation,* and Djuna Barnes, who had yet to publish *Nightwood*. In those days Ray was primarily a painter and he once sold six canvases in a minute to the shrewd Chicago collector Arthur Jerome Eddy. The summons of dada had to be answered, not only on his easel but in his found objects, to which he invariably added something of his own. The day was coming when he would create *Cadeau,* a clothes iron into whose base were stuck fourteen nails. This would be followed by his *Indestructible Object,* a metronome with an eye affixed to its pendulum. It was originally entitled: *Object to Be Destroyed*. When it was lost, he produced an exact replica.

On Bastille Day, 1921, Ray reached Paris and was almost

immediately offered an exhibition, which Breton, Éluard, and Aragon all hailed. Not a single work was sold. This was unfortunate. It may be the reason that Ray gave us so many photographs and so few paintings. "I had to get money to paint," he confessed. "If I'd had the nerve, I'd have become a thief or a gangster, but since I didn't, I became a photographer." In no time he was photographer in residence for the couturier Paul Poiret, moving on from this job to catch one celebrity after another, including the lap dog of Boni de Castellane.

When not enjoying himself with his noticeable mistress Kiki of Montparnasse, he found the time for his rayograms, an idea that came to him when by chance he left an object on an unexposed negative. On developing the negative, he discovered that the object left a white impression while the rest of the print remained black. He also turned out a movie or two, in one of which, *Emak Batia,* a man appears with a valise containing white collars, which he tosses to the ground. The collars then rotate out of focus, producing the precise abstract effect at which Ray was aiming.

The actor in this scene, Jacques Rigaut, had lips with "rather a bitter twist," Ray remembered. This was not surprising, once you understand that Rigaut was one of the dada legends. "Every Rolls Royce that I meet prolongs my life by a quarter of an hour," he announced, and no convention could claim him, even though he was once the secretary of the fashionable portrait painter Jacques-Émile Blanche and spent some years in New York, where he married a wealthy American girl. However, readers of his *Lord Patchogue,* located, if anywhere, on Long Island, may wonder whether the marriage was ever consummated. "Suicide," he claimed, "must be a vocation," a revelation that caught the attention of Breton the psychiatrist. "The first time I killed myself, it was to spite my mistress. The second time, it was because of my laziness. The third time—

but I'll spare you the account of my other suicides . . . Life is not really worth the trouble of leaving it." On November 5, 1929, he finally succeeded in taking his life in a suburb of Paris. He was then thirty.

"I shall be as serious as pleasure itself," Rigaut promised. The most serious of all the dadaists was Marcel Duchamp, who understood, as do so few art historians, that art history is an expression of the mediocrity of an era.

"I have never worked to earn my living," Duchamp boasted. "I consider that working for your living is silly from the point of view of economics. I hope that someday people will be able to live without doing any work at all." Although he was awarded an honorary degree by Wayne State University in 1961, he cannot be said to have labored for this honor. He stopped painting in 1923, and playing chess became the major occupation of his last forty-five years on earth. To death he seems to have been indifferent. At least he left instructions that on his tomb would be engraved the words: "After all, it's always the other people who do the dying."

Whether in Paris or New York (he became an American citizen in 1955, at age sixty-eight) he dreaded the importance so many people attach to the word *creation*. "In the ordinary, social sense of the word, creation is very nice, but at heart I can't believe in the creative function of the artist. He's a man like anyone else, and that's all there is to it . . . The fact that people live with artists and talk to them has deeply displeased me."

That he and his brothers had talent is beyond question. The sons of a notary, they grew up at Blainville in the countryside near Rouen where their talent was early encouraged. (One brother became the painter Jacques Villon, the other the sculptor Raymond Duchamp-Villon.) But Duchamp seems to have been bored during his lifetime by the talent he possessed. It was so easy for him to produce the impressionist canvases of

his youth, so easy for him to laugh when he was not admitted to the École des Beaux-Arts.

His reputation was made in 1913 when he sent four paintings to the Armory Show in New York—*Sad Young Man in a Train, Portrait of Chess Players, King and Queen Surrounded by Swift Nudes,* and *Nude Descending a Staircase.* He had obviously glanced at what the Italian futurists were accomplishing translating the sensation of speed into art, but was adventuring down roads they would never travel. These chilly canvases created what looked like a permanent surprise, and Arthur Jerome Eddy was wise to walk off with both the *Chess Players* and the *King and Queen.*

Duchamp's heart trouble saved him from conscription. In the summer of 1915 he was back in New York where he moved into an apartment on Beekman Place and sought the congenial company of Walter Arensberg, the Harvard graduate who had given up writing imagist verse in order to prove that Bacon was the author of Shakespeare's plays. Another intimate friend was Man Ray, who did him the honor of photographing the dust-laden *Bride Stripped Bare by Her Own Bachelors, Even,* a contrivance of glass, rust, tinfoil, and red lead, executed without paint brushes. This was a portrayal of love as a simultaneous mechanism, in no way implying either a spiritual or a physical union. Abandoned in 1923, it was never completed. Earlier, in 1913, he had conceived of the *Chocolate Grinder,* an oil with a message of its own. "The chocolate on the roller," we are informed by one Duchamp scholar, "coming from no one knows where, after being ground, will form a deposit of milk chocolate."

Duchamp's world may have been the blackest of any twentieth-century artist. His disdain for what you might call human relations was certainly complete, as when he painted in 1912 the desolate *Passage from the Virgin to the Bride.* He had, however, no intention of ignoring women. In New York he

took up with Katherine S. Dreier and got her to found her famous collection of modern art, named Société Anonyme by Man Ray, who then fancied that this French phrase meant "Anonymous Society" instead of "Incorporated." Duchamp was also twice married. The first marriage was over in six months; the second, to Teeny Sattler, once the wife of the art dealer Pierre Matisse, was permanent.

He found his amusement where he could. In 1917 he submitted a urinal signed R. Mutt to the Society of Independent Artists in New York. When it was refused, he resigned from the organization. Later he would produce a bicycle wheel implanted in a stool, a typical example of his ready-mades. Another ready-made was his *Why Not Sneeze?* of 1921, a painted metal cage containing marble cubes, a cuttlebone, and a thermostat.

When the dealer Knoedler offered him a retainer of $10,000 a year in the 1920s, he turned it down, satisfied that he could survive by selling off the Brancusi sculptures he had acquired at the auction of the John Quinn collection. Whether in New York, Paris, or Buenos Aires, he was not only imprudent but impudent. "Picasso," he one day announced, "is no better than a flag. The public needs a flag, be it Picasso, Einstein or someone else." Were there any problems worth worrying about? Duchamp thought not. "There is no solution," he argued, "because there is no problem." Thinking of all these things, Breton reached the conclusion that Duchamp was "the most intelligent and probably the most annoying man of the century."

Paul Valéry's good friend André Gide presented a different problem. There was no denying his rapid mind, nor the nihilism he exploited so gaily in *The Vatican Cellars*. Yet he yearned all his life to be the glorious victim of Calvinism. Breton was disgusted by the novel *Strait Is the Gate* based on the quite Calvinistic torture that pinioned him and his Cal-

vinistic wife. Another difficulty was Gide's lifelong pederasty. "I accuse the pederasts," Breton declared, "of asking us to tolerate a mental and moral bankruptcy . . . a system that paralyzes every enterprise for which I have any respect."

Respect, however, could not be altogether withheld from *La nouvelle revue française,* the all-important magazine of the Gallimard publishing house, in which both Gide and Valéry enjoyed an unassailable position. Here was a dilemma that could not be solved, and Breton cast aside for a moment his loyalty to Valéry when he wrote Tzara early in 1920 that "we are only using Gide, Valéry, and a few others in order to compromise them and to add as much as possible to the confusion."

The tension of directing *Littérature,* the magazine he had just founded, may have led Breton to utter this unfortunate remark. Or he may have been encouraged in this direction by Louis Aragon, who invariably resented any author who did not come, as he did, from the lower class. "Benefactors beware" was the Aragon motto, as he made clear when he explained that he lived in dread of being "accepted." "Right away," he scoffed, "we are being welcomed as the successors, the heirs of Gide, Valéry, and the others . . . What do they want with us?" The idea of being served up as a fancy dessert for the well-placed and the well-born did not appeal to him in the least. His one apparent aim was to be a misfit.

The truth, which Aragon did not desire to acknowledge, was that Gide and Valéry were guilty of incorrigible kindness in their dealings with Breton. They saw to it that he got a job with the Gallimard firm answering correspondence, and for a short time he was assigned the task of correcting the proofs of Marcel Proust. As a proofreader he was manifestly incompetent. "My next book," Proust gently complained in a letter to one of Breton's friends, "even though read over by Monsieur Breton, was filled with so many mistakes that if I didn't draw

up an errata list, I'd be dishonored." Proust then apologized to Breton himself. "Please don't think I was out of sorts . . . in that letter to your friend, which was intended for both of you. I must tell you that I proposed you for the Blumenthal Prize." This award of 10,000 francs from the New York financier George Blumenthal was in fact almost presented to Breton. He was the first choice of Gide and Valéry as well, but was too closely identified with dada by the fall of 1920 to win the support of the critic Edmond Jaloux, and so the decision was unfavorable.

"I had to get the hell out," Breton told Picabia in the summer of 1920 about the end of his job with Gallimard. He also flatly refused to go on studying to be a doctor, even though Valéry pointed out that a diploma might have its advantages. At the time Valéry was doing his best to stand up for Breton in his quarrels with his father, who had no idea of encouraging his literary career.

And Valéry refused to vanish from the horizon in the fall of 1921. On September 15 he was a witness to the marriage of Breton to Simone Kahn, the very beautiful daughter of a Strasbourg importer, to whom he had been introduced by his medical friend Théodore Fraenkel. The very few letters from Simone that have come to light suggest that she was an extremely sympathetic companion.

Who knows, the marriage might not have been possible if Breton and Aragon had not landed jobs in July of that year with Jacques Doucet, the couturier determined to found an important collection of literary manuscripts and works of art. Thanks to Breton, Doucet picked up Henri Rousseau's *Serpent Charmer,* a sketch of Seurat's for his *Cirque,* Picasso's *Demoiselles d'Avignon,* Chirico's *Disturbing Muses,* and a number of other pictures by Duchamp, Picabia, and Miró. "Getting him to buy a picture called for a lot of work," Breton recalled. "Not only did you have to point out in person the exceptional

qualities of a work of art time and time again, but you had to write letter after letter." Doucet liked to drive hard bargains. When offered a painting of five vases for 500 francs by Max Ernst, he sent Breton to tell the artist that he was prepared to pay 200 francs for a painting of two vases. Then, when shown a landscape, he asked Breton if something weren't missing. Dumbfounded, Breton said: "Yes, perhaps a little bird is needed. We're going to ask that good man Masson to add one." The difficulties might multiply, but Breton was able now and then to select a good thing or two for his own collection, and these he could dispose of later on if the going got rough.

Breton's magazine *Littérature,* the first issue of which appeared in March 1919, hardly padded his wallet. The title was supplied by Valéry, who remembered that Verlaine had once remarked that "tout le reste est littérature." The initial funding came from a critic by the name of Henri Cliquenois, but his name was missing from the masthead, where only Breton, Aragon, and Philippe Soupault appear as editors. Soupault, whose aunt had married the brother of the auto manufacturer Louis Renault, may have contributed some cash of his own to the enterprise.

Prudent was the word for the beginning of *Littérature.* Gide was honored by excerpts from his *Nouvelles nourritures,* reflections from which the flame of his previous *Nourritures terrestres* had faded. Valéry was remembered by his poem "Cantique des colonnes." However, there was genuine malice in the treatment given Jean Cocteau, whom Breton described as the most hateful creature he had ever run across. His name was on the cover, but not a line of his was included, although his protégé Raymond Radiguet was permitted a poem or two. Apollinaire had already proclaimed that Cocteau was a cheat, a verdict with which Gide agreed.

Littérature grew less prudent in later issues when dada was

given a chance and Ezra Pound was invited to boost the work of his good friends William Carlos Williams and T. S. Eliot. One item of surprising interest, in view of the intense seriousness with which Breton would later pronounce his name, was the interview with Freud that ran in March 1922. In his Vienna office the father of psychoanalysis proved most inhospitable, and Breton was far from servile. Readers of the magazine could easily anticipate the vindictive charge of anti-Semitism that Freud would one day spew in the direction of his onetime disciple Alfred Adler.

The historic moment of *Littérature* came in the fall of 1919 when it ran three chapters from *Champs magnétiques* (or *Magnetic Fields*) by Breton and Soupault. This was the first sign of automatic writing and hence the first example of genuine surrealism. Unhappily, the text was historic in the sad sense of the word. The magic that Breton would later display by using this method was not evident. "Prisoners of drops of water, we are only perpetual animals," ran one of the rare encouraging lines. Possibly, quite possibly, the result could be blamed on Breton's collaborator, Soupault, who may be eventually remembered not as a poet but as a friend. In any event Breton was far more imaginative in the chance brief poems he was writing at this time. And he was entirely himself when he mailed out a questionnaire to a choice group of authors asking, "Why do you write?" The best possible answer—"out of laziness"—came from Valéry.

These were the days when the eager Tzara was dashing from one end of Paris to the other to address meetings that were not always as lively as we could desire. "Art is not meant to be serious," he solemnly announced at one rally. At still another get-together Soupault proclaimed that he was writing a manifesto precisely because he had nothing to say. Breton put on a better performance the day he read out loud Picabia's

Cannibal Manifesto. "What are you doing here, laid out like so many serious oysters? For you are serious, aren't you?" he added.

A genuine sensation occurred on May 13, 1921, when Breton staged a mock trial of Maurice Barrès, one of the heroes of his adolescence. Barrès, who left town that day, was replaced by a mannequin, to whom Breton and the others addressed their insults. Twenty years of forced labor was the sentence passed, for no one chose to forget that the reactionary of 1921 had once written: "I have no patience with young people who don't start life with insults in their mouths . . . If young people approved what older people had done, they would have to realize that their coming into the world was useless."

Tzara, who seems to have been bored by every minute of the trial, explained that he had no faith in justice, even if justice was administered by dada. At this moment Barrès is still stationed in purgatory, but a fair trial might have admitted that the voluptuous prose of the defendant—he had gone into ecstasy over the life of the murdered Empress Elisabeth of Austria—might one day regain its audience. And nothing was said about Barrès's behavior at the time of the assassination of the socialist leader Jean Jaurès. Barrès had the tact, the day after the crime, to call on the murdered man's daughter to express his deep sympathy. "She was," he noted in his diary, "a superb young woman exactly like a statue on the Place de la Concorde."

The Barrès trial might well have ended dada in Paris. What more could be accomplished? "I have decided," Picabia declared, "to separate from the dadaists so as to get a little pleasure out of living." His distance from Breton was apparent in the spring of 1924 when he recalled that he had read Lautréamont when nineteen and "it bores me to talk about a man who my friends discovered twenty-six years later." He

had the kindness to add that "Breton will always be interesting to me, for he is a friend of mine." But not too much of a friend. "When I've finished smoking my cigarettes, I don't make a habit of keeping the butts," he answered one communication from Breton in the pages of his *391*. For his part Breton flatly refused to write a preface for Picabia's new book, *Jesus Christ the Swindler*. "God was a Jew. He was cheated by the Catholics," ran one excerpt in *391*. Although Breton was invited in 1922 to be a passenger in one of Picabia's motor cars while on his way to lecture in Barcelona, it was evident that the time had passed when Picabia was saluted as "the man you have to meet two or three times to have the courage to go on living." Picabia's old age in the Second World War was dedicated to the Côte d'Azur, where he maintained the most friendly relations not only with the French but also with their German visitors.

As early as 1922, when Marcel Duchamp sent Tzara a fierce cablegram from New York forbidding him to show any of his (Duchamp's) work in a contemplated dada salon, it was obvious that the man from Zurich was becoming something of a nuisance. Dada itself was in trouble. And although editor Jacques Rivière of *La nouvelle revue française* had proved he was willing to encourage dada talent, André Gide was inclined to be more critical, perhaps because he assumed that Duchamp's painting a moustache on a duplicate of the *Mona Lisa* and affixing an obscene label to his labor was not an immortal gesture.

"I attended a dada meeting," Gide wrote. "I kept hoping to have a better time and that the dadas would take greater advantage of the unsophisticated stupor of the public. Some young people, solemn, stilted, tied up in knots, got up on the platform and as a chorus declaimed insincere inanities. In the back of the room some one called out, 'Make a gesture or two!'

and everyone broke out laughing, for it appeared, precisely, that for fear of compromising themselves, not one of them dared to budge."

There was but one way for Breton to settle his account with Gide—an imaginary interview. "To tell you the truth," Breton began, "the author of *The Vatican Cellars* amuses me more than he alarms me." When asked his opinion of *Selections from Gide,* just published, he protested that he had not yet read it. "Here's a copy," said Gide. "I still have a great deal to write, but I know what I'm up to, and the plans for all of my books are laid out. You may be sure that I'm going right ahead, slowly, to be sure, but in my own voluptuous way." Upon which Breton reminded him that he might not win the game anyway. "I only have to render my accounts after my death," answered Gide, adding, "What difference does it make to me after all, since I'm convinced that I'm the man who will have the most influence fifty years from now." "Then," Breton inquired, "why do you want to save appearances?'"

Gide's feelings were hurt. "Everything that André Breton has me say in his fake interview is more like him than myself," he jotted in his diary. "I can't believe that Breton, so mindful of the influence he claims to have on young minds, hasn't tried to do anything but discredit me . . . And I must confess that he has succeeded in drawing a most hideous and consistent portrait."

In the very end, after Gide was dead and gone, Breton was not so unkind. Thinking of the honesty with which Gide confessed his homosexuality, and the courage with which he denounced Stalinist Russia, Breton managed to overlook his "theatricality." Again and again, Breton insisted, Gide testified for what he thought was the truth, and should win the salutations of all free men.

To return to Breton. Deeply embarrassed by what appeared to be the dead end of dadaism, he had the bravery in the

beginning of 1922 to suggest that it was time to summon a Congress of Paris to lead art and literature in a new direction. But his plans were vague, and although he enlisted the painter Fernand Léger, the musician Georges Auric, Jean Paulhan of *La nouvelle revue française,* Éluard, Aragon, and a commendable number of other figures, the congress was doomed. Tzara, joining and then resigning, did his best to sabotage the idea, and Breton, infuriated, labeled him "that promoter from Zurich, an imposter crazy about advertising." They were never to be friends again, although Tzara's presence was tolerated in 1935 in one issue of a surrealist review.

Littérature printed its last number in the summer of 1924, by which time Breton was shattered. "It is my intention," he disclosed on April 17, 1923, "to stop writing in the near future, perhaps in a month or two from now . . . I consider that the situation of the ideas that I am defending is desperate. I even think that the game is absolutely lost."

One ray of hope on the horizon of 1922 was the twenty-two-year-old Robert Desnos, who could so gently fall into an hypnotic sleep, murmuring puns that betrayed a telepathic connection with Marcel Duchamp, who was in America at the time. Breton was enchanted by the skill of this young poet until one evening, after dining with Éluard in the suburbs, Desnos, sunk in sleep, began chasing Éluard (whom he secretly resented) with a knife. Breton and his friends had to subdue this actor, who of course could no longer play his role in Breton's presence.

Banished, Desnos was desolated. "I shall doubtless not have the heroism . . . to commit murder or suicide. Your companionship reassured me for an instant. Unhappily the charm is broken and if my affection for you is as warm as ever, I perfectly understand that I can no longer hold in your eyes that curious position which, without my confessing it, was one of the reasons of my existence. Your solitude will not inhabit my

own, but the far-off echoes are still of a nature to trouble me." In 1945 Desnos would die of typhus in a German concentration camp.

In the midst of his distress over the behavior of Desnos, Breton determined in the fall of 1923 to make a pilgrimage to call on Saint-Pol-Roux, the venerable symbolist poet whom he had long revered and never met. Retreating from the world with his daughter Divine to his castle on the Breton Coast, Saint-Pol-Roux, looking very like a druid with his gray beard, would rarely deign to make a public appearance. While his drama *The Lady with the Scythe* was considered too mystical for performance, and Debussy unfortunately hesitated to write the incidental music he craved, the nobility of this prince of poetry could not be questioned. "Man invented death," he proclaimed to his initiates.

"I have not the honor of your acquaintance," Breton wrote Saint-Pol-Roux, adding that "I believe, as do my friends, that you are the man to whom our age has been the most unjust." Nothing could cloud the conversation of Breton and his wife with this saint. Back in Paris, Breton pleaded: "If you want me to take charge of your moral interests, I shall defend them with all my heart." Like Baudelaire, this great poet was suffering from the stupid insults of fools. "Of all of us alive, you are the one who is so accursed, and I honor you for this."

In November, when Breton's slender book of poems *Clair de terre* (or *Earthshine*) was published, it bore this dedication: "To the great poet SAINT-POL-ROUX. To those who like him can afford the MAGNIFICENT pleasure of being forgotten."

Breton, who despised Anatole France as deeply as he worshiped Saint-Pol-Roux, was not the man to miss the occasion of saluting France's death in 1924. *A Corpse* was the title of the obituary notice that he and Soupault and Éluard and Aragon released to the public. "With France," noted

Breton, "something of human servility has vanished from the earth. Let us stage a festival on the day we bury all trickery, all traditionalism, all patriotism, all opportunism, all scepticism, all realism, and all heartlessness. Remember that the vilest comedians of our time have used him as their crony, and we shall never forgive him for having dressed up his grinning inertia in the colors of the Revolution."

Cowardice was the essence of Anatole France, Éluard made plain. And Aragon, who was not at all pleased that Soviet Russia had joined the France cult, as had that choleric royalist Charles Maurras, was even more emphatic. "I hold any admirer of Anatole France for a degraded human being," he exploded, hugely delighted that here was a hero for "that old rhinoceros Maurras and the disgusting old men in Moscow."

This manifesto did not escape the attention of Jacques Doucet, who immediately dismissed Breton and Aragon from his service.

This was a financial blow but at the same time a revelation of the independence of Breton and Aragon. Breton now understood that dada was simply a railway station from which trains ran in all directions, and in October 1924 he launched the surrealist movement. "Surrealism," he stated, "is a secret society that will introduce you to death."

He would now be delving, this archangel, deeper than anyone else into the bad taste of his own era. "We now know," he cried, calling on the shades of Lautréamont, "that poetry must lead someplace."

CHAMPION OF THE
BLEEDING NUN

The mystery of Breton's recovery from the despair that overcame him in the spring of 1923 may never be explained, but it is wise to remember that all his life he was pursued by accomplices, not all of whom were required to be alive. At any moment he might be assailed by Rimbaud's allusion to "eating air." Or he might imagine the patient lobster on the leash who accompanied the great romantic poet Gérard de Nerval on his promenades in Paris. This lobster, Nerval pointed out, never chattered like an awkward child.

And since Breton fell into the habit of carrying a beautiful red rose he might present to any unknown and attractive woman, it is easy to understand why he was haunted by the figure of the Marquis d'Hervey-Saint-Denys. The marquis was the author in 1877 of a book entitled *Dreams and How to Control Them: Practical Observations.* His instructions were priceless. He had an orchestra at his disposal, led by a sophisticated conductor. The orchestra would play two waltzes, to which he would dance with the two women he idolized. Then, before falling asleep, he would urge a friend to slip an iris root between his lips. Fortified by this taste, he

would immediately dream of whichever woman he desired. To Breton's disappointment, Freud paid slight attention to the marquis's invention.

Only twenty-eight when he published the *Manifesto of Surrealism,* Breton was of course unready to recognize any authority except his own. "Dear imagination," he announced, "what I like best about you is that you won't forgive." And he would defend in 1924 the rights of the insane with the vehemence he never chose to abandon. "Everyone knows," he declared, "that the insane are put away only because of a tiny number of legally reprehensible actions, and without those actions, their liberty would never be placed in question." He added that "they enjoy their delirium sufficiently for them to recognize that it is quite worthwhile as far as they are concerned." Breton did not need to be told that hallucinations and illusions are a far from negligible source of enjoyment. "I'd gladly spend my life winning the confidence of madmen," he admitted. "They are scrupulously honest and their innocence is equaled only by my own." "Columbus," he went on, "had to set off with his madmen for the discovery of America, and just think how that madness has taken root and endured."

"The marvelous is beautiful," he explained, "no matter what kind of marvelous is beautiful, only the marvelous deserves to be called beautiful." Naturally he understood that the marvelous can't be the same in all ages, and was un- ashamed of his fondness for stage props of all kinds, whether romantic ruins, nineteenth-century sofas, or twentieth-century mannequins. "If I'd lived in 1820," he confessed, "I'd have been crazy about bleeding nuns."

He kept searching for bleeding nuns in the Gothic novels he read in a state of ecstasy. One of his favorites was *The Monk,* published in 1795 by Matthew Gregory Lewis when he was only twenty. "The breath of the marvelous is on every page," Breton was positive, and he may be said to have fallen in love

with Matilda, the young woman whose passion for Ambrosio, the vigorous preacher of the Capuchin church of Madrid, cannot be contained. To Breton, Matilda was not a character but a continual temptation. "And if a character is not a temptation, what is going on?" Passing herself off as the boy Rosario, Matilda, once she reveals herself as a woman, awakens the lust of Ambrosio who is, after all "in the full vigor of manhood." "Drunk with desire, he pressed his lips to those which sought them; his kisses vied with Matilda's in warmth and passion; he clasped her rapturously in his arms; he forgot his vows, his sanctity and his fame; he remembered nothing but the pleasure and the opportunity." Matilda, skilled in witchcraft, will lead Ambrosio from one enormity to another: he will murder his mother and rape and murder his sister. The plot is restless. Not every incident may be mentioned, but the final page is worth waiting for. Antonio has surrendered his soul to Lucifer, who, snatching him in his talons, hurls him from on high to his death on a cliff.

The Monk meant so much to Breton that he would lovingly recall its horrors in the midst of his exploration of all the other Gothic novels, which he firmly believed echoed or anticipated the blessed convulsions of the French Revolution. No such claim could be made for the standard novels of modern literature, whose characters were lifeless—so many marionettes foreordained to behave as their creators intended. In Breton's eyes Dostoevsky was a bore. So was Proust.

Breton had no idea of neglecting the achievement of Horace Walpole, whose *Castle of Otranto* was after all the very first Gothic novel. The contriver of Strawberry Hill at Twickenham, an unforgettable advertisement of the Gothic Revival in England, Walpole reproduced its floor plan in *Otranto* while revelling both in the three drops of blood falling from the statue of Alfonso and the enormous helmet, "a hundred times more large than any casque ever made for

human being" that crashes and kills the young prince Conrad.

Breton was sure that Walpole was an addict of surrealism while composing this novel. For proof he could turn to Walpole's letter of March 9, 1765, to his friend William Cole. "Shall I confess to you what was the origin of this romance?" Walpole wrote. "I waked one morning in the beginning of last June from a dream, of which all I could recover was, that I had thought myself in an ancient castle (a very natural dream for a head filled like mine with Gothic story) and that on the uppermost bannister of a great staircase I saw a gigantic hand in armor. In the evening I sat down and began to write without knowing in the least what I intended to say or relate. The work grew on my hands, and I grew fond of it—add that I was very glad to think of anything rather than politics. In short I was so engrossed with my tale . . . that one evening I wrote from the time I had drunk my tea, about six o'clock, til half an hour after one in the morning, when my hand and fingers were so weary, that I could not hold the pen to finish the sentence, but left Matilda and Isabella talking in the middle of a paragraph."

This letter was so welcome to Breton that he could not resist the temptation of concluding that Walpole and his great French friend the Marquise du Deffand were tried and true atheists. A prudent professor, accustomed to the discipline of footnotes, would not have committed this mistake. The truth is, the marquise heartily detested the atheists among the *philosophes* of Paris. As for Walpole, he made plain that "free-thinking is for oneself, surely not for society."

Possibly because William Beckford's oriental tale *Vathek,* written in French, had already been praised by Mallarmé as an almost perfect example of French prose in the hand of a foreigner, Breton kept silent on the subject of Beckford's Gothic castle of Fonthill Abbey, whose great tower, 128 feet high, crashed into ruins on December 21, 1825. This omission

was indeed an oversight, for Breton was frank to say he was searching all his life—unsuccessfully—for the modern equivalent of a Gothic revival house.

Breton might leave Beckford's career untouched, but was compelled to pay some attention to the novels of Ann Radcliffe. She began to conquer a vast audience in 1794 with her *Mysteries of Udolpho,* in which she exploited the ghastly aspect of the Apennines without ever setting foot on Italian soil. However, her darkest work was undoubtedly *The Italian,* with its exploration of the character of the evil monk Schedoni, determined at any cost to prevent the marriage of the lovely Ellena Rosalba to young Vincentio di Vivaldi. "The girl is put out of the way of committing more mischief, of injuring the peace and dignity of a distinguished family," he cries out when about to work his will on Ellena. "She is sent to an eternal sleep before her time. Where is the crime, where is the evil of this?" In the end, after Schedoni is shown to be the murderer of Ellena's father, the lovers are reunited.

This happy ending could not please Breton, who wondered if the spread of Mrs. Radcliffe's wings was really fell. Let others shiver over her productions. He vastly preferred Monk Lewis, and above all other Gothics, the Reverend Charles Robert Maturin, the Church of England clergyman who produced *Melmoth the Wanderer* in 1820. Whenever he preached on the foulness of the Roman Church, the pews were packed at his Saint Peter's in Dublin, and no wonder, for Maturin enchanted not only Scott and Byron but Balzac and Baudelaire as well. In fact, the sinister Melmoth, a kind of Wandering Jew who refused to die, would come back to life in Balzac's *Melmoth réconcilié* in the *Comédie humaine.*

Breton recognized that *Melmoth* was the greatest of all the Gothic novels, and who would challenge his judgment? "I never desert my friends in misfortune," the Wanderer tells the Englishman Stanton. "When they are plunged in the lowest

abyss of human calamity, *they are sure to be visited by me* . . . The place shall be the bare walls of the madhouse, where you shall rise rattling in your chains, yet you still have *the curse of sanity* and of memory."

This threat is worth remembering, but we have not yet done with Melmoth. There are many other scenes in which he casts his spell, on stage or off. How else explain the two lovers carbonized by lightning, or the bride turned into a corpse in the arms of her husband—who never recovers his reason? And then there are the ships that Melmoth lures to their doom on the Irish coast. If you have survived these incidents, you may be ready for Maturin to announce that "Spain is but one great monastery." Or to follow Melmoth in his pursuit of Immalee, the mysterious girl from an island off the Indian coast who changes her name to Isidora once she finds herself in Spain. "Christ shall be my God and I shall be a Christian," she decides. Her nuptials with Melmoth are concluded by a hermit who happens to have died the day before the ceremony. "And I," she dares complain, "already married to you and about to become a mother." She will shortly be examined by the Holy Inquisition. As for Melmoth himself, he vanishes on the last page in "silent and unutterable horror."

Breton is an alarming guide to English literature, and it is sad to confess that he is not always the perfect guide. He makes the mistake of recommending Edward Young, snippets from whose *Night Thoughts* may be unearthed in the generous anthologies of eighteenth-century verse. Young was guilty of proclaiming that "procrastination is the thief of time" and Lautréamont on the *Poésies* could not help remembering that the *Night Thoughts* caused him "too many headaches."

Breton does redeem himself by listing Swift as one of his saints. He was willing to approve the argument against abolishing Christianity In England perhaps because of Swift's understanding of the problem of overpopulation in Ireland.

This admitted, said Swift, of an easy solution, for "a young healthy child, well nursed is at a year old, a most delicious, nourishing and wholesome food, whether stewed, roasted, baked or boiled." Breton might well have darted in another direction and emphasized Coleridge, but then "Christabel" is so well known as to be in no need of advertising. It is, however, unfortunate that Breton nowhere comments on Thomas Lovell Beddoes, whose *Death's Jest-Book* could have lit the way for him on many a dark night.

But since Breton never proposed writing a history of English literature from the surrealist point of view, he may be excused for failing to compare Lear with Carrol and even for not rescuing Tennyson from the classroom. This he could easily have accomplished. Although Tennyson pointed out that his mother was "not learned save in gracious household ways," Breton could have made much of the poet's recurrent fits of psychopathic depression, not to mention the madness that afflicted so many members of his family. Breton would not have forgotten that brother Septimus bragged of being "the most morbid of all the Tennysons." Nor would he have overlooked the poet's passion for Gothic revival architecture.

But let no one be too critical of Breton the critic. His fondness for George Du Maurier's *Peter Ibbetson* could not be suppressed, and the "dreaming true" of the Duchess of Towers and her lover led him naturally to savor the lyrical moments of Synge's *Playboy of the Western World*.

All this while Breton was well aware that surrealism would one day take its place in all the dictionaries, and in the manifesto he obligingly provided two definitions.

SURREALISM. Noun. Psychic automatism, by which it is proposed to express either verbally, in writing, or in any other fashion, the real functioning of thought. Dictation of thought, in the absence of any control exercised by reason, and aside from any aesthetic or moral preoccupation.

SURREALISM. Philosophy. Surrealism is based on the belief in the superior reality of certain forms of association neglected until now, on the supreme importance of the dream, and on the disinterested play of thought. It tends to ruin definitely all other psychic mechanisms, and to take their place in solving the principal problems of life.

At the time these definitions were established, Lenin's commissar for education, Anatoly Lunacharsky, had made it plain that communists should not be too bossy with intellectuals when it came to political matters. "We must not forget," he announced, "that the red flag to which more and more intellectuals will rally, will always have its pink reflections." This may have been a comforting idea to Breton, who—no matter what his misgivings in later years about communism in Stalinist Russia—founded the movement under the auspices of Marx, Engels, Hegel, and Lenin.

Breton's fascination with atheism was so intense that it had a surprising influence on the favorites he selected from German and French literature. He was a profound admirer of Oscar Panizza, the expressionist sentenced in 1894 to a year in prison for publishing his drama *The Council of Love*. There was no questioning Panizza's atheistic message: the first act of the *Council* portrays God the Father, Jesus Christ, and the Virgin Mary facing the immorality raging in Naples in 1495. They ask the Devil to plague mankind—provided mankind may be redeemed. The Devil's prescription is syphillis. Which leads the Virgin Mary to declare: "C'est glorieux! C'est charmant! C'est diabolique!" Breton was so impressed with all this that he wrote the preface in 1960 for a French edition of the play. He may also have sympathized with Panizza's confinement for over half a century in a Bayreuth insane asylum. To the very end Panizza was positive that William II was an insane bull.

Breton was ecstatic over the achievements of the German romantics. Here the problem was Novalis, whom he was

driven to quote again and again, even though the author of the peerless dream novel *Heinrich von Ofterdingen* was a devout Christian, yearning for the Middle Ages when all Europe was under the spell of Rome. Breton could not very well deny the charm of Heinrich's quest for the blue flower and his meeting with the magician Klingsor. Yet he was relieved to discover that Hegel had harsh words for this novel. To Hegel, Novalis was led astray by his brilliant powers of invention, not realizing that his aim was foolish because the real world would never allow such things to occur.

So Breton laid special emphasis on Novalis's contemporary Achim von Arnim, and when certain of his tales were reissued in French in 1933, was delighted to introduce them. We may miss in Arnim the pure revelations of Novalis, who wrote on the third day after the death of the fifteen-year-old girl who was to have been his bride, that "evening has come while I was glancing at the dawn. Evening has come and I have a premonition that I shall die young." He did die not yet twenty-nine in 1801, surrendering to consumption.

Arnim, however, has his claims. One of his partisans was the mischievous Bettina Brentano, who became his wife after teasing and adoring the aging Goethe. The very mention of Bettina was sufficient to remind Breton of her brother Clemens, who could not resist the temptations of the Roman Catholic Church. As for Achim, he could never be accused of this failing. In fact, Breton, overcome by Achim's skill in bringing inanimate forms to life, saw nothing religious whatever in his behavior. Instead, he liked to recall that Achim, long before Rimbaud, insisted that the holy poets were seers, all of them.

The unholy patience with which Achim von Arnim invented his private world is quite evident in *Isabella of Egypt,* a tale he could never have written if he had not, like Clemens Brentano, sunk himself in the study of German folk legends.

The gypsy Isabella, daughter of Duke Michael, who has been hanged by the gypsies' enemies, is obsessed by the conviction that she might conceive a child by Charles V and that this child might lead her people back to safety in ancient Egypt. She will dare all for this ambition, and since a mandrake, and a mandrake alone, will make it possible for her to acquire the money by which she may wander unseen at night, she fulfills every condition to obtain the mandrake. After shedding her innocent tears at the foot of the scaffold where an innocent criminal has been hanged, she prods her fierce black dog into digging up the mandrake. However, she forgets to stop her ears, and the horror of the mandrake's howls will strike her unconscious. She does conceive her child, and Charles salutes her as the princess of all the gypsies, even though a golem assuming the shape of Isabella makes a threatening appearance before crumbling to dust.

Here was almost everything that Breton could command of a German romantic, and those who share his joy may wonder what persuaded him to approve of the dignified figure who won such great fame as the founder of psychoanalysis. Freud's medical competence is beyond the scope of this book, but Freud as a connoisseur of literature and the fine arts is an admittedly puzzling topic.

The taste of Freud is easily explored. At the end of a hard day's work with his patients, he would pick up almost any novel of Anatole France. Dangerous authors the like of Nietzsche were scrupulously avoided. The thought of Nietzsche was "too rich" to sample, he advised his disciple Lou Andreas-Salomé. He knew that he was safe only with unimaginative fiction; when searching for a story he might use as a reference book for his interpretation of dreams, he fell upon Wilhelm Jensen's *Gradiva,* the dreary tale of a pedantic archaeologist who has fallen in love with a bas-relief of a Grecian girl with a supposedly striking gait. The archaeologist

is positive that the original must have perished in the destruction of Pompeii. However, the girl he yearns for is actually one of the forgotten playmates of his childhood. Prized by Freud, *Gradiva* was saluted by Breton and his friends with almost the enthusiasm they lavished on *Isabella of Egypt*.

The answer to this riddle is disappointingly simple. Breton did not need to be told that Freud was a firm atheist, and the judgment of a firm atheist was bound to be respected even in matters of art and literature. Freud's sense of humor was not apparent when he discussed the Almighty. In 1915 he made plain to one of his early American admirers, Professor James J. Putnam of the neurology department at Harvard, that "I have no dread at all of the Almighty. If we were ever to meet, I should have more reproaches to make to Him than He could to me. I should ask Him why He had not given me better intellectual equipment." The same somewhat solemn Freud labored long over an essay on Moses and monotheism, in which he proved that Moses was not a Jew but an Egyptian. Semitic theology could now be scrapped. "Religious phenomena," he pointed out in this work, "are only to be understood as the familiar neurotic symptoms of the individual."

Breton would pay many compliments to Freud. These compliments were hardly worth his attention, Freud pointed out in a letter to Breton of December 26, 1932. "Although I receive so many indications of the interest that you and your friends bring to my researches, I really am not in a position to understand what surrealism is and what it means. Perhaps I am not intended to understand it, since I am so far away from art."

The heady perfume of atheism was perpetually fascinating to Breton, and the misadventure with Freud was to be played out with many other figures. One of the dead atheists Breton sought to impose upon the surrealist world was Denis Diderot, chief compiler of the famous *Encyclopedia*. Diderot came late

to the world of art. He was thirty-seven when he became aware of the existence of art and might never have turned into an art critic if he had not been guided by his friend Friedrich Melchior Grimm. The sculptor Pigalle was amazed by Diderot's sudden interest. "Promise me," Pigalle told him, "that you won't be afraid of a beautiful woman without a stitch of clothing." Unlike Breton, Diderot was a perfect prude, revolted, for example, by the immoral sensuality of Boucher. His hero was Greuze. When he discovered Greuze's *Filial Piety* in the Salon of 1763, he was overjoyed. "This is just what I like," he exclaimed. "It is moral painting. Come now! Hasn't the brush been dedicated long enough to debauchery and vice?" Diderot was sounding the call for social realism, the type of art that would be so popular in Stalinist Russia and Nazi Germany. But Diderot was not the only eighteenth-century atheist to win Breton's allegiance. He also doted on Holbach and La Mettrie, whose tomes in our time are consulted only by doctoral candidates specializing in the topic.

Another eighteenth-century atheist of whom Breton was frantically fond was the Marquis de Sade, the ferocious champion of the sexual act divorced from all affection. As a scholar on the subject of abnormal psychology, Breton may have found much that was worth his while in Sade's fiction: here was a madman whom he could not desert, even though Breton will be remembered as the poet of romantic love. The ghastly monotony of Sade's world is, of course, difficult to defend and Breton did not attempt to raise this issue.

To tick off all the passionate joys and hatreds that overcame Breton whenever he contemplated the past and present of French literature would take some time but would hardly advance this narrative. By 1930 Valéry had vanished from the surrealist horizon. That Voltaire as well was on the index will surprise no one, for Voltaire was not much of a poet. But for those who expect Breton to be a faithful atheist at all times, it

may come as a shock that Châteaubriand was declared "surrealist in his love of the exotic," for he did his best to revive the Catholic Church. His exotic aspect may not be denied but is not the best advertisement of his genius. He believed that man is what man remembers and his memories of the women he worshiped are so enchanting that Victor Hugo in his youth declared that he would be "Châteaubriand or nothing." Unfortunately, flippancy was apparent in the surrealist homage to Hugo, who was set down as "surrealist when he wasn't stupid." The comment is close to the pseudo-clever remark of Cocteau who maintained that "the greatest French poet was Hugo, alas."

Faults may be discovered in the surrealist survey of French literature, but it remains a compelling invitation to follow the example of the great French innovators, even though Baudelaire was scolded for praying for his mother, and Baudelaire's idol Poe was chided for inventing that dull genre, the detective story.

In dead earnest when he founded the movement, Breton did not hesitate to say that "surrealism will lead you down to death, which is a secret society. It will put a glove on your hand, burying the great M, which is the first letter of the word Memory. Do not forget to draw up a careful will. For my part, I must ask to be taken to the cemetery in a moving man." To which he added a warning: "Surrealism does not allow those who take it up to drop it when they please. Everything leads us to believe that it acts on the mind like stupefying drugs."

With all his labors launching the movement, Breton in 1924 could not resist surprising his followers with the charming prose poems entitled *The Soluble Fish*. Here he introduced a ghost about two hundred years old, who could still speak a little French, as well as an enormous wasp haunting the Place de la Bastille while puzzling children with riddles. Nor was this all. What was that woman's torso floating in the Seine?

She was headless, she lacked her hands and feet, even though her body was admirably polished. He hinted that her body was new and never yet caressed, and her white and palpitating breasts really belonged to a living creature that would awaken men's desires. Then there was that radiator with blue eyes telling the dancer that she should dance for him alone. But no one should forget the glass diving suits that took Breton down to the bottom of the pool filled with glass women.

And in the very next year he was addressing a letter to all clairvoyants, pitying them for living on the third floor of houses in the wrong part of town. We were living unfortunately in a time where men's minds were being industrialized, and the achievement of Flamel in creating the philosopher's stone was overlooked merely because he had never made any money. Mediums, he argued, should never be subject to observation by doctors, scientists, and other ignorant people. The fact that mediums had been caught cheating was only the proof of their honesty and good taste.

It was not until 1928 that he published *Nadja,* a novel that was not a novel. As a trained psychiatrist, he was completely aware of what might be accomplished by the free association of ideas: the opening pages testified to this habit.

Whatever was on his mind is instantly revealed, beginning with the boredom inflicted by the fiction of Flaubert. On this point he tried, in vain, to be generous. If someone could prove to him that Flaubert had been eager in *Salammbô* to give his impression of the color yellow, then he might end up as one of his admirers. Otherwise, no. He went on to say that he was wishing we could expect from Chirico a detailed account of his fascination for artichokes, gloves, dried cakes, and bobbins. But this, he was frank to admit, was wishful thinking. He immediately confessed that he was yearning to sleep on a glass bed with glass sheets in a glass house.

Soon he was remembering the woman who called, unan-

nounced, to recommend a friend with a high talent. What was this but a prophecy of the coming of Benjamin Péret, that welcome ally. The very next moment he was immersing himself in the recollection of a movie in which a Chinaman, multiplied into millions, was invading New York City. It was always his custom to walk into a movie theater without having any idea of what was on the screen. He could be more particular when it came to plays. One of his favorites was *Les détraquées,* or *The Girls Who Went Wrong,* dealing, as you might imagine, with all that could go wrong in an institution for young girls. The lead was played by Blanche Deval, whom he could never forget and was never to see again.

So much for the first few pages. On October 4, 1926, he was to meet for the first time Nadja, the demented girl who would haunt him day after day. She had called herself Nadja, because that was the beginning of the word *hope* in Russian but only the beginning. She was wretchedly dressed but her smile was mysterious. Her one relaxation was to ride in the evening in a second class compartment of the *métro,* gazing at the faces of those who had done a good day's work. This was a most unfortunate obsession, Breton reasoned, reminding her that he detested work of all kinds. She had, she explained, tried to find work, but the jobs she was offered paid ridiculous wages. She lives again when she tells Breton that he is searching for a star. "You can't miss going toward that star," she explains, making plain that the star resembles the heart of a flower without a heart. She then breaks into tears when Breton quotes a line of Jarry about "eating the noise of grasshoppers." She had been glancing at a book of Breton's essays, *The Lost Steps.* "There are no lost steps," she tells him, whereupon she reveals that she was seized by the police; the charge involved cocaine traffic. "Fire and water are the same thing," she explains, "but fire and gold are something different." When she sees an Easter Island sculpture in Breton's collection, she is sure that the statue is

saying, "I love you." And she knows that Breton will write a book about her.

Finally the word reaches Breton that she has lost her mind. "For Nadja," he decides, "there can't be an extreme difference between the inside of an asylum and the outside."

You don't need to have made your way into an asylum to realize that they *make* mad people there, just the way houses of correction turn out bandits. At the slightest sign of intolerance, they'll accuse you of being unsociable, and however paradoxical this may sound, they ask you to be sociable, which is bound to create a new symptom, which will put an end to your recovery, of it should happen.

In my opinion all confinements are arbitrary. I can't see why anyone would deprive a human being of his liberty. They put Sade away; they put Nietzsche away; they put Baudelaire away. The process which consists of surprising you at night, of slipping a strait jacket on you, or any other method of putting you in their power, is no better than that of the police, which consists of slipping a revolver in your pocket. I know that if I were insane, and put away for a few days, I'd take advantage of any remission of my delirium to assassinate, coldly, anyone—the doctor, best of all, who might fall into my hands. At least I'd take my place, like those who are raving, in a cell of my own. They might let me alone.

The contempt that I usually feel toward psychiatry, its pomposity and its achievements, is so strong that I've never dared ask what became of Nadja. If she had been treated in a private asylum, with all the care lavished on the rich, and safe from any promiscuity that might harm her, but also comforted by the presence of her friends and her tastes considered as much as possible, which would have meant that no one annoyed her in any way, and someone took the trouble to discover the source of her anxiety—I may be exaggerating but everything leads me to believe that she would have come out of her difficulties. But Nadja was poor. She was all alone, too.

"You are all the friends I have in this world," she was telling Breton's wife on the telephone the last time she called up.

"Who's there?" Breton asked. "Is it you, Nadja? Is it true that the other world is in this life? I can't hear you. Who's there? Is it just me? Is it myself?"

Although he could never forget that Nadja described

herself as "a wandering soul," his kindness to her did not mean that Breton could relax for a minute the discipline to which his disciples were subject. They were meant constantly to misbehave, but in the correct way—that is, in the manner which he, as the master anarchist, approved. He set the style which they were to follow in the pages of *La revolution surréaliste,* the magazine whose first issue appeared on December 1, 1924. "Open all prison doors! Send the army home!" the review proclaimed in the second issue. In the third the Pope was insulted. All Catholics were normally treated without mercy. All, that is, with the exception of young Abbé Gegenbach, Jesuit-trained, who was defrocked after carrying on an affair with an actress charmed by the soutane he wore. He was drawn to the surrealists by their inquiry: "Is Suicide A Solution?" It took some time for him to discover that Breton was the incarnation of Lucifer. The Catholic whom the surrealists most detested was, of course, Paul Claudel, then the French ambassador to Japan. Claudel made the mistake of suggesting that the group was notorious for its homosexual practices. The answer to this libel was forthcoming not in *La revolution surréaliste* but in a public manifesto. "The only thing pederastic about our activity is the confusion it brings to the minds of those who are not joining us," Breton and the others began their letter. "We are taking this occasion to break publicly our ties with whatever is French. Treason and whatever can do harm to the security of the State is much easier to reconcile with poetry than the sale of 'vast quantities of lard' for the account of a nation of pigs and dogs." Here they were alluding to the lard Claudel bought in South America for the French army in the World War. This was not all. They hoped that revolutions, wars, and colonial insurrections would annihilate the western civilization whose vermin Claudel was defending in the Orient.

But to return once more to *La revolution surréaliste,* there

you will find the manifesto "Hands Off Love," the group's heartfelt defense of the moral standards of Charlie Chaplin, the record of their joy in the fiftieth anniversary of the medical discovery of hysteria, any number of poems, some of them still quick with genius, and the record of the group's experimentation with exquisite corpses, poetic lines begun by someone and finished by someone else. And you will also find the surrealists' intimate examination of how to make love. This is an interesting item, but not half so interesting as a short one by Pierre Naville in the issue of April 15, 1925. Naville, who eventually married Denise Lévy, the cousin of Breton's wife, and wrote a few poems in the Valéry manner, made the mistake of his life when he wrote: "All I know about taste is distaste. You masters, you mastersingers, slop away at your canvases. No one can ignore any more the fact that there is no *surrealist painting.*"

To Breton, whose taste was not only exacting but marvelous, this was intolerable. He had to keep a certain distance between himself and the magazine, but with the next issue he took over the management of *La revolution surréaliste. He had lived for painting for many years. He would live for painting the rest of his life.*

CHAPTER FOUR

~~~

## THE CLOCKS STOPPED
## AT THE PRECISE HOUR;
## AND THEN . . .

The Roman Catholic novelist François Mauriac, who explored sin with the cunning of a diabolic surgeon, may have succeeded in fathoming the solitude of Breton. "He was the exact opposite of Rimbaud," said Mauriac. "Until his last day on earth, he kept faith with the obstinate adolescent he had been."* Despite his imperial manner, Breton obviously enjoyed the thunder of his indignation, which could be heard as frequently as the cry of joy that escaped him when he believed he had discovered in someone the sign of genius.

Breton the art critic is best introduced by his response in November 1929 to a message from the Medical-Psychological Society. They had read *Nadja,* some of these psychiatrists, and they were not pleased. Dr. Paul Abély reported the case of a maniac in his care who carefully devoured the page on which Breton spoke of the pleasure he would have, if he were insane,

---

*Mauriac was no peeping Tom but could pass for one when he caught his characters in lonely moments. Take Mathilde Cazenave, for example, who must die in childbirth at the beginning of *Genitrix*. She cries out to a brother who might have been alive, but to no avail. "The dead," Mauriac points out, "are of no help to the living." Mathilde dies the sweet death of those who have not known love.

of assassinating the doctor in charge. "This invitation to murder will only provoke the glory of our disdain," Abély made plain, "or at best will scarcely touch our nonchalant indifference." However, the psychiatrists were not all of them passive spectators. Dr. Pierre Janet, who had been treating for years the case of Raymond Roussel, an author whom the surrealists approached with complete reverence, made public his disgust for Breton and his allies. Their books were the work of dubious characters who happened to be obsessed. He was impatient with them for playing with the associations of words tossed at random into a hat. As for Dr. Clérambault, he realized that being defamed was one of the risks an alienist had to run. To protect themselves against such risks, a fund should be established to provide subsidies, indemnities, legal and judicial assistance, and even pensions.

Breton left no doubt of his reaction to all this. "The most simple surrealist act," he stated, "consists in running down the street with your revolver and firing at random into the crowd. Who is there who hasn't at least once tried to get rid in this way of the little schemes of degradation and debasement so evident in such a crowd? . . . The legitimation of such an act, in my opinion, is not in the least incompatible with the belief in that glimmering light which surrealism is anxious to reveal in all of us."

Here was Breton the anarchist who will come to the fore so often when he contemplates the fine arts.

The very first painter to appeal to Breton was Gustave Moreau, frequently mentioned as the teacher of Georges Rouault and Henri Matisse. He was more than just a teacher, as the public of New York recognized in 1961 when the Museum of Modern Art mounted a full-scale exhibition of his work. Long ago, when sketching the troubles of Des Esseintes in *À rebours,* Huysmans had been a prisoner of Moreau's visions. In fact he was transfixed by the canvases of Lady

Macbeth, Helen of Troy, Delilah, Salome, and the other evil women to whom Moreau was devoted: here was a unique artist, a magician of the rank of Baudelaire. Marcel Proust as well came under his spell, insisting that the 800 paintings, 350 watercolors and 7,000 drawings that the artist left to his museum in the rue de La Rochefoucauld revealed a god who existed only for the others.

Breton was even more emphatic. "The discovery of the museum, when I was sixteen years old, determined for a long time my idea of love. It was there that beauty and love were revealed through the poses of certain women and certain women's faces—the spell was complete." His ambition was to break into the museum after dark with a lantern.

He never could comprehend the critics who damned Moreau as a reactionary for resisting the temptations of impressionism. Out of his cult for Delacroix and Chassériau, Moreau had fashioned a world all his own. His power of evocation was unrivaled, and it was ridiculous to make too much of Moreau the professor, no matter if he had trained Rouault and Matisse. Breton's only criticism was that Moreau placed too much importance on "beautiful inertia" and the "necessary richness." *Inertia* was too passive a word. And by *richness* he should have explained that he meant luxury in the sense of Baudelaire.

Moreau died two years before Breton was born. So he could never listen to Breton's comments on his vocabulary, or his reference to the "temple of debauchery," which was his favorite phrase for the museum.

Breton was a merciless critic, proving this in the first edition of *Le surréalisme et la peinture* in 1928. "Matisse and Derain," he declared, "are old lions, discouraging and discouraged." Like a madman Breton had dashed up and down the slippery halls of museums, "abandoning without remorse a number of adorable beggars: nothing is so dangerous as to take liberties with liberty." His constant hope was Picasso, who never needed to

apply for membership in the surrealist group. "The mysterious road where fear is watching over our every step, and where the yearning we have to retrace our steps is only vanquished by the fallacious desire of being accompanied—for fifteen years it has been swept by a powerful projector. For fifteen years Picasso, exploring this road himself, has thrust out his hands filled with x-rays. No one before him had dared to glance in that direction. Poets had talked of a land they had discovered, where, the most natural thing in the world, a drawing room had been sighted at the bottom of the lake." Now that this echo of Rimbaud has been mentioned, it is good to recall that poets could be in dead earnest. As for Picasso, "by what miracle did this man, whom I am astonished and delighted to know, find himself in possession of what was needed to turn what had been the domain of the highest fantasy into reality?"

Picasso was the creator of tragic toys for adults that made men grow up. This could not be said of Georges Braque, who had taken every precaution. "Braque likes the rules that correct emotion, while for me I deny violently these rules. At the present time Braque is a great refugee. I fear that in a year or two, I may no longer be able to pronounce his name, I must hurry."

But Breton's despair was centered on Giorgio de Chirico. "I have given up five years to giving up Chirico, of admitting that he lost any idea of what he was doing. There was the time when we were not afraid of promises. You can see that I am talking freely. Men like Chirico passed for sentinels on the endless road of challenge. Once we arrived at where he stood, we could not retrace our steps, we had to go on at any cost. We have gone on. What sadder story can you imagine than that of this man, now lost among those besieging the city he built to be unassailable. Inspiration has abandoned Chirico, the very Chirico whose principal care today is to stop us from proclaiming his decline."

Breton was longing for the paintings created between 1910 and 1917, when Chirico gloried in clocks that stopped at precise hours on lonely squares, on dying locomotives still smoking on desolate tracks, on girls spinning hoops into nowhere, and on surgical gloves remembering love affairs. The Chirico problem may never be unraveled, but may be revealed to anyone who will study his life.

Chirico was born July 10, 1888, at Volos, the capital of the Grecian province of Thessaly, to an engineer engaged in building the railroads of Greece. The father came from Palermo, the mother from Genoa. On the torrid afternoon of his birth, the candles were melting in their candlesticks, and Chirico as a child could never forget the enormous mechanical butterfly his father had given him. "I looked," he remembered, "at this toy with curiosity and fear, as the first man must have looked at the gigantic pterodactyls which in the sultry twilight and cold dawns flew heavily with fleshy wings over warm lakes whose surface boiled and emitted puffs of sulphurous vapor."

Chirico grew up to worship his father. He was, he said, "a man of the nineteenth century. He was an engineer and also a gentleman of olden times, courageous, loyal, hardworking, and good. He had studied in Florence and Turin, and he was the only member of a large family of gentry who had wanted to work. Like many men of the nineteenth century he had various capacities and virtues: he was a very good engineer, had very fine handwriting, he drew, had a good ear for music, had gifts of observation and irony, hated injustice, loved animals, treated the rich and powerful in a lofty manner, and was always ready to protect the weak and the poor. He was also an excellent horseman and had fought some duels with pistols; my mother preserved a pistol bullet, set in gold, which had been extracted from my father's right thigh after one of his duels."

The father died in 1905, on a day that Chirico remembered
for the scratching of mice and the howling of the family dog
Trollolo. Thereupon the family moved to Munich, where
Giorgio's brother Andrea, who intended to be a musician,
studied with Reger and Giorgio himself enrolled for two years
in the Munich Academy. It was in Munich that Chirico made
the discovery of the work of the Swiss artist Arnold Böcklin,
who had recently died in Florence. Students who have taken
too many art history courses may have learned that Böcklin
was a reproachable painter. This is a mistake, for Böcklin was a
master of surprises and may soon be rediscovered. *The Isle of
the Dead* in the Metropolitan Museum, which served for so
many years as an advertisement for Steinway pianos, is an
excellent example of his work; another is *The Pestilence* in the
Basel Museum. Paralyzed in his last years, Böcklin kept
chattering day after day of the flying machine he would one
day construct. He also kept holding gigantic seashells to his
ears so as to listen to the roar of the ocean he could no longer
visit.

Another great discovery was Nietzsche, dead in 1900 after
twelve years of insanity. Chirico caught the poetry of Nietzsche
and claimed he had a particular sympathy for the *Stimmung* or
feeling of Italian cities on autumn afternoons. The bravery of
Nietzsche could hardly be overlooked. "I love the man,"
Nietzsche protested, "who corrects the future and redeems the
past, for that man will go down to destruction in the pre-
sent . . . I love all those who are like heavy drops, falling one
by one out of the dark cloud that hangs over man." Nietzsche
also emphasized the doctrine of the eternal return, which may
be traced back to Anaximander, but no matter. For Nietzsche
it was one of the rare keys for comprehending the universe.
"Do you see this gateway?" his Zarathustra asks a dwarf in his
way. "It leads in two directions. Two roads come together
here. No one has ever followed them to the end. This long road

to the rear, it goes on to eternity. And that other long road, that, too, leads to eternity. These paths contradict each other, insult each other, and here at this gate, is where they come together. The name of the gate is written above it: 'The Present Moment' . . . Has not everything that can run already run down this road? Must not everything that happens have already happened?" Nietzsche swore that anyone who refused to believe in this circular concept of the universe was bound to believe in God. In any event the eternal return unlocks the world of Chirico, even including the mannequins doubling as robots.

While reading Nietzsche, Chirico—for reasons that are difficult to understand—came to pay particular attention to Nietzsche's sister Elisabeth, the vicious anti-Semite whom Nietzsche loathed. And about this time Chirico was drawn to the writings of Otto Weininger, the pathological Jewish anti-Semite who committed suicide at twenty-three in 1903. Although one presumably scholarly monograph on Chirico refers to Weininger as a philosopher, he does not seem to have deserved that title, at least to readers of his *Sex and Character*. "It is the Jew and the woman," Weininger insisted, "who are the apostles of a pairing to bring guilt on humanity. Neither believes in himself, but the woman believes in others . . . she has a center of gravity even though it is outside her own being. The Jew believes in nothing, within him or without him. Women must really and truly and spontaneously relinquish coitus. That undoubtedly means that woman, as woman, must disappear, and until that has come to pass, there is no possibility of establishing the kingdom of God on earth."

In later years Chirico confessed he grew weary of Weininger's doctrines, and it is true that he finally found a woman whom he saluted as "the greatest philosophical mind of the century." But was he ever cured of his anti-Semitic urges? He did complain, mildly, about Mussolini's racial laws

in the Second World War. But in his autobiography he heats up again on the Jewish question, claiming that anti-Semitism will come to an end only when Jews "stop hiding and assuming the attitude of whipped dogs."

Is it possible that Chirico was a Jew, suffering from the cancer of anti-Semitism implanted by Weininger? And could this have put an end, this nightmare, to the inspiration that lasted from 1910 to 1917? This theory, now that Chirico is no longer alive, may never be proved, but it is curious that Julien Levy, Chirico's art dealer in New York, was seized by some such suspicion. Supposing, thought Levy one night while driving him through the ghetto of Manhattan, he fancied he was a Jew, living the life of a Jew?

Although Chirico's career as a great artist seems to have come to an end long ago—there is something stale about his efforts to repeat himself in the 1920s and something sad about the series of gladiators he threw upon the art market—yet no one can forget that in 1929, when he published his novel *Hebdomeros,* he let the world know that he could still wander, at least in prose, with his dreams.

His hero Hebdomeros leads a schizophrenic life, beginning by staring at a building very like the German consulate at Melbourne. Dentists have their offices therein, and specialists in venereal diseases. Soon you will meet a pianist playing an instrument that emits no sound, listen to a sad song from an orphan asylum, and visit abandoned villas crammed with old furniture and stuffed animals. Searching for ghosts more curious than those who cluster in desolate cemeteries, Hebdomeros awaits the arrival of the steamboat *Argolide,* bearing the prodigal son of Thomas Lefcourt. Lefcourt, a widower, has been spending his declining years in a villa where he contemplates the manufacture of cheese. On the very last page green islands float into view while processions of immaculate white birds are singing in flight.

Breton and his allies could not denounce *Hebdomeros,* even though they deeply missed the old Chirico, who would turn up so frequently on the eve of the First World War, to be hailed in Apollinaire's apartment as that astonishing painter who hated trees and loved statues. And of course they recalled the ominous portrait he painted of Apollinaire, foretelling the flesh wound in the temple he was to receive in the war.

For a long time the surrealists made much of Chirico's intimacy with ghosts. "Could that be a ghost behind us?" Aragon asked when sitting at Breton's side in a café. Upon which Chirico pulled out a pocket mirror and replied in the affirmative. Two of Chirico's favorite ghosts from the past were Napoléon III and Cavour. When the two met at Plombières before the war that freed Italy, Chirico reasoned that it was the first time in history that two ghosts had met to produce concrete results.

There was also an occasional prose poem that Breton prized, like Chirico's hymn to the palace of Versailles. "During a clear winter afternoon," wrote Chirico, "I found myself in the courtyard of the palace of Versailles. All was calm and silent. Everything looked at me with a strange and quizzical look. I saw then that each angle of the palace, each column, each window had a soul that was an enigma. I looked around me at the stone heroes, motionless in the clear sky, under the rays of the winter sun, shining *without love* as in deep songs. A bird was singing in a cage suspended from a window. I then felt all the mystery which forces men to create certain things. And the creations seemed to me even more mysterious than the creators. One of the most strange sensations that prehistory has left us is the sensation of the omen. It will always exist. It is like an eternal proof of the nonsense of the universe. The first man must have seen omens everywhere. He must have shivered at each step he took."

But Chirico could never forgive Breton and the other

surrealists for preferring his earlier to his later work. "I found strong opposition," he set down in his autobiography, "from that group of degenerates, hooligans, childish layabouts, onanists, and spineless people who had pompously styled themselves *surrealists* and also talked about the *surrealist revolution* and the *surrealist movement*. This group of not very worthy individuals was led by a self-styled poet who answered to the name of André Breton, and whose aide-de-camp was another pseudo-poet called Paul Éluard, a colorless and commonplace young man with a crooked nose and a face somewhere between that of an onanist and a hysterical cretin."

Finally, Chirico decided that Breton was "the classic type of pretentious ass and impotent arriviste." He scarcely enjoyed Breton's "reading extracts from Lautréamont in a sepulchral voice." Nor did he have any patience with that "dismal pseudo-painter who answers to the name of Salvador Dalí, and who, after having imitated Picasso, had begun to imitate my metaphysical paintings which he had not understood at all, and which a man like him could not possibly have understood . . . Dalí . . . is forced (in order to arouse a little interest in his painting, which basically nobody likes) to create scandals in the most clumsy, grotesque, and provincial way imaginable and in this way succeeds more or less in attracting the attention of certain transatlantic imbeciles consumed with boredom and snobbery, but it looks now as though even these imbeciles have begun to have enough of it."

Even though *Hebdomeros* was written in French, Chirico had now become a professional Francophobe. *"Proustitis,"* he charged, "made more victims in Italy . . . than Spanish flu about a year later. *Paul-Valéryitis, Gideitis* and *Claudelitis* were still in process of incubation; later their germs acquired great virulence, which they still preserve today."

Max Ernst and Breton did indeed have their disagreements, but nothing so disagreeable as the quarrel with Chirico ever

occurred. For this happy situation, both men are to blame. Breton was positive that Ernst's was the most magnificently haunted brain of the time. Furthermore, Ernst was free from the abysmal preoccupation with form which led Cézanne and Renoir to sing that idiotic hymn to the "three apples." For his part, Ernst was pleased to realize that Breton, that born father confessor, played the game of truth and consequences, always aware that the game was a sacred occupation. When Éluard asked Breton: "Do you have any friends?" his answer was "No, my friend." "Doubtless," Ernst reasoned, "he was conscious of the beauty of this confession of absolute solitude. His demands were terrifying. Before being admitted as one of his friends, you had, tacitly, to sign a contract of nonreciprocity. For Breton friendship was confused with the game of friendship, a tragic exercise to which he was committed until the end of his life. He took all the risks, including that of the absolute ruin of all his friendships."

We must now begin at the beginning of Ernst's life. He was born at Brühl in the Rhineland, a town immortal for the glorious baroque castle of Augustusburg, the masterpiece of the architect Balthasar Neumann. Brühl is ten miles away from Cologne, but Ernst chose to remember that he came into the world at 9:45 A.M. on the second of April, 1891, "hatched from the egg which his mother had laid in an eagle's nest and over which the bird had brooded for seven years."

He was to be haunted all his life by the forests of the Rhineland. "Who will be the death of the forest?" he once asked. "The day will come on which a forest, hitherto a womanizer, resolves to frequent only teetotal places of refreshment, walk only on tarred roads, and consort only with Sunday afternoon strollers. He will live on pickled newspapers. Enfeebled by virtue, he will forget the bad habits of his youth. He will become geometrical, dutiful, grammatical, judicial, pastoral, clerical, constructivistic, and republican. He will become

a schoolmaster. Will the forest be praised for his good behavior? Not by me, anyway."

He was also persuaded that love was the great enemy of Christian morality. He might not have arrived at this conclusion if he had not come from a pious Roman Catholic family. He was the second child and first son of the seven children of Philipp Ernst, who spent his life teaching deaf mutes and producing meticulous paintings. On one occasion father Ernst omitted a tree from one of his landscapes. This was an embarrassment, and he went back to the forest to saw down the tree in question.

Young Max, worried by one of his father's watercolors representing a hermit reading, ran off one day to follow the telegraph wires along the railroad tracks. A parade of pilgrims took him for the Christ child. On his return home father Ernst painted him as the Christ child, but young Max had no idea of pleasing his father under any circumstances. He was six when one of his sisters died after kissing the rest of the family good night, and he at once blamed his father for her loss. Nor was Max pleased when a new sister was born the night his favorite parrot Hornebom died.

Obedience was the lesson daily instilled in the Ernst family, and young Max made up his mind to loathe doing his duty. One of his sisters, who never married, took her father's place teaching the deaf mutes. Another, who took the veil, lost her life in the persecutions of the Third Reich. There was also a brother, who made a career of medicine. His great achievement was verifying the miraculous cures that made Lourdes a center for pilgrims.

In his childhood young Max was an addict of Jules Verne, Fenimore Cooper, and Grimm's fairy tales. He also devoured the tales of E. T. A. Hoffmann and soon was dipping into Lewis Carroll, Nietzsche, and the exotic novels of Maurice Barrès. By the time he entered the University of Bonn he was

all but paralyzed by the drawings of the insane he carefully inspected at the local asylum, and for a while was enchanted by the prospects of a career in psychiatry. He also met August Macke, a member of the Blue Rider group of artists, who did him the favor of introducing him to Guillaume Apollinaire, then visiting the Rhineland. "We were speechless," Ernst recalled, "utterly captivated by Apollinaire's winged words, which flew from the lightest to the most serious, from deep emotion to laughter, from paradox to incisively articulated formulation."

In 1913, already introduced by the famous Sonderbund exhibition in Cologne to the work of Cézanne, Van Gogh, and Picasso, he set off for his first trip to Paris. Macke had given him letters of introduction, but he looked up no one, wandering all over town and experiencing the feeling of belonging.

Then, one day in 1914 in Cologne, he happened into a gallery exhibiting Cézanne, Braque, and Picasso, where he came across an elderly gentleman obviously ill at ease. "I am seventy-nine," he was complaining, "and never in the course of a life without reproach and dedicated to art have I been so shamelessly outraged." "If you really are seventy-nine," put in a young man who was showing him around, "your place is not here. You should have gone to heaven long ago." Purple with rage, the old gentleman left the room. And Max rushed to congratulate the young man, who was no other than Hans Arp. Such was the beginning of the lifelong friendship between Arp and Ernst.

The sculptor Arp, born in Alsace, got out of Germany just in time to avoid playing his part in the First World War. Ernst was not so lucky. Sent to the front as an artillery engineer, he was twice wounded before being invalided out of the army in 1917. "How," Ernst was to ask himself, "to overcome the disgust and fatal boredom that military life and the horrors of war create? How? Blaspheme? Vomit? Or have faith in the

therapeutic virtues of a contemplative life?" Circumstances were not favorable. However, he decided to make an attempt. A few watercolors, even paintings (executed in moments of calm), attest this.

The calm was not too evident. Dada was blowing a hurricane over the defeated Germany of William II, and Ernst was joining in every conceivable insult. One of his allies was Alfred Grünewald, the Oxford-educated son of a Cologne insurance magnate. Taking the name Baargeld (or Ready Cash), he presumed to publish *Der Ventilator,* a magazine the British army of occupation decided to suppress. "I curse you! You have dishonored us!" cried Ernst's father on discovering the company he was keeping. One of his undesirable—and hence delightful—new friends was Kurt Schwitters, the inventor of the *Merzbilder* with which he alarmed unwary citizens. Stopping at house after house with his suitcases, some of them filled with trash from flea markets, some of them with all but incomprehensible collages of his own, Schwitters was pointing out a tempting road for Ernst to travel. These were also the days when Ernst was arrested by the work of Chirico in Italian magazines while rejoicing in the lonely canvases of the great romantic Caspar David Friedrich.

At the University of Bonn Ernst had scrupulously avoided all courses that might degenerate into ways to earn his living. This was his only preparation for life as the husband of Louise Straus, the daughter of a Jewish hatmaker. She bore him one son in the midst of pursuing her studies in art history. The marriage was to last only four years, perhaps because she failed to appreciate the wit of Ernst's friends. Of these the most valuable was Paul Éluard. He was convinced that "the nakedness of women is wiser than the teaching of philosophers."

In 1919 Ernst was surprised by the pages of an illustrated catalog featuring objects for use in anthropological, psychological, mineralogical, and paleontological demonstrations.

Here was an invitation to produce collages far more mischievous than those of the cubists. He began painting demoralizing additions to the engravings in such catalogs.

Breton, having heard of this new activity in Cologne, insisted he must have an exhibit in Paris in 1921. In that summer Ernst met Breton and his wife in the Tyrol. This was the beginning of a long friendship, even if Ernst was stubborn about maintaining his independence. "The sacred discipline imposed by our leader, as you call him, only had its effect on those who, thanks to their inclination, their timidity, their fanaticism, their ambition, or their other virtues, yearned to be martyrs. These people were indispensable for the functioning of the group, they were rather numerous and easy to replace if sent away. Rare were the ones who, indispensable, could set their will of nonsubordination against the domination of the leader. This called for the use of special techniques which the first surrealists elaborated and perfected during several years of more or less friendly relations with Breton. Éluard knew how to play this ferocious game like no one else."

Although Breton was the first to get Ernst's message, Éluard and his Gala came to visit Ernst in the Tyrol in the summer of 1922, and this was the year that Ernst turned up in Paris on Éluard's passport. Éluard also had the intelligence to acquire at this time two of Ernst's remarkable paintings, *Oedipus Rex* and *The Elephant of Celebes,* which revealed the ominous use he was making of his experiments in collages.

Once in Paris, Ernst moved in with Éluard and Gala, who were soon living in the suburb of Eaubonne. Max had drawn too close to Gala, decided Max's ex-wife Louise when she came to call. For Louise, Gala was "that slithering, glittering creature with dark falling hair, vaguely oriental and luminant black eyes, and small delicate bones, who had to remind one of a panther. This almost silent, avaricious woman . . . having failed to entice her husband into an affair with me in order to

get Max, finally decided to keep both men, with Éluard's loving consent." Louise was certainly out of sorts. "Why do you allow him to scream at you like this?" she asked Gala. "This is something he has never dared with me." "Yes," came Max's answer, "I also never loved you as passionately as I do her." Then Éluard made a comment that did nothing to calm Louise's nerves. "You must understand," he said, "that I love Max Ernst much more than Gala does." In the meantime Ernst had been struggling to survive, turning out trinkets in Paris for the tourist market.

Was Éluard sincerely worried by Max's attentions to Gala? We may never know the answer to this question, but one day in March 1924, Éluard, who had been asked by his father to deposit a large sum from his real estate dealings, escaped to Monte Carlo with the cash and—so the story goes—broke the bank there. He then vanished from sight, having already saluted Ernst in a most mysterious poem beginning "In a corner the agile incest is circling around the virginity of a little dress." The next thing anyone heard from Éluard was a cable from the South Seas. "Come join me with Max!" was the cry to Gala. The three met in Singapore, returning to Paris in time for the father's forgiveness and the publication of the *Surrealist Manifesto*. Contemplating Ernst's collages, Breton announced with relief that the day of the pipe, the guitar, the newspapers, and the other machinery of the cubists was at last over.

Ernst was the happy illustrator of two anxious books of poems by Éluard, *Répétitions* and *Les malheurs des immortels*. These were followed in 1924 by the still bewildering painting *Two Children Are Threatened by a Nightingale*. In 1925 while in Brittany Ernst discovered that frottage, the rubbing of paper on unwilling floorboards and other fragments of wood, could stimulate as could nothing else the power of his imagination. These frottages were first revealed to the world in *Histoire naturelle,* a portfolio published by the Galerie Jeanne Bucher in

1926. No doubt *Histoire naturelle* was a blessing. Once it was on the market, Breton could recover from his displeasure at the news that Ernst and Joan Miró had taken the liberty of creating the sets for the fashionable Diaghilev ballet of *Romeo and Juliet.*

Ernst was now ready in 1927 to fall in love with Marie-Berthe Aurenche, a girl of twenty serving as secretary in a Paris art gallery. She had been educated by the nuns of the Faithful Companions of Jesus on the island of Jersey, and her father was the close friend of Jean Chiappe, the French equivalent of J. Edgar Hoover. A lesser man might have hesitated on considering the influences to which Marie-Berthe was subjected, but Ernst was determined she would be his bride, no matter what objections the family might raise. When the father forbade the marriage, the two fled to Noirmoutiers, an island off the Breton coast, where bloodhounds succeeded in tracking them down. At this point all might have been lost, since Marie-Berthe was brought back to her parents and there was even talk of sending her back to the convent. However, she ran away again with Max, and he had the privilege of confronting her father, reminding him that she had come to him of her own accord and besides was only a month or two away from her majority. A policeman was standing by as a witness, and the father summoned him. "Arrest this man! He is trying to abduct my daughter." Max was equal to this emergency. "Arrest this man!" he ordered the policeman. "He is insane! He is dangerous!" For a second the policeman hesitated while the father held out a warrant for Max's apprehension. Fortunately Max was not alone. Up came Breton and the other surrealists. "You can see," said Breton, "that this man is out of his mind. *I* am Max Ernst." Everyone was then escorted to police headquarters, with the exception of Max, who managed to get away, and in the next few days he and Marie-Berthe were married in Bordeaux. One cannot say

they lived happily forever afterward, for in 1936 in London she saw fit to make her confession to a Catholic priest and that was the end. In the meantime Marie-Berthe's mother made much, perhaps too much, of her being, such was the legend, the direct descendant of the lost dauphin Louis XVII.

Max, whom his best friends judged to be a kind of human, or inhuman, bird, was to reveal his birdlike nature in 1929 with the publication of *The Hundred Headless Woman,* a collage novel that would have charmed Charles Robert Maturin himself. This was a book that could not be overlooked, especially with its vehement preface by Breton. No one could possibly neglect Loplop, the father superior of the birds, who fed the street lamps of Paris their nocturnal nourishment. Or, for that matter, the numb train, or the engraving identified by the words, "This monkey, could he be a Catholic, perhaps?" In the very next year appeared yet another novel, *The Dream of the Little Girl Who Wishes to Enter the Carmelite Order.* Marceline-Marie was her real name, although her father called her Spontanette. She lost her virginity at the age of seven, and her teeth were smashed. "Now that I no longer have my milk teeth, I can take communion," she proclaims, adding on one somber page, "Who am I, myself, my sister or that gloomy scarab?" The anticlerical vein was not forgotten in 1934 with *A Week of Kindness,* populated with slobbering lions, bat-winged men and women, bird-headed horrors, roosters human-size, and sphinxes staring without mercy into trains.

"No one knows anything about the dramatic origin of teeth," Ernst one day declared. "There came the time when the equator put an end to the fear of heat." Tempted to take his chances with sculpture, he went to work in this new dimension in 1934 while visiting Alberto Giacometti in Switzerland. The son of a post-impressionist painter who had been overlooked, Giacometti had been wandering to find his way before joining the surrealists in 1930. He was not without prudence. This he

displayed by studying with the charming but far from rash sculptor Antoine Bourdelle. Then, all of a sudden, his mind began to dictate cruel, compelling visions like his *Palace at 4 A.M.* Nothing could be altered in these visions which came to him completely formed, calling for the complete surrender of his subconscious. But these were demanding works, and by the end of 1934 Giacometti gave up the battle. He was meant, he now thought, to turn out facile portraits which constantly evoked the dripping of wax. Of course he was banished from Breton's world the moment he decreed that he would sculpt only from living models. He came to scorn the originality for which he had once been prized, and perhaps he enjoyed his exile from the group. Fortunately there was a ready market for his unimaginative inventions.

And fortunately Ernst came across other artists who held to the surrealist faith. One of these was Meret Oppenheim, the Swiss girl who reached Paris from Berlin in time to create her immortal *Fur-Lined Teacup* of 1936. She was also to serve as the model for certain of the eerie nude photos of Man Ray. Still another recruit was the German sculptor Hans Bellmer, whose paradise was filled with nudes looking for all the world like smashed dolls.

The faith itself was to present a problem or two in the 1930s. In 1936, for instance, Breton had his reservations about a large surrealist exhibit at the Museum of Modern Art. Ernst ignored the warnings that came from the founder and showed forty-eight examples of his work. Two years later Ernst refused to join in the official boycott of Paul Éluard. Breton was displeased that Éluard consented to publish his poetry in a magazine too close to the Stalinist point of view.

Ernst was searching in this period for a woman who might share his longings. In 1936 he discovered the Argentine painter Leonor Fini, busy inventing witches who might climb out of her canvases at any moment to pay a visit to Loplop's great

friend. But his passion was for Leonora Carrington, the daughter of an immensely rich textile manufacturer from Lancashire. She was never bashful, either in her prose or in her art. She was presented at court, and a ball was given in her honor at the London Ritz. To conform, however, was not in her nature. Although she was sent as a child to two Roman Catholic boarding schools, she was expelled from each of them. Which was her way of preparing for her career as a painter. She was obviously fond of the animalets who might easily have escaped from the forests of Ernst.

"The only person present at my birth," Leonora claimed, "was our dear and faithful old fox terrier Boozy, and an x-ray apparatus for sterilizing cows. My mother was away at the time snaring crayfish which then plagued the Upper Andes." She was only twenty when she met Max in London in 1937 but was obviously eager to write a portrait of him as the Bird Superior. "Fear, in the form of a horse and dressed in the furs of a hundred different animals, leaps into the kitchen throwing up a shower of sparks under her hooves," she made plain. "The sparks turn into white bats and flit blindly and desperately . . . The Bird Superior ties Fear to the flames of the fire by her tail and dips his feathered arms in the color. Each feather immediately begins to paint a different image with the rapidity of a shriek."

Max and his Leonora were to spend two years together at Saint-Martin d'Ardèche, a tiny town not too far from Avignon, but this idyll came to an end when Max was interned in 1939 as an enemy alien. Released, thanks to a petition signed by Éluard, Max returned to Saint-Martin only to be pursued by the Germans. The time had come for him to flee to the United States for safety, and his later career belongs in another chapter. Leonora, crazed with worry over his internment, was sent to a hospital for mental patients at Santander. Ultimately she would emerge in Mexico City as the wife of a Hungarian.

Her final fantasies on canvas would reveal that she had fallen under the spell of the Mayan legends.

The silences of Joan Miró were legendary, reported his perceptive biographer Jacques Dupin. This should serve as a warning for all those searching for anecdotes of the type for which Max Ernst was celebrated. There were days when Miró was willing to dismiss Ernst as a fashion plate. And although Miró was ravaged by poetry and music—Varèse, Stockhausen, and Cage were among his favorite composers—he had no patience with intellectual theories, and in fact was hardly an intellectual. His impatience at times with Breton was noticeable. "He never gave me the opportunity to expand at my own free will," he said of Breton. "I am not sure he was always ready to welcome a surprise. Instead he was watching for the proof of something he had written." Besides, he was "surrounded by second-rate types, and all these people were listening to Breton and worshiping him like a pope. He was a pope. He needed his congregation. I stopped going to see him because it was so sad."

For his part Breton was willing to forgive Miró's independence. "He can pass for the most surrealist of us all," Breton admitted. "His production gives proof of an innocence and a freedom which have not been surpassed. This in spite of a certain arresting of his personality at the infantile stage." Still, he realized that Miró would never engage in the political adventures he advocated. "Pure imagination is the only mistress of what she appropriates from day to day, and Miró must not forget that he is only an instrument . . . Without wishing to lambaste a few idiots, I hold that other laws than those of painting are indefeasible, and in spite of everything I hope Miró won't contradict me if I make the claim that he has other obligations besides procuring for whomever you wish a gratuitous pleasure of the mind or the eyes."

In the end Miró was to recognize the value of all that Breton had done to ready the world for his achievement. On Breton's death, which occurred while Miró was in Japan, he sent a generous telegram. "From Tokyo," ran the wire, "I am searching for the message of the Orient which the visionary André Breton had sensed, and whose importance he suggested to me."

First and foremost a Catalan with his feet on the ground—such was the opinion of his devoted American friend James Johnson Sweeney—Miró decided he would have nothing to do with his nephews, who spoke only Castilian. His father, a jeweler who repaired watches, was not at all enthusiastic about having an artist in the family, but this may have been a blessing. "When I saw the boys who went up to Paris with me, all of them from good families, well, they were finished. As for me, the life I led in my childhood allowed me to acquire some muscles." His mother may have comprehended his ambition, but the most remarkable of his ancestors was his maternal grandfather, a furniture maker who never learned to read or write, but had the determination to travel all over Europe and even as far as Russia.

He was born at Montroig, just outside of Barcelona, on April 20, 1893. At fourteen he began studying at the Barcelona School of Fine Arts, where his first teacher was Modesto Urgell, famous for gloomy landscapes in the manner of Böcklin. Another teacher who had his influence was José Pasco, who drilled him in draftsmanship. His father then intervened, sending him to a school of commerce and obliging him to spend plodding months in a pharmaceutical supply house. Finally, his father relented after two years, and for another three years he was free to attend the academy managed by Francesco Galí, who made much of Manet, Cézanne, and Van Gogh while welcoming the visits of the great architect

Gaudí, who often came to sketch in the academy rooms. One of Miró's fellow classmates was Llorens Artigas, the potter with whom he was to collaborate in later years.

At twenty Miró began painting on his own, encouraged by the gallery owner José Dalmau, who not only showed Picabia and Picassos of the Blue Period but gave Miró his first exhibit when he was twenty-two. Paris was now inevitable. He could be described at this time as a Catalan fauve, but no label would fit his ambition. Writing to a close friend in 1919, he sketched his own attitude at the time of his descent on Paris in March of that year. "If you are thinking of going to Paris only as a spectator," he said, "to see and study the great impressionists and the modern people, there's no hurry about that. In that case, I advise you as a friend to keep on living in the country until the world begins to calm down, and then go there and take your time. But if you intend to show up as a fighter, it would be an aberration to let time go by and imagine that tomorrow things will be easier. I don't give a damn about tomorrow. Today is what interests me. I say this in all sincerity, I'd rather be a failure, a complete failure in Paris than swim around in the stinking waters of Barcelona . . . Let us forget what has been accomplished and go on searching deeper and deeper, so that when we reach our maturity, we can do something really interesting."

His first call in Paris was on Picasso, to whom he brought a cake just baked by Picasso's mother. Miró should not be discouraged, said Picasso, who acquired a Miró self-portrait for his own collection. "Act just as if you were getting on the *métro*," he told him. "You've got to get in line. Come on, wait for your turn." He went back to Montroig that summer, as he would again and again, but Paris was a stimulus even though the famous dealer Paul Rosenberg hesitated to climb the stairs to his studio. His new-found friend André Masson assured

him that Picabia's day was over, and that the future lay with Breton.

He was still a fauve at heart in 1922 when Ernest Hemingway, with whom he shared boxing lessons, made a down payment on a picture. Whether Hemingway was actually seized by the painting is a question, for the price was only 5,000 francs, which could not have placed too great a strain on his royalties. "When I first knew Miró," wrote Hemingway in a virtual parody of his own prose style, "he had very little money and very little to eat, and he worked all day every day for nine months painting a very large and wonderful painting called 'The Farm.' He did not want to sell the picture, or even have it away from him. I wouldn't trade it for any picture in the world."

Toward 1924 Miró began working in the style which he would make so famous. "It is difficult," he said as he made his way, "for me to speak of my painting, for it is always born in a state of hallucination, provoked by some shock or other, objective or subjective, for which I am entirely irresponsible." By 1948 he was telling his friend James Johnson Sweeney, "Nowadays I rarely start a picture from an hallucination, as I did in the twenties. What is most interesting to me today is the material I am working with. It supplies the shock which suggests the form, just as cracks in a wall suggested shapes to Leonardo." There were days in 1928 when he played at humorous references to Dutch genre work, but he was always too warm a temperament to sneer at humble efforts.

He never could sense the difference between poetry and painting. When asked if he would join an abstraction-creation group headed by Mondrian, he shuddered. "For a thousand men of letters, give me one poet," he announced.

His works were always ill at ease in the chilly international style buildings that carried out the commands of Walter

Gropius. One such example was the vast mural he completed in 1947 for the Terrace Hilton Hotel in Cincinnati, the design of Skidmore, Owings and Merrill. Another was the mural of 1951 (Artigas was his collaborator) for the Harvard Graduate Center, planned by Gropius and his cohorts. Still another was the wall he and Artigas created for the Unesco Building in Paris, across the street from Ange-Jacques Gabriel's École Militaire. Here the chief perpetrator was Marcel Breuer.

Paul Klee in the early 1920s admired Miró's genius, but Miró was too sensual to feel any real kinship for the cool world of Klee. "Painting has been decadent since the time of the caverns," Miró urged. His joy in erotic imagery was always evident: proof of this was the genitals transformed into spiders, and other mischievous commentaries.

"As for me," he made plain, "my hope has always been to work fraternally, as part of a team. In America the craftsman has been killed. In Europe we must save him. I believe he will live again, with power and beauty. The studios of the Middle Ages will be revived, and students will participate fully, each bringing his own contribution. Artistic education and understanding will no longer be reserved for the few, but will be for all."

His wife Pilar Juncosa, who came from Palma, Majorca, and bore him one daughter, was the perfect companion for this anti-intellectual artist. When asked if he ever discussed his work with Pilar, Miró grew almost violent. "Pilar is my guardian angel," he protested. "It would be horrible to have a wife who wanted to dictate to me."

Temperamentally, Salvador Dalí lived in a different world. "I was struck by Dalí," Miró recalled. "By Dalí the man. I had known him in Barcelona and his intelligence was obvious. He was brilliant, he was scintillating. But I never made a friend of him. That very intelligent man lacked the personality to match

his intelligence. He didn't have the strength of a human being. Ah! His painting interested me up to a certain point. But then came his collapse thanks to his lack of dignity." As for Jackson Pollack, he was "very good as a point of departure. I had great respect for him. I liked him very much. But he had his limits. This he realized and committed suicide." Of all Miró's artist friends he seems to have appreciated Alexander Calder most of all.

In a sense Miró was prepared for the coming of Franco by the attitude of his own sister, a reactionary whom he dreaded. His contempt for Franco ran deep, so deep that he refused to waste his time in public exhibitions of his opinion. Yet he hinted vigorously at his position by hanging *The Reaper,* a mural on masonite panels, next to Picasso's *Guernica* in the Spanish Pavilion at the Paris World's Fair of 1937. And there was also a telling lithograph in which Franco was depicted as another Nero.

By the spring of 1940 he was settled in the charming village of Varengeville on the Norman coast beginning the magnificent *Constellations,* a series of twenty-three gouaches (one was made over to his wife) that were ultimately shown at the war's end at the Matisse Gallery in New York. His inspiration at the time was drawn from rereading Saint Theresa and Saint John of the Cross. To Breton the *Constellations* were a window wide open on all the trees and flowers spared by the desecration of Europe. "You had to be on hand to recreate, at will, the sweetness of the breath of air that came from over there."

He had retreated to Majorca while the Germans were overrunning France, keeping his silence in Spain while the war went on. His appearance in America when the war was over provoked many new commissions, including the sculpture of the impertinent girl for the Loop in Chicago, and in 1954 he was awarded the prize for his graphic work at the

Venice Biennale. He died on Christmas Day, 1983, over ninety years old, happy at having endowed Barcelona with a museum of his own creations.

There must be one simple anecdote. When James Johnson Sweeney was celebrating his fiftieth wedding anniversary in Paris, he was puzzled for a moment when Miró seemed too shy to attend. But not for long. Miró, who recalled that he had met Sweeney and his wife for the first time fifty years before, showed up with a marvelous gouache created for this great occasion.

André Masson was too naive to join Miró's company.

Born on January 4, 1896, at Balagny near Senlis in the environs of Paris, he was the son of an accountant who eventually went into the wallpaper business. When he was barely eight, the family moved to Lille and then to Brussels. At the age of eleven he was admitted to the Brussels Academy, but his knowledge of modern art was obtained only by glancing at reproductions in magazines in the academy library, and when he first came upon the productions of Picasso, Braque, and Léger, he was certain that art of that kind could be produced only by men obsessed with railway accidents.

Yet he grew to be fascinated by the discipline of cubism: its influence would reappear from time to time as he kept on searching for his very own way of expressing himself. This quest took so many turns that Masson gives the melancholy impression that he was almost an art historian rather than an artist convinced of the path he should follow. How else explain his frantic interest in later years in Turner and Sung painting? He was also hypnotized by massacres and other violent experiences, as though he was never sure of his inner sense.

The violence that appealed to him may be explained by his ghastly experience in the First World War and his misunderstanding of the message of Nietzsche. What he made of Nietzsche is revealed by the long walks he took barefoot in

Switzerland on the eve of the war: he was resolved to harden his body. In Switzerland when the war broke out, he decided to return and enlist, to pass through "an examination of his own strength." "Whatever happens to you, even if you get out alive, you will always be wounded," a German friend had warned him. "There are wounds of the soul which will never close."

The German friend was a wise counselor. Joining the army as a foot soldier when he was barely nineteen, Masson went through the worst of trench warfare until he was critically wounded in the chest in the Chemin-des-Dames offensive of April 1917. For the next year and a half he passed from one hospital to another until an ambitious psychiatrist had him put away in an asylum. This psychiatrist, who suffered from cancer of the tongue and strangely resembled the duke of Alba, was sure he was a defeatist. One of the doctors forced up his arm, reopening his wound, and he then screamed out his disdain for the war effort. It was only thanks to his mother's intervention that he was released in November 1918. "It took me months to get back my ego," he complained. "That ego had been pillaged forever." Another psychiatrist advised him never again to live in a city. This advice he had no intention of respecting, although he did spend some time in the village of Martigues in the south of France quarreling with Soutine over the importance of Van Gogh.

He was in Paris experimenting with automatic drawings when he came across Breton in 1924. Breton was so kind as to buy his painting *The Four Elements,* but their first meeting was hardly reassuring. When he blurted out his appreciation of Nietzsche and Dostoevsky, and Breton could not agree with his point of view, there was a hint of more serious disagreements in the future. "I can't understand how someone like you, such an anarchist by nature, could be part of a group, become orthodox on anything," Gertrude Stein told him. "What has

Breton done to you?" "I found him seductive right off, and then he flattered me a lot," Masson replied. Upon which Gertrude Stein broke into a fit of laughter. "And I am still laughing," said Masson afterward.

Masson, who did not hesitate to place himself on a higher plane than Breton, once remarked that "I am too much of a surrealist for those who don't care for surrealism and not enough of a surrealist for those who like it." This statement should prepare anyone for the break with Breton that occurred in 1929. By this time Breton could no longer digest what he might have called Masson's impudence. "Monsieur Masson," he wrote, "despite his well-advertised surrealist convictions, could not resist reading a book entitled *Surrealism and Painting* whose author, rather careless when it comes to establishing hierarchies, did not think he should or could place him above Picasso, whom Monsieur Masson finds a low fellow, or Max Ernst, whom he accuses of not painting as well as he does." Breton made plain that he got this information directly from Masson.

It seems more than likely that Masson never grasped the essence of surrealism. "Toward 1930," he announced, "there appeared in the bosom of surrealism a frightful plague: the demagogy of the irrational . . . What a sad conquest that was, of the irrational by the irrational." The trouble was that artists began expressing themselves with the academic methods of the nineteenth century. And he named Meissonier, proving that he was unwilling to join Dalí in rehabilitating the battle artist of the Second Empire. This called for a sense of humor he never possessed.

There were serious-minded Americans in those days who cultivated Masson's work, making much of the sand paintings, in which glue and sand were mixed with pigments to attain the results he cherished. In the year 1929 his first marriage, to Odette Cabalé, ended in divorce, and he eagerly depicted

murders, battles, and devourings. "Woman is a trap you have to go through," he proclaimed. "It's always women who are massacred," he went on. "Sometimes there are adolescents, but the mature man escapes. These massacres of female figures take on a ritual, sacrificial cast. I can't believe they grow out of some misogyny of mine that I'm unaware of. Besides, there is often pity in the expression of the immolator."

He was to marry Rose Maklès in 1934, but his psychological difficulties did not come to an end. He followed at first hand the Spanish Civil War, yet never aimed a gun at the fascists. Were his difficulties actually over? In 1940, when he and Breton met in Martinique on their way to the United States, there was a brief reconciliation, but a genuine partnership never took place.

Yves Tanguy, who joined the surrealists in 1925, was no thorn in the flesh in the Masson manner. Born in Paris in 1900 in the very bed that had once belonged to Courbet, he was the son of a retired captain of the French navy and spent his childhood vacations on the Breton coast, where he was enchanted by the primitive menhirs, which may have inspired the curious half-excremental forms of his brown landscapes. But Tanguy was never a major surrealist: he was too repetitive for that. He was also quite slow in deciding he would be a painter, serving on freighters bound for England, Africa, and South America, driving taxis in Paris, and playing stockbroker or streetcar conductor. He did make up his mind in 1923 when he was surprised by a Chirico in an art gallery window. He began painting without any formal instruction, although he may have received a hint or two from his ultimate dealer, Pierre Matisse, who happened to have been his schoolmate.

René Magritte, the drastic Belgian surrealist, dismissed Tanguy by claiming that he was continually repainting the same picture. Magritte was never afraid to speak his mind. "I detest my past, and the past of other people," he said. "I detest

patience, professional heroism, and all the obligatory beautiful sentiments. I also detest boy scouts and drunks." While he never said he detested Breton, he did say that he found it hard to get on with anyone who did not like music.

Born at Lessines in the province of Hainaut on November 21, 1898, Magritte was the son of a realtor dealing in factory sites. Were the sites never to be occupied? One might suppose so from the peculiar gloom—the bright gloom—of so many Magritte canvases. When Magritte was thirteen he woke up one night to discover that his mother had slipped out of her bedroom. He roused the rest of the family, and they followed her footprints down to the bridge over the Sambre River. The corpse, on being fished out of the water, left no clue of what the mother expected to find in death. Her face was hidden in her nightgown, and no one could tell if she had covered her eyes so as not to see the death she selected.

Magritte knew a cheerless childhood. When he played, it was with a little girl with whom he explored an abandoned cemetery. The two of them would pry open the heavy iron doors of burial vaults and explore the contents for hours on end. One of his consolations may have been his brother Paul, who became a musician, but a musician who practiced poetry. "If the rain often succeeds in wetting man, the latter has not succeeded in wetting rain or in causing it the least moral or material discomfort," began one of his poems in prose. "This establishes, in irrefutable manner, the superiority of rain."

Magritte's ambition as a painter was to embarrass and humiliate almost all museum curators. On one day he would pay his respects to David's portrait of Madame Récamier by redoing the painting, replacing her figure within a coffin. Or he might entitle an empty room *The Memoirs of a Saint.* Or might alarm all mentally retarded critics by painting a pipe, labeling it *This Is Not a Pipe.* Or better yet, would execute *The Rape,* a girl's head whose breasts had become her eyes and her

genitalia her mouth. One of his favorite means of exploiting his imagination was to reread the dime novels turned out by Pierre Souvestre and Marcel Allain, the famous Fantômas series devoured with equal impatience by the surrealists in Paris. Fantômas was the perpetually successful criminal, out-witting the police year after year.

Magritte's companion, his wife from 1922 until his death on August 15, 1967, was Georgette Berger, whom he had first seen at the fair in Charleroi in 1913. He was always at home in Brussels, at whose academy he had studied back in 1916. When in Paris he would prefer its lugubrious suburbs, which re-minded him of Brussels. There came one day in Paris when he and Breton had an interchange that almost finished their acquaintanceship. Georgette was wearing a cross on her bosom, which forced Breton into one of his atheistic explosions. Yet Breton could not forget that Magritte was an indispensable member of the group.

And with his usual tolerance for the urges of his followers with a real message, Breton had no idea of neglecting the achievement of another Belgian, Paul Delvaux, whose dreams were of hypnotized women, bare-breasted or naked, most of them, strolling often along streetcar tracks. These somnabulists were the tribute Delvaux paid his mother, who had instilled in her polite son a holy horror of the wiles of her sex. Delvaux was not freed from his mother's instruction until he ran off in 1949, when fifty-one, with Anne-Marie de Marteleer, a woman he had been avoiding for a quarter of a century.

Delvaux did not know Magritte too well. The son of a Brussels attorney, he had studied, like Magritte, at the acad-emy, from which he emerged as an idolater of Poussin, Piero della Francesca, Mantegna, and Paolo Uccello. He cannot be said to have enjoyed Magritte's work, which he evidently regarded as a threat, and Magritte did not go out of his way to encourage him. Wrote Magritte: "I know him well enough to

be sure that he is an innocent fellow, quite pretentious underneath, and very respectful of what we must call the sense of order of the bourgeoisie. His fame is derived uniquely from the great number of naked women that he manufactures without too much trouble on vast panels. For him, these nudes are the very thing that academic professors refer to as the most sublime subjects of the heroic-classic tradition." Magritte did not deign to mention that Delvaux's great retrospective at Ostende in 1962 was closed to all boys and girls under the age of eighteen. Nor did he recall that the authorities of the Brussels streetcar system were obliged to praise the fidelity with which he reproduced ancient streetcars. As a child, Delvaux had loved pretending to be the station master at Ottignies.

Breton was as generous to Delvaux as he had been to Magritte. "Delvaux," he declared, "turns the universe into the empire of a woman always the same who reigns over the great suburbs where the old mills of Flanders keep turning over a pearl necklace in the light of minerals." He might have added that Delvaux was unfailingly polite to his models.

The time has come to talk of Salvador Dalí, whose first Paris exposition, in 1929, drew more than praise from Breton. "The art of Dalí," Breton announced, "the most hallucinating one can imagine until this time, constitutes a real menace . . . Dalí is standing here like a man who might hesitate (and the future will show that he didn't hesitate) between talent and genius, or as one might have said in the old days, between vice and virtue."

Dalí was to comprehend, as did no other surrealist except Breton, the uses of publicity. No American artist, not even Whistler, could come close to his genius in that useful direction.

"There are existing already in the world a number of incommensurable 'living madmen,'"—so he advertised him-

self to the United States in 1933—"who profess to revive 'the same prerogatives for dream and delirium,' the same fetichist credit, as usually accorded reality, who extend at each moment the 'most demoralizing discredit to the rational-logical-practical world,' who exchange the substance and the shadow of objects, the substance and the shadow of love, who affront aesthetes and highbrows with the perverse mechanism of erotic imagination, and who emerge at sundown to watch, with infinite cannibal nostalgia, the distant and sparkling sewing machines cut in blocks of ruby: such are the *surrealists*.

The *surrealists* are involuntary mediums for an unknown world. As a *surrealist* painter myself, I never have the slightest idea of what my picture means, I merely transcribe my thoughts, and try to make concrete the most exasperating and fugitive visions, fantasies, whatever is mysterious, incomprehensible, personal and rare, that may pass through my head. Pictorial means only serve to approximate as closely as possible an ideal of "colored snapshot" which painting must become in order to present in the most extra-artistic manner all the "unbelievable and imminent deliriums of obsessive exactitude which constitute the desired land, the treasure island" of unexplored and marvelous "delirious phenomena of unconscious and irrational thought." A new world remains to be discovered, a world of "irrational knowledge of the universe."

Here an interruption is inevitable. It was Dalí's privilege to behave at all times like a madman while remaining sane. His wife Gala, once the wife of Paul Éluard, completely comprehended his position.

Towards the end of those clear autumn afternoons at Port Lligat it has been my custom to balance two broiled lambchops on Gala's shoulders, and observing the movement of tiny shadows produced by the accident of the meat on the flesh of the woman I love, while the sun was setting, I was finally able to attain images sufficiently lucid and "appetizing" for exhibition in New York. I have never been to America, but by this simple process I have learned already what great lies are all the photographs, descriptions, films, and other miserable stories which are repeatedly and monotonously retailed to me from over there.

No inexactitude is more flagrant than that of the mythical and standard skyscraper. After all, where is this agitation? this electricity? this music?

To me New York is only a great silent plane of yellow alabaster, where fearsome dry grasshoppers, a few straw watches, and some raisins carried by the wind have just caught on the sticky surface of one-year-old children entirely covered with a thick coat of white enamel. What immense solitude! It is true (but it only accentuates so much horizontal melancholy) that in the exact center of the plain, rising to a colossal height, are two well-known anguished silhouettes, antique statues, representing the celebrated and tragic couple of Millet's *Angelus*. The figure of the man is myself: I am represented as blind, with a golden mouth splashed with excrement, very beautiful feminine breasts, a whip in my hand, and crowned with roses: the female figure is made flesh by Sacher Masoch, her eyes look into mine with infinite sadness, she is dressed in furs and wears an immense lamb chop on her head. At sunset these two silhouettes acquire an irresistible and hallucinating melancholy. The cumulus clouds that rise from the horizon at the end of the day invariably adopt the vague but radiant and golden outlines of Napoleon at the head of his cavalcade. At night—the furs of Sacher Masoch become phosphorescent and one sometimes hears from a distance, tired and monstrous, the agonized bellow of the antediluvian monsters of the exhibition of Chicago.

New York: why did you erect my statue long ago, long before I was born, higher than another, more desolate than another?

Born on May 11, 1904, at Figueras, a town some sixty miles north of Barcelona, Dalí was the son of a presumably patient notary with atheistical longings, who liked nothing better than reclining in his rocking chair while listening to Gounod's *Ave Maria* on the family victrola. The ambition of his son was evident even when he was still a child. Dalí's sister would never forget that his favorite pastime was taking a hammer and smashing rows of celluloid ducks and swans. He himself has written, "At the age of six I wanted to be a cook. At seven I wanted to be Napoleon. And my ambition has been growing steadily ever since." Although he was embarrassed by the family's remembering an older brother who died of gastroenteritis at two, just nine months before his own birth, his own

whims were invariably honored not only by his father but also by his pious Catholic mother. And his grandmother, who usually talked in rhymes and recited the poetry of Góngora with real elegance, had no doubts whatever about his future. "My grandson will be a great painter," she proclaimed. "The greatest of all Catalan painters."

Far from being completely self-centered, this incredible egotist was always ready to encourage young artists and writers in whom he could detect any imagination. There were days when Dalí's sister tried to comprehend him. "My brother has a grand sense of humor," she maintained. "It is only when an abnormal desire to call attention to himself overcomes him that he becomes capable of doing the most absurd things." What worried her was the destructive impact of surrealist ideas on his mentality. "They destroyed the peace of our home," she complained, and she found it hard to believe that he ever put his heart into a campaign to "destroy religion, the family, and love."

George Orwell, who reported that Dalí's autobiography was "a book that stinks," may never have appreciated his quite Spanish sense of humor. Orwell claimed that no one ought to "pretend, in the name of 'detachment,' that such pictures as 'Mannequin rotting in a taxicab,' are morally neutral. They are diseased and disgusting." *The Secret Life of Salvador Dalí* he dismissed as "simply a strip-tease act conducted in pink limelight." However, he added that "as a record of fantasy, of the perversion of instinct that has been made possible by the machine age, it has great value." He may have been irritated by Dalí's boasting of having at five pushed a boy smaller than he off a bridge: "I ran home to announce the news." Dalí also strongly objected to a doctor's piercing his sister's earlobes. Brandishing a leather-thonged mattress beater, he whipped the doctor across the face, breaking his glasses. "'I would never have thought he could do a thing like that, fond of him as I

was,' exclaimed the doctor, in a voice as finely modulated as a nightingale's song, broken by sobs." Wrote Dalí, "Since then, I loved to be sick, if only for the pleasure of seeing the little face of the old man whom I had reduced to tears."

Sent at seven to a public school where he learned nothing, at eight he was transferred to a school run by the Christian Brothers, where he fixed with a steady glance two cypresses through the classroom window. The cypresses were only one of the many obsessions which he began to collect with a truly clinical joy. Crutches played a role which cannot be exaggerated. He noted that "the growing and all-powerful sway of revery and myth began to mingle in such a continuous and imperious way with the life of every moment that later it has often been impossible for me to know where reality begins and the imaginary ends." He has recalled for us his first "superb crutch." "Already it appeared to me as the object possessing the height of authority and solemnity. It immediately replaced the old mattress beater with leather fringes which I had adopted a long time ago as a scepter and which I had lost one day on dropping it behind a wall out of my reach. The upper bifurcated part of the crutch intended for the armpit was covered by a kind of felt cloth, extremely fine, worn, brown-stained, in whose suave curve I would by turns pleasurably place my caressing cheek and drop my pensive brow. Then I victoriously descended into the garden, hobbling solemnly with my crutch in one hand. This object communicated to me an assurance, an arrogance even, which I had never been capable of before then."

Then there was his preoccupation with grasshoppers. "The fright which grasshoppers cause me has not diminished since my adolescence," he admitted in his autobiography. "On the contrary. If possible I should say it has perhaps become still greater. Even today, if I were on the edge of a precipice and a large grasshopper sprang upon me and fastened itself to my

face, I should prefer to fling myself over the edge rather than endure this frightful 'thing.' The story of this terror remains for me one of the great enigmas of my life. When I was very small, I actually adored grasshoppers. With my aunt and my sister I would chase them with eager delight. I would unfold their wings, which seemed to me to have graduated colors, like the pink, mauve, and blue-tinted twilight skies that crowned the end of the hot days in Cadaqués."

The phenomenon of the grasshoppers was eventually to be replaced by his mystical concern with loaves of bread. "My obsession with bread led me to a revery which became crystallized in the plan of founding a secret society of bread, which would have as its aim the systematic cretinization of the masses." The day came when he got a loaf baked fifteen meters in length and had it placed in the gardens of the Palais-Royal. "Once the bread was in place some members of the society, who would previously have rented an apartment overlooking the spot, would come and take their posts in order to be able to make a first detailed report of the various reactions which the discovery of the bread would occasion. It was easy enough to foresee the highly demoralizing effect which such an act, perpetrated in the heart of a city like Paris, would have."

"No matter where I go," Dalí concluded, "madmen and suicides are there waiting for me, forming a guard of honor. They know, obscurely and intuitively, that I am one of them, although they know as well as I, that the only difference between me and the insane is that I am not insane."

In 1921 he enrolled in the Academy of Fine Arts in Madrid, where he found teachers who had nothing to teach him. On his own he explored nearly every avenue of modern art worth visiting. He seems to have been very fond of Picasso's classical period; at least in 1925 he executed a drawing of his father and sister whose elegance rivaled that of Picasso himself. One of his friends at the Residencia or student center was Federico García

Lorca, whose poetry Dalí grew to detest for its folkloric quality long before Lorca was murdered in the Civil War. But Dalí designed the sets for one of Lorca's dramas, *Mariana Pineda,* a reading of which the author presented in the Dalí house in Figueras. And Lorca wrote an ode to Dalí, invoking his "olive-laden voice." "I can't brag about your imperfect, adolescent brush, nor your color which woos the colors of your time. I sing of your anguish!" Another friend made in this period was Luis Buñuel, with whom he would collaborate on the surrealist movies *Un chien andalou* and *L'age d'or.* Still another was Ramón Gómez de la Serna, whose wit was celebrated in Paris by Valery Larbaud.

Dalí began dipping banknotes in whiskey to watch them disintegrate, and he took all possible pains with his appearance. "I bought the most expensive sport suit in the most expensive shop I could find in Madrid, and I wore a sky-blue silk shirt with sapphire cuff links. I had spent three hours slicking down my hair, which I had soaked in a very sticky brilliantine and set by means of a special hairnet . . . after which I further varnished my hair with real picture varnish. My hair no longer looked like hair. It had become a smooth, homogeneous hard paste shaped to my head." He may have looked like that on the day that Alfonso XIII visited the academy. "His face," Dalí recalled, "which was commonly called degenerate, appeared to me on the contrary to have an authentic aristocratic balance which, with his truculently bred nobility, eclipsed the mediocrity of all his following. He had such a perfect and measured ease in all his movements that one might have taken him for one of Velásquez's noble figures come back to life."

Dalí was suspended from the academy in 1923. In 1926 he was expelled. He had already been arrested and sentenced to a month in prison for burning the Spanish flag at an anarchist rally at Figueras. But he had no reason to worry after his expulsion from art school. In November 1925 and again

December 1926 he was given one-man shows at the Dalmau Gallery in Barcelona, the very place that launched Miró.

And in 1926 he made his first trip to Paris, where he called on Picasso. "I've come to see you before visiting the Louvre," he told Picasso. "You're quite right!" came the answer. Whereupon Dalí went on to exhibit a small painting of his, *The Girl from Figueras*. Picasso looked at it for fifteen minutes and made no comment. Then Picasso went on to show dozens of his own canvases. "At each new canvas," Dalí realized, "he cast me a glance filled with a vivacity and an intelligence so violent that it made me tremble, I left without in turn having made the slightest comment. At the end of the landing of the stairs, just as I was about to leave, we exchanged a glance which meant exactly, 'You get the idea?' 'I get it.'"

At about this time Miró sent a letter to Dalí's father explaining to him the wisdom of spending some time in Paris. "I am absolutely convinced that your son's future will be brilliant," Miró prophesied. "It's going to be hard for you," Miró confided in Dalí. "Don't talk too much (I then understood that perhaps his silence was a tactic) and try to do some physical culture. I have a boxing instructor, and I exercise every evening." "Already," Dalí commented, "Miró's work was beginning to be the contrary of everything that I believed in and of everything that I was to worship."

Thanks to Miró, Dalí was invited to have dinner with the dealer Pierre Loeb and half a dozen of his "colts." "All of them already had their signed contracts and had managed to attain a small and befitting glory, which had lasted only a short time, which had never been too hot and was already beginning to cool. These artists, most of them, already had the sneer of bitter mouths that see before them the unencouraging prospect of having to eat an eternally warmed-over glory for the rest of their lives. And they also had that pale greenish complexion which is but the consequence of the excesses that are paid in

bile, the product of all the visceral rages to which the system has been subjected." One happy exception in this crowd was Pavel Tchelitchew, the person who showed him how to get into the *métro*. "For nothing in the world would I enter it. My terror made him laugh so heartily that his eyes were drowned in tears . . . I arrived, I went up, I got out . . . After this horrible oppression of the *métro*, everything struck me as easy. Tchelitchew had just shown me the underground way, and the exact formula for my success. For the rest of my life I was always to make use of the occult and esoteric subways of the spirit."

By this time Dalí had reached a complete understanding of what his paintings would be like: they would incorporate his obsessions and be advertised by his meticulous command of an academic technique. The first painting to conquer Breton was *Dismal Sport,* featured in 1929 at the Camille Goemans Gallery in Paris. "When Breton saw this painting," Dalí has told us, "he hesitated for a long time before its scatological elements, for in the picture appeared a figure seen from behind whose drawers were bespattered with excrement. The involuntary aspect of this element, so characteristic in psychopathological iconography, should have sufficed to enlighten him. But I was obliged to justify myself by saying it was merely a simulacrum." This picture, acquired by the Vicomte de Noailles, was a most emphatic advertisement of his critical-paranoiac method, preparing the public for performances like *The Great Masturbator, The Persistence of Memory*—popularized as *The Soft Watches* of the Modern Museum, and the immortal *Evocation of Lenin* with its six haloed heads on a piano keyboard.

By now a triumphant surrealist, Dalí was soon at work interpreting the meaning of Millet's *Angelus* whose importance he discovered in the summer of 1929 when the dealer Goe-

mans, Luis Buñuel, the Magrittes, and the Éluards came down to visit him at Cadaqués. His very first impression of Gala Éluard was not entirely favorable. Although her face was intelligent, "she seemed to be in very bad humor and rather annoyed at having come." She admitted "she had thought me an unbearably obnoxious creature because of my pomaded hair and my elegance, which she thought had a 'professional Argentine tango slickness.'" When they met the next day, he was seized with one fit after another of hysterical laughter and may have wondered whether he had made a mistake by smearing his armpits with goat dung, which gave out a stifling stench. But Gala would have to discuss the *Dismal Sport*.

"It's a very important work," Gala told him, "and it is precisely for this reason that Paul and I and all your friends would like to know what certain elements, to which you seem to attach a special importance, refer to. If those 'things' refer to your life we can have nothing in common, because that sort of thing appears loathsome to me, and hostile to my kind of life . . . On the other hand, if you intend to use your pictures as a means of proselytism and propaganda—even in the service of what you consider an inspired idea—we believe you run the risk of weakening your work considerably, and reducing it to a mere psychopathological document."

Dalí has told us he was tempted to answer her with a lie. "If I admitted to her that I was coprophagic, as they had suspected, it would make me even more interesting and phenomenal in everybody's eyes. But Gala's tone was so clear, and the expression of her face, exalted by the purity of an entire and lofty honesty, was so tense that I was moved to tell her the truth."

"I swear to you that I am not 'coprophagic,'" he replied. "I consciously loathe that type of aberration as much as you can possibly loathe it. But I consider scatology as a terrorizing

element, just as I do blood, or my phobia for grasshoppers."

In a matter of minutes Gala lost all her fears. "My little boy!" she cried. "We shall never leave each other."

"The beginning of my sentimental relationship with Gala was marked by a permanent character of diseased abnormality," Dalí has confessed to us. "My laughing fits, from having been euphoric, became more and more painful, spastic, and symptomatic of a prehysterical state which already alarmed me in spite of the manifest self-satisfaction which I continued to derive from all these symptoms."

We have Dalí's own word for it that he was not assailed by memories of Millet's *Angelus* until the summer of 1932. Yet the painting did play a definite role in the awakening some three years earlier of his love for Gala. When he came to study in *The Tragic Myth of Millet's Angelus* all of the erotic machinery he found in the famous canvas, the woman in which was no better than a praying mantis, he realized that he had been living at the time of his meeting with Gala in terror of the act of love, to which he then attributed the characteristics of extreme animality, violence, and ferocity, so extreme that he was absolutely incapable of surrendering to a woman, not only because of his supposed physiological insufficiency, but also for fear of the annihilating power of the sexual act. This terror had begun again at the beginning of his relations with Gala. For Gala was really taking the place of his mother, to whom he owed the fear of sexual activity with a woman and the belief that it would cause, fatally, his death.

We may now begin to understand why Dalí was moved to scribble on one of his canvases that he spat on his mother's face. This, of course, led to an estrangement from his father.

In the meantime the Vicomte de Noailles's purchase of *Dismal Sport* gave him the cash to buy a cottage at Port Lligat where he could paint at his leisure. The vicomte, whose country house at Fontainebleau had been designed by Gabriel

for the Marquise de Pompadour, also had the kindness to join Zodiaque, a group that provided Dalí with a pleasant annual income. And since the vicomtesse, the former Marie-Laure Bischoffsheim of the German banking dynasty, was distantly related to the Marquis de Sade through her grandmother, Dalí could begin to appreciate the importance society figures might have in his career.

In the course of his first dinner at the de Noailles house, where Romanée 1923 was served to the guests, Dalí admitted that he discovered two things. "First, that the aristocracy— what was then called 'society'—was infinitely more vulnerable to my system of ideas than the artists, and especially the intellectuals. Indeed 'society people' still wore clinging to their personalities the dose of atavism, of civilization, of refinement which the generation of the middle class with advanced social ideas had just joyfully sacrificed as a holocaust to the 'young' ideologies with collectivist tendencies. The second thing I discovered was the climbers, those little sharks frantically scrambling for success who with their assiduous flattery, their intriguing and competitive gossiping and anxiety crowd around all the tables covered with the best crystal and the best silverware. I decided that I would henceforth have to make use of these two kinds of discoveries—of society people to keep me, and of the climbers to open a way of prestige for me with the blundering calumnies of their jealousy. I have never feared gossip. I let it build up. All climbers work and sweat at it. When they finally hand it to me as complete, I look at it. I examine it and I always end by finding a way to turn it to my advantage."

Gala was now his and remained his until she died on June 10, 1982. Dalí was to praise his wife for "probably having saved me from becoming an authentic madman."

Although Dalí had no very high opinion of most movies— he wrote in 1932 that "the cinema is infinitely poorer and more

limited, for the expression of the functioning of thought, than writing, painting, sculpture, and architecture. The only thing beneath the cinema is music, whose spiritual value, as everyone knows, is just about nil." Yet he was to leave an indelible impression on movie screens, and not just for assisting Alfred Hitchcock with *Spellbound*.

In 1928 he produced *Un chien andalou* with Luis Buñuel. It ran for only seventeen minutes, but he was satisfied. It was, he said,

the film of adolescence and death which I was going to plunge right into the heart of witty, elegant, and intellectualized Paris with all the reality and all the weight of the Iberian dagger, whose hilt is made of the blood-red and petrified soil of our pre-history, and whose blade is made of the inquisitorial flames of the Holy Catholic Inquisition mingled with the canticles of turgescent and red-hot steel of the resurrection of the flesh . . .

The film produced the effect that I wanted and it plunged like a dagger into the heart of Paris as I had foretold. Our film ruined in a single evening ten years of pseudo-intellectual post-war advance-guardism.

That foul thing which is figuratively called abstract art fell at our feet, wounded to death, never to rise again, after having seen "a girl's eye cut by a razor blade"—this was how the film began. There was no longer room in Europe for the little maniacal lozenges of Monsieur Mondrian . . .

The shooting of the scene of the rotten donkeys and the pianos was a rather fine sight, I must say. I "made up" the putrefaction of the donkeys with great pots of sticky glue which I poured over them. Also I emptied their eye-sockets and made them large by hacking them out with scissors. In the same way I furiously cut their mouths open to make the white rows of their teeth show to better advantage, and I added several jaws to each mouth so that it would appear that although the donkeys were already rotting they were still vomiting up a little more of their own death, above those other rows of teeth formed by the keys of the black pianos. The whole effect was as lugubrious as fifty pianos piled into a single room.

The *Chien andalou* distracted me from my society career to which Joan Miró would have liked to initiate me.

"I prefer to begin with rotten donkeys," I told him. "This is the most urgent; the other things will come by themselves."

I was not mistaken.

He was not to be so happy with *L'age d'or,* the second film on which he collaborated with Buñuel, even though the Vicomte de Noailles, who was footing the bills, had agreed that the movie should be a faithful representation of the fancies of both of them. "My mind," Dalí wrote, "was already set on doing something that would translate all the violence of love, impregnated with the splendor of Catholic myths. Even at this period I was wonderstruck and dazzled and obsessed by the grandeur and the sumptuousness of Catholicism." He told Buñuel, "I want a lot of archbishops, bones and monstrances. I want especially archbishops with their embroidered tiaras bathing amid the rocky cataclysms of Cape Creus." But Buñuel, he reported, "with his naiveté and his Aragonese stubbornness, deflected all this toward an elementary anti-clericalism. I had always to stop him and say: 'No, no! No comedy. I like all this business of the archbishops; in fact, I like it enormously. Let's have a few blasphematory scenes, if you will, but it must be done with the utmost fanaticism to achieve the grandeur of a true and authentic sacrilege!'"

Shown privately for the friends of the Vicomte de Noailles, *L'age d'or* was released to the public, having passed the film censor, late in November 1930. But on December 3, the League of Patriots and the Anti-Semitic League organized a riot, hurling smoke bombs and slashing paintings in the foyer. On December 10 the censor's approval was revoked and the picture banned. Another regrettable consequence was that the charming vicomte was expelled from the Jockey Club.

In 1930 eight paintings and two drawings by Dalí went on view at the Wadsworth Atheneum in Hartford, Connecticut. This first exposure in the United States was followed in 1933 by his first one-man show at the Julien Levy Gallery in New York, and the appetite for his production was growing at an almost sinister rate. In his early days in New York he and Gala stayed at the Hotel Saint Moritz, but the far more elegant Saint

Regis was to become his permanent headquarters. There, on one brisk October afternoon, he walked out of his suite to discover hundreds of red rose petals scattered on the floor in the corridor. This was the work of the blind son of a princess from Western Pennsylvania. "Ah!" he cried out in his strong Catalan French: "Des rroses morrtes!"

In New York he would indulge his appetite for publicity to the fullest. A gigantic opportunity was offered by the windows of the Bonwit Teller store on Fifth Avenue in the fall of 1934, which happened to coincide with his second one-man show at the Levy Gallery. Modern mannequins, "so hard, so inedible, with their idiotically turned-up noses," did not please Dalí in the least, and he succeeded in finding in an old shop some frightful wax mannequins of the 1900 period with long natural dead women's hair, covered with dust and cobwebs. "Be sure not to let anyone touch that dust, it's their chief beauty," he advised the Bonwit representative Tom Lee. "I'm going to serve these mannequins to the Fifth Avenue public as one serves an old bottle of Armagnac that has just been brought up from the cellar with infinite precautions." Two windows were planned, one symbolizing day, the other night. In the day window, one of the mannequins was stepping into a hairy bathtub lined with astrakhan. The tub was filled with water, and the mannequin's beautiful wax arms holding a mirror called to mind the Narcissus myth. In the night window there was a bed topped by a canopy made out of the black and sleepy head of a buffalo with a bloody pigeon in its mouth; the bed's feet were the feet of the buffalo. The bedsheets of black satin had been burnt, and live coals could be seen through the sheets' holes. More live coals served as the pillow on which the model was resting her head. When all this was ready, Dalí and Gala went off to attend *Lohengrin* at the Metropolitan. Once the opera was over, the two of them spent the rest of the night on the finishing touches.

It was not until five in the afternoon that Dalí stopped by to glance at his windows. He then discovered that everything had been ruined thanks to the caution of Bonwit's. Conventional mannequins replaced the wax mannequins on which he set his heart, and even the bed with the sleeping woman had been removed. All that remained was the satin-padded walls. Furious, Dalí went to the management and demanded the withdrawal of his name. "If this is not done in ten minutes, I shall take drastic action," he complained.

When the management failed to comply with his demands, he descended to the windows with the idea of turning the tub over. The tub smashed into the window, and Dalí raced down the avenue, only to be arrested by a policeman who took him to jail. He was shortly released by a considerate judge who seemed to understand that an artist had the right to defend his creations. He may have expected that the authorities in charge of the forthcoming New York World's Fair would respect his wishes, and went ahead planning a pavilion entitled "The Dream of Venus." Once again he was disappointed. He created costumes for swimming girls after the ideas of Leonardo, but the authorities insisted on sirens with rubber fishtails. Dalí would not hear of this and took the trouble to cut, snip, and puncture everything. "I never did see my work completed," Dalí recalled. "I was to learn subsequently that no sooner had I left than the corporation took advantage of my absence to fill "The Nightmare of Venus" with the anonymous tails of anonymous sirens thus making what little was left of Dalí perfectly anonymous."

He must have been relieved by the attention paid him at this time in England, where Sir Roland Penrose and Edward James were building their collections of surrealist art and where he had the privilege of calling on Sigmund Freud. "In classic paintings," Freud declared, "I look for the subconscious—in a surrealist painting for the conscious."

"This," thought Dalí, "was the pronouncement of a death sentence on surrealism as a doctrine . . . But it confirmed the reality of its tradition as a doctrine . . . a 'drama of style,' a tragic sense of life and of aesthetics." Freud also said of Dalí: "I have never seen a more complete example of a Spaniard. What a fanatic!"

Dalí could not deny that he was appreciated in the United States. He was to design the sets for the "Bacchanale" from *Tannhäuser* which was presented at the Metropolitan Opera, even if with improvised costumes and without his being on hand for a single rehearsal. And in 1982 Reynolds Morse, a plastics engineer from Cleveland, succeeded in founding in Saint Petersburg, Florida, a museum to house his important collection of Dalí's work. On various occasions someone other than Morse would volunteer to pick up a restaurant check. But Dalí insisted that Mr. and Mrs. Morse should pay. "It's a tradition," he would say. "And besides, it's good for Morse to suffer for Dalí."

Long before the founding of the Morse Museum, Dalí was expelled from the surrealist movement. An "Order of the Day" for February 5, 1934, summoned those faithful to Breton to meet at his apartment on the rue Fontaine. The order read as follows: "Dalí having been found guilty on several occasions of counterrevolutionary actions involving the glorification of Hitlerian fascism, the undersigned propose that he be excluded from surrealism as a fascist element and combated by all available means." It was true that he had painted *The Enigma of Hitler.* "I often dreamed of Hitler as a woman," Dalí has told us. "His flesh, which I imagined as whiter than white, ravished me. I painted a Hitlerian wet nurse sitting knitting in a puddle of water . . . There was no reason for me to stop telling one and all that to me Hitler embodied the perfect image of the great masochist who would unleash a world war solely for the pleasure of losing and burying himself beneath the rubble of an

empire: the gratuitous act par excellence that should indeed have warranted the admiration of the surrealists." Quite possibly Breton was revolted by the frantic publicity that Dalí was generating, and by his cult for artists as reactionary as Meissonier and Bouguereau. "Avida Dollars" was the anagram by which Breton hoped to consign Dalí to oblivion. Said Breton: "Dalí even declared to me in February, 1939—and I listened carefully enough to assure myself that he was being completely serious—that the basic trouble confronting the world today was *racial* and that the only solution was for all the white races to band together and reduce all the colored people to slavery. I have no idea what doors such a declaration may open to its author in Italy and the United States, the two countries between which he shuttles, but I know what doors it will close to him."

Éluard seems never to have joined in the denigration of Dalí that Breton imposed. And Dalí himself seems to have refrained from downgrading Breton with the vituperation one might have expected. "My painting," Dalí wrote in 1976, "never really convinced Breton. My words were stronger than his theories." Breton, he added, was "basically rational and bourgeois."

As the founder of the surrealist movement, Breton was undoubtedly within his rights in exiling this artist. And it is unfortunate that Dalí was no longer subject to his criticism. The religious and patriotic subject matter of his later canvases is not half so appetizing as the really paranoic works before his exclusion. And it is also true that the later Dalí was occasionally guilty of complacency, attempting, for example, to rewrite his autobiography and publishing one truly anemic novel of high life, *Hidden Faces*.

Yet Dalí will always remain one of the great surrealists. He was the man who rediscovered not only the architecture of that fearless Catalan Gaudí, but also the architecture of the Paris

subway entrances. Gaudí's Sagrada Familia church, he decided, was "a gigantic erogenous zone with gooseflesh aching to be stroked by hand and tongue." He also left no doubt of his admiration for Hector Guimard's achievement—the *métro* stations. "I believe," he quite truthfully wrote, "to have been the first, in 1929, to consider without a touch of humor the delirious architecture of the 'modern style' as the most original and extraordinary phenomenon in the history of art." A convulsive mastication was in order, leading to a terrifying impurity which can only be compared to the immaculate purity of oneiric tanglings. "In a 'modern style' building, the Gothic is turned into something Hellenistic. Everything which has been utilitarian or functionalistic in the architecture of the past no longer serves any purpose whatever."

This salute to "the utter shamelessness of the pride" of Hector Guimard and his rivals deserves to be treated quite as seriously as the ecstasy of the surrealist group as a whole when face to face with the Ideal Palace of the postman Cheval at Hauterives near Lyons. "We are the sighs of the statue of glass that raises itself by the elbow while man is asleep," wrote Breton in the poem he dedicated to Cheval in 1932. This heroic postman who labored ten thousand days, ninety-three thousand hours and thirty-three years on the uncompromising monument to his own dream world was indeed a surrealist in 1879 when he began planning the monument that included an Egyptian tomb as well as a tomb for druids, a Hindu temple and two grottoes, one for the Virgin Mary and the other for Saint Amadeus. He would recall, while transporting in his wheelbarrow the materials for his creation, that Napoleon did not believe in the existence of the word *impossible*. "In creating this rock," he maintained one day, "I wanted to find out all that willpower can do."

Dalí was to rise to the postman's level on the day he conceived of the most perfect of all surrealist objects, the *Rainy*

*Taxi,* shown at the Paris Surrealist Exhibition of 1938, for which he and Max Ernst served as special advisers. The taxi's roof, full of holes, allowed the seepage of rain on a mannequin surrounded by two hundred edible snails. The model was wearing a sordid cretonne print representing Millet's *Angelus,* and the driver of the taxi was a hideous monster. Even for those who have gone from one museum to another in search of Dalís, from Saint Petersburg to the Teatro Museo Dalí in Figueras, this will produce a shock.

"No one imitates Salvador Dalí with impunity," Dalí has written, "for he who tries to be Dalí dies."

# CHAPTER FIVE

~~~~~~~~~~~~~~~~~~~~~~~~~~~~

THE MAD MADE
WELCOME

The patience of Breton with the mentally unbalanced was indeed remarkable: the strange state of mind of Raymond Roussel and Antonin Artaud did them no damage in his eyes. He was willing to overlook the homosexuality of Roussel, and although he tried in vain to excuse the drug addiction of Artaud, he was capable of all the sympathy Artaud needed in his unhappy final years.

Roussel, who committed suicide on July 14, 1933, at Palermo while staying at the solemn Grand Hôtel et delle Palme, the very place Wagner selected in which to perfect *Parsifal,* was the precious son of precious parents, as distant as Swinburne from the perils of the real world. The father, a successful stockbroker, died of one glass too many of champagne and brandy after placing his affairs in the hands of a friend whose pearl-gray trousers he particularly admired. The mother, respected for the special trains she commanded for trips to Biarritz, one day decided on a voyage to India on board her yacht. Having set sail with her coffin, in which she arranged her wardrobe, she was disappointed by the glance she gave the Indian coastline. "Is this all?" she asked. "Let us return to France."

last." The invariably polite Marcel Proust assured him that "you have that rare thing, inspiration, and without losing your breath can write a hundred lines in the time it would take someone else to write no more than ten!" The book was otherwise unnoticed and Roussel was devastated. He became the patient of the eminent psychiatrist Pierre Janet, who described him in the case histories of his *De l'angoisse à l'extase*. Janet, as we have seen, had no patience with the surrealists. He had none with Roussel.

"Martial"—so Janet renamed him—"lives an isolated life, which seems quite sad, but fills him with joy, for he is constantly at work. 'I bleed,' he tells me, 'over every phrase.' These literary works, whose value I shan't consider, have had almost no success. But the author has his own opinion. He not only keeps on working with tireless perseverance, he has an absolutely unshakable conviction as to their incommensurable artistic merit."

"I shall reach immense heights," Roussel confided in Janet, "and I am born for a glory like lightning. That may take some time, but I shall be more famous than Victor Hugo or Napoleon. Wagner died twenty-five years too soon and never know real fame, but I hope to live long enough to contemplate my own. My glory is like a great shell that has not yet exploded . . . Yes, I once realized that I bore a star in my forehead, and I'll never forget that."

To Janet it was obvious that Roussel was experiencing an almost religious ecstasy when he recalled his moments of glory. "One has the strange sensation," said Roussel, "that one is creating a masterpiece, that one is a prodigy. There are prodigal children who have a revelation at the age of eight; th' came to me when I was nineteen. I was the equal of Dante a Shakespeare. I felt what Victor Hugo felt at seventy, w Tannhäuser dreamed of in the Venusberg. I felt that I glorious . . . What I was writing was surrounded

Her son, who won forty-five medals for his accuracy with pistols and was accounted a genius at chess, did not make friends too easily. "Everything that is new bothers me," he confessed, and he did not encourage the advances of Count Robert de Montesquiou, the man on whom Proust modeled his Charlus. "Someone told me he was demented," commented Montesquiou in his autobiography. "I sniffed a genius, and I was not far off . . . The man is not very cordial; but how could he be? His soul is constructed like those of his characters, who labor over mosaics of teeth, or stage scenes with galvanized corpses. There is something chilling, something pneumatic about his appearance." And although Montesquiou frequently came across Roussel out walking his poodle—who was perpetually smoking an empty pipe—he was not moved to interrupt him. This in spite of the fact that Roussel's social standing was irreproachable. He was made a Chevalier of the Legion of Honor in 1928 (after presenting the Legion with 50,000 francs) and was even asked by his brother-in-law Charles Ney (of the Napoleonic dynasty) if he would not join the Jockey Club. This honor he declined, but was invariably fastidious about his dress, patronizing the shoemaker Hellstern on the Place Vendôme and the Irish tailor Cavanaugh on the Elysées. He also never wore his stiff collars more than once.

He may have had a gift for music. In any event his mother had him entered at the Conservatoire in 1890 when he was thirteen. His class included Alfred Cortot, and he once won honorable mention at the piano from a jury on which sat Gabriel Fauré. But at seventeen he decided that his real talent lay in literature. At his own expense he published *La doublure* (*The Extra*), a novel of painstaking alexandrines dealing with the career of an unsuccessful actor who never succeeded in getting a first-rate part. "Since this book is a novel," the author warned, "it must be begun on the first page and ended on the

radiance. I drew the curtains, for I feared that the slightest opening would have allowed the luminous rays to escape from my pen. I bore the sun inside of me, and I could not prevent this formidable flash of lightning . . . At that moment I was in a state of unheard-of happiness . . . at that moment I was more alive than at any time of my life."

Janet was given to understand that Roussel had a very interesting conception of what literary beauty was all about. Roussel maintained that "a work of literature must contain nothing real, no observation of the world, nothing but combinations of completely imaginary objects."

Furthermore, Janet was struck by his patient's fascination with the ideal of chastity. Roussel was shocked by the display of naked women in the theaters and was also upset at the thought of girls from good families taking care of the wounded in ambulances. Equally objectionable was the sight of girls painting from nude models. And how could one allow girls to gaze upon athletes who were not fully clothed? All swimming meets should be forbidden, all licentious posters should be removed from public view and the most stringent laws should be enforced against nakedness. He had no objection to prohibited acts being performed in private cabinets, so long as one could be punished or exposed to the scorn of respectable people. Anything that had to do with love should remain something rare and forbidden—really inaccessible. For a girl to see a man naked must be a windfall, not something casual that happens in a hospital or a studio. If a woman's breasts are shown in public, there will no longer be any pleasure in seeing them: the charm of forbidden fruit must not be removed, else we might lose the cult of the secret garden. Our moral standards must never be lowered.

It followed that pleasure, once it was made available to everyone, was no pleasure at all. Roussel was a great traveler, visiting all of Europe, Asia Minor, and the South Seas. But

travel could be ruined in a democratic world. When he reached his hotel in New York, he wanted to take a bath and the idea gave him a certain satisfaction. Then he learned that there were 3,000 bathrooms and that 2,999 travelers could take a bath at the same time he did. At that news his pleasure vanished: you can only enjoy yourself if you win first prize— the happiness of others can only cause suffering.

Roussel may have been dwelling on the unhappy subject of other people's happiness while writing *La vue* (*The Glass*), his second rhymed production, for this account of life on a beach, at a concert, and eventually at a watering place is singularly lifeless. Yet a careful reader will be bound to observe that his vocabulary is unusual, almost as if he counted on a crossword puzzle dictionary, this at a time when the crossword puzzle craze was in the future. For example, the word *chanterelle* turns up, which may mean either a musical bottle, a decoy bird, or the first string of a violin. It is obvious that Roussel was passionately fond of puns, very like the curious Jean-Pierre Brisset, who constructed an anatomy of language that was pun-based. Brisset argued that faith and madmen were sisters.

The time has come to reveal Roussel's method of composition, which he did not disclose until after his death. "It seems to me," he announced in *How I Wrote Certain of My Books,* "that it is my duty to expose this, for I have the impression that the writers of the future could perhaps exploit it with profit." The method consisted of using almost identical sentences involving words of similar sounds with differing meanings. To put this into English, you might try *She escaped by a hair's breath. Hair* may become *heir; breath* may become *breadth.*

The method's advantages could be sensed in *Impressions d'Afrique,* the prose novel of 1910. Like all of his works, this was published at his own expense and never gained the audience that Roussel longed for. However, it did attract a small but select following. Marcel Duchamp confessed that

here was the inspiration for his *Bride Stripped Bare by Her Own Bachelors, Even,* and pointed out that intellectual expression could be as vital as animal expression. And as early as 1921 Breton recommended this book to Jacques Doucet. Even though Breton conceded that the "form" of this novel could be considered vulgar, he was impressed by the constructive, architectural element of its fantasy. In the *First Surrealist Manifesto* he ruled that Roussel was "surrealist in the art of the anecdote." Besides, "he could mesmerize his readers like no one else."

Jean Cocteau, who had no hesitation about poaching on the surrealist preserve, held that Roussel was "a genius in a pure state." As for André Gide, he too was captured and communicated his enthusiasm to the select group of writers he met at Adrienne Monnier's bookstore. Aragon, not to be eclipsed, argued that Roussel was "a perfect statue of a genius." Éluard joined him by declaring that his imagination "bore on its head the earth and the heavens."

Roussel seems to have realized that *Impressions d'Afrique* might place certain demands on the unwary. He took the trouble to indicate that those who had not already experienced the range of his talent would do well to begin on page 212, continue on to the end, and then begin again on page 1. The crowing of Talou VII, Emperor of Ponukélé and king of Drelchkaff is mentioned in the very first paragraph, which should prepare anyone for the dynastic quarrels of this imaginary land. However, African history is greatly complicated by the shipwreck of the S.S. *Lyncée,* whose passengers are not without their problems. You will eventually meet, among others, a band of acrobats bound for Buenos Aires, including the armless and legless Tancrède Boucharessas with his five children. Hoping to play a role is the plump, moustachioed Livonian dancer Olga Tcherwonnenkoff, once a star in St. Petersburg. She will be joined by young Carmichael from

Marseilles, who dresses as a woman to advertise his falsetto voice.

Marius, the ten-year-old son to Tancrède Boucharessas, was close to Roussel's heart, for he was in charge of the joyful game of prisoner's base in which dozens of cats, some wearing green ribbons, some red, displayed themselves with a fury that ended only with the victory of the reds. For some strange reason Roussel paid almost no attention to the most alarming of all the inventions of the *Impressions,* the launching of a train running on rails of soft calfskin. This device was used to transport a number of statues alongside the new stock market of the capital city of Eljur. The most extravagant of all the statues was the bust of Immanuel Kant, whose cranium was transparent and brilliantly illuminated.

But Roussel was to surpass himself in 1914 with his next prose novel, *Locus solus.* The title derives from the estate at Montmorency, a dozen miles outside of Paris, of the fastidious bachelor Martial Canterel, the master-mind of a series of charades that solve problems as difficult as any facing Lord Mountbatten when contemplating the independence of India.

Haunted by the imaginary history of Africa as well as that of Brittany, Roussel has Canterel welcome his guests by exhibiting the statue known as the *Federal with the Worm-Seed.* This is a memorial in honor of Duhl-Sérou, the queen of Timbuctoo who frequently lost her mind as the result of no menstrual discharge. Her sanity was eventually saved by the seeds of a small plant found in the palm of a statue of a naked smiling child. A tornado had the tact to deposit the plant in that position. The attention of Canterel's visitors is then riveted on three high-reliefs, one of an enraptured young woman gazing at the word NOW in the clouds, another of the same woman extracting a one-eyed puppet from a seam in a cushion, and still another of a one-eyed man dressed in pink whose eyes are fixed on the word EGO in green marble. All this leads to an

examination of a Breton legend concerning Hello, the only daughter of King Kurmeen, who inherits his crown thanks to the advice of the one-eyed jester Le Puillec.

But Canterel (or Roussel) is equally at home in the twentieth century. A vast paving beetle suspended from an aerostat entertains everyone by scattering teeth in all conceivable colors, forming a mosaic that leaves everyone spellbound, especially when it is revealed that Cantarel has just invented a new method for extracting teeth.

However, the wonders of *Locus solus* have not ended. Canterel does not forget to produce a gigantic diamond filled with water, in the middle of which swims a woman whose hair is vibrating musically as she bathes in the water. At her side is a skinless cat making its way through the water to the skull of Danton, who will deliver a patriotic address. In no time Canterel will set to work reviving eight corpses he deems will hold the attention of those who have sufficiently examined the mosaic of the quaintly colored teeth.

Roussel may not have succeeded in reaching a conservative audience with his writings, but must have fascinated his mother, who once hired a woman dressed in black to read *The Three Musketeers* out loud every evening. Madame Roussel died on October 6, 1911, just as her son was spending a considerable portion of his considerable income in stage productions of *Impressions d'Afrique*. The idea that he could broaden his public by this method had been advanced by his mother's great friend Edmond Rostand, the author of *Cyrano de Bergerac*.

Roussel was to pay his last respects to his mother, just before she was embalmed, by opening a window in her coffin for a last sight of her face. The memory of her confidence in him may have encouraged other expensive theatrical adventures. *Impressions* was twice revived before being sent on the road in Belgium and Holland. The receipts were minimal but Roussel

was determined, and in 1921 he hired the commercially successful Pierre Frondaie to work up a condensation of *Locus solus*. The costumes were designed by no less a couturier than Paul Poiret, but François Mauriac held back his approval. "A millionaire," he said, "can do exactly what he pleases. Monsieur Roussel decided to write a madman's drama, and he has succeeded all too well."

Undiscouraged, Roussel in 1924 offered *L'étoile au front,* another drama of his own invention. Trézel, a collector of distinguished autographs, plays somewhat the role of Canterel in *Locus solus* retailing anecdotes that could have been inspired by random glances at entries in biographical dictionaries. There is, for example, no evidence that Roussel was a passionate admirer of Milton's poetry, yet Milton has his importance for Trézel. One of the prize exhibits of his collection is the egg shell kissed by Maud de Perley, the young girl whom Milton gazed fondly upon as she lay dying. This may well be the liveliest of all the anecdotes, but no one can dismiss the final scene, in which Trézel's niece, about to marry his disciple Claude, receives as a wedding present a copy of *The Predestined,* the major work of the psychographer Boissenin. Boissenin argues that those who will one day bring beauty into the world bear a star on their forehead at the time of their birth. "Who knows," Genevieve announces, "perhaps your gift will bring me great happiness and my first child will bear a star on his forehead."

There were only three performances of *L'étoile au front,* all of them matinees, but Roussel took the trouble to issue invitations, including two hundred seats for the General Association of Students. In spite of all these precautions, boos and catcalls greeted his kindness. Upon which Robert Desnos rose in protest, rebuking the audience. "The claque has its nerve!" someone called out. Desnos's answer was more impertinent: "We are the claque, and you are the cheek!" Breton was

once again convinced by Roussel's artistry, but not too much so. "I can't claim," he wrote, "that the passionate approval I gave the show was based on an immediate comprehension of the text. But most of my friends and I had read and reread *Impressions d'Afrique* and *Locus solus* and that was all we needed to give the author our complete confidence."

Two years later Roussel put on his final play, *Poussière de soleils,* set this time in French Guyana. If proof was needed that Roussel was telling the truth when he claimed he had gone around the world and seen nothing, here was the evidence. *Sun Dust* is centered on the quest of Julien Blache for all that his uncle bequeathed him. There must be more than the mansion, valued at 280,000 francs, more than the contents amounting to another 60,000. What has happened to the uncle's extraordinary collection of precious stones? This was of more than casual interest to Julien's daughter Solange. Could she trust the native sorcerer Kléolssem? Or the female dwarf Buluxir, 106 years old? Buluxir, at first favorable to Blache and his daughter, warns everyone to beware of Zuméranz, whose intentions must be dishonorable. Roussel apparently had no trouble inventing other curious characters for the cast, including Ignacette, the shepherdess, but such was the author's shyness that the cast is almost never convincingly identified. And rare are the readers who can share the ecstasy of Solange on marrying her lover Jacques, whose unblemished ancestry is revealed at the very point the two lovers are ready to contemplate the sun dust of the universe. The play languished, Breton confessed.

Roussel was to publish yet another novel in verse, the *New Impressions of Africa,* which caught the admiring eyes of Dalí, but the time has come to consider the daily life of Roussel in his last years. Although he purchased at least one example of the work of Masson, Ernst, and Miró, he cherished his private life and had next to no contact with his surrealist well-wishers. In

1925 he celebrated his solitude by sinking a million gold francs in the acquisition of a *voiture roulotte,* or traveling van, with carriage work by Lacoste. On board he carried his *valet de chambre* and two chauffeurs. This amused him for no more than two years but it allowed him to pass up all hotels on his way to his audiences with the Pope and Mussolini. It was his custom to travel with only one suitcase, picking up on the way whatever he needed. Whenever without the *roulotte,* he scrupulously avoided trains at night time, for he liked to know exactly where he was. Passing through tunnels filled him with anguish.

Finding the right platonic mistress took some time. One choice, a woman who tried to extort 100,000 gold francs from his mother for the ordeal of hearing him recite his works, had to be dismissed. The ultimate choice was Charlotte Dufrène, who stayed in his service for twenty-three years, although she was relegated, on evenings at the opera, to the balcony occupied by kept women. She had to be told never to mention any dental problems and never to refer to snakes. She was, however, given an allowance that freed her from financial worries, and the allowance was continued even though Roussel dipped deeply into his principal to pay his literary bills and maintain the standard of living suggested by his *voiture roulotte.* The time came when the Roussel estate at Neuilly was placed on the market and disposed of.

One item that Roussel could not eliminate from his budget was the allotment for the barbiturates to which he became addicted in his last years. Charlotte seems to have done her best to wean him from his dependency on drugs. Who knows, she may have sensed that the end was near on June 15, 1933, when she was sent back to Paris from their Palermo hotel to dismiss his servants and bring back some funds. He pleaded with Charlotte to take his revolver and shoot him. When she refused, no matter how much he offered to bribe her, he

handed his razor to his valet, begging him to cut open the veins at his wrist. This too failed and Roussel seems to have accomplished his suicide simply by dosing himself to excess.

But Roussel's life was not without its cheerful moments. He was a talented mimic, amusing himself and an occasional caller by taking off actors. No such incident brightened the career of Antonin Artaud, who was often convulsed with sympathy for himself. He would gamble on his charm—as in his dealings with the editors of *La nouvelle revue française,* but rarely win. Born in Marseilles to a Greek Levantine mother notorious for her hysterical rages, he was a drug addict at nineteen. Invalided out of the French army, he made the first of his many entrances into insane asylums. "Lunatic asylums," he maintained, "are consciously and premeditatedly receptacles of black magic."

He joined the surrealists in 1924 and was placed in charge of their research division. "We have nothing to do with literature," he made plain, "but like the rest of the world we are quite capable of exploiting it when we need to." The third issue of *La révolution surréaliste* proclaimed the end of the Christian era, a decision that seems to have pleased Aragon, who announced the coming of a dictator. "Antonin Artaud," said Aragon, "is the man who threw himself into the sea. He respects nothing, neither your lives nor your secret thoughts."

Peace, however, could not be maintained for long between Artaud and the surrealists. In 1926 Breton, Éluard, and Aragon joined the Communist Party—a short-lived adventure. Artaud refused to take this step, a declaration of independence that might have been excused had he not been guilty at this time of discussing the Roman Catholic faith with Jacques Maritain, then famous for bringing Jean Cocteau into the fold. The time had come for Breton, Éluard, and Aragon to disown Artaud. "Now that we have vomited up this scum," the three announced, "we can't see why this filthy beast would need any

more time to become a convert or, as he might say, declare himself a Christian." Artaud's answer could have been foreseen. "Surrealism," he had no hesitation in saying, "is dead, thanks to the imbecilic sectarianism of its adherents."

There remained for Artaud the possibility of a career on the stage. He did please André Gide and made an indelible impression on the great actor Jean-Louis Barrault. "He was essentially an aristocrat," Barrault held. "He was a prince." As early as 1922 he had taken his place in Charles Dullin's Théâtre de l'Atelier and by 1926 founded Le Théâtre Alfred Jarry. This was a sensational but hardly successful venture. On one occasion he staged the third act of a Claudel play without disclosing the author's name. Breton, in the audience, cried out that it was the work of Claudel. Whereupon Artaud admitted that "the play we have just performed is by Monsieur Paul Claudel, French ambassador to the United States and a traitor." On still another occasion he irritated Breton by putting on a Strindberg drama, and fearful that Breton would make a scene, called in the police to expel him from the premises.

Although he *apparently* fell in love with the Rumanian actress Genica Athanasiou and eventually with Cecile Schramm, the daughter of the boss of the Brussels streetcar lines, love had no real place in his imagination. He was, he confessed to one of the alienists treating his mental condition, "the best qualified and the purest representative of the genuine religion of Jesus Christ, of which the superficiality of Catholicism was only a shameless caricature." The religion in which he believed demanded complete chastity not only on the part of the priests, but also of any man worthy of the name. "It preached the absolute separation of the sexes. Everything unchaste and sexual, in and out of marriage, is condemned, and human reproduction can't take place by the exercise of filthy copulation."

He was a failure as a dramatist. His *Elagabalus* was no better than a coarse tribute to a Roman emperor better forgotten, and he eventually decided it was not worth reprinting. His *Cenci,* a rewriting of Shelley's play exposing incest in the Renaissance, lasted for only seventeen performances in 1935, even though the sets and costumes were the work of Balthus. He may not have been a failure as a theorist: a number of professional intellectuals were impressed by his essays on what he termed the theater of cruelty, which was his way of emphasizing his interest in dramas of the Elizabethan period. "It is a fact," he insisted, "that no play can be successful without an element of cruelty. The important thing is to understand what use this cruelty is to the spectator. There is such a thing as cosmic cruelty, without which nothing can be created." Scenery was of minimal importance; he had already warned the administrator of the Comédie-Française that "your brothel is too greedy. Representatives of a dead art should try to stop bursting our eardrums. Tragedy has no need of a Rolls Royce or the prostitution of jewelry." He preferred hangars or barns to what then passed for theaters. And modern costumes were out of the question. "We shan't stage any plays that are written down, but we'll refer to themes, facts, and situations that everyone knows about. We'll aim at settings that threaten the audience." Above all the theater should be freed from reciting texts: he was eager for a unique language halfway between gestures and sentences.

He arrived at all these conclusions while psychiatrists were pleading for the consolation of the rational.

In 1936 he was off to Mexico, where he experimented with mescalin and investigated the peyote rites of the Tarahumara Indians. "To be chaste or perish, that is what I learned from the Tarahumaras of the mountains," he confessed. "There is nothing more erotically pornographic than Christ, that ignoble concretization of all the false psychic enigmas." Talking to

students at the University of Mexico, he said that he came bearing no surrealist message. "I came to tell you that surrealism was out of fashion in France. The surrealist attitude was negative." And in an open letter to the governors of the Mexican states, he pointed out that "for me, European culture is bankrupt, and I see myself as a traitor to the European conception of progress." He felt closer to the Tarahumaras, one of whom told him that "the mind of man is tired of God."

In 1937 he made his strange way to Ireland, where he discovered Saint Patrick's cane, which was also the cane of Christ. The second he stepped on board the S.S. *Washington,* which was to take him back to France, he was placed in a straitjacket. For the next six years he passed from one insane asylum to another. One of his conclusions from the care he was given was made public in his essay on "Van Gogh, the Suicide at the Hands of Society." "I acquired," he wrote, "on reading the letters of Van Gogh to his brother, the strong and sincere conviction that Dr. Gachet, 'the psychiatrist,' really detested Van Gogh as a painter, but especially as a genius." This in spite of the fact that not every psychiatrist was without sympathy for his own case. Back in 1920, Dr. Édouard Toulouse of Villejuif declared that Artaud "was of the same race that produced the Baudelaires, the Nervals, and the Nietzsches . . . Will it be possible to save him?"

On the eve of his internment in the third of his asylums, at Ville-Evrard, he was found sleeping in the open air. "Monsieur, the world has none me so much harm," he pleaded with a man about to pass him by. "You are part of this world. So you have harmed me." These were the days when he convinced himself that Lewis Carroll was the incarnation of revenge and fury: his "Jabberwocky" was no better than "an obscene profiteer."

Breton came to haunt him in his despair. At times he believed that Breton—joined, incredibly, by the forces of the

Action française—had made the effort to save him from the machine-gun fire of the police. He was also positive that Breton's poetry in the profane realm recalled the ecstasies of the great mystics calling upon God. "I have often thought of Gabriel the archangel when I watched the face of Breton light up during the manifestations of surrealism . . . He too will come back to God."

Artaud was to die of rectal cancer on March 4, 1948. Two years before this an auction was held to rescue him. Over a million francs was raised for this purpose. Picasso, Braque, Léger, Duchamp, and Giacometti contributed their art work, and Éluard, Gide, and Mauriac handed over their manuscripts.

Saluting on this occasion what appeared to be Artaud's liberation from psychiatric interference, Breton recalled that his personality was "magnificent and black." Nor could he forget the phosphorescence of the third number of *La revolution surréaliste,* published under his direction. A shiver ran down his spine at the thought of this man climbing the heights up to and beyond thunder itself. "Under other skies than the empty sky of Europe, the word from Artaud, constantly inspired, would have been received with the utmost deference . . . I have become too faint a follower of the old rationalism that we covered with shame in our youth to refer to the extraordinary testimony advanced against him by common sense. I should have liked to have brought peace to Antonin Artaud when I saw that he was distressed by the fact that my recollections, during the more or less atrocious decade that we have lived through, did not exactly substantiate his own." So, gently, Breton denied Artaud's story that his old friend raced to Le Havre in 1937, losing his life in the attempt to save him from the machine guns of the police.

Breton's faith in the wisdom of the insane was unshakable, as both Roussel and Artaud must have understood.

CHAPTER SIX

TEMPTATION ALONE
IS DIVINE

"Temptation alone is divine," Breton explained in one of the major confessions of his life, and since he also believed that the imaginary is what tends to become real, he could be judged an unreliable candidate for admission to the Communist Party. He might rage as violently as any card-carrying member against the French army's attempt to throttle the Riff revolt in North Africa, but was impatiently awaiting the day the Communists would recognize the peculiar contribution he had to offer. Lenin could point to the future. So could Lautréamont.

In the brief period in 1927 that he considered himself a party member, Breton was ordered to write up the working conditions of the Italian gas industry, an assignment he considered intolerable. He was also asked by Henri Barbusse, who enjoyed the confidence of the leaders of the party, to write a few short stories for *L'humanité,* the party organ. "I have never written short stories," he protested, "having no time to waste, nor any desire to make other people waste their time." He had no use for Barbusse: the creator of the famous antiwar novel *Le feu* was guilty of praising Cocteau and Claudel, both of them

authors of nauseating patriotic poems. *L'humanité* itself ignored all ideas. It was "far from the inflammatory newspaper that we'd like to hold in our hands."

La révolution surréaliste, which he published from 1925 to 1929, was of course a model. "Everything remains to be accomplished," he announced. "Any means should be used to discredit the ideas of the family, the fatherland, and religion . . . Those who keep our faith are looking forward to the desolation of the bourgeois public, so ignobly ready to pardon youthful errors . . . An unwavering faith in the commitments of surrealism means that you are indifferent to risk . . . besides, it is too late for the germ not to spread everywhere throughout humanity, just like fear and crabgrass which must win out in the end."

One woman he enthroned in the pages of his magazine was Germaine Berton, the anarchist who assassinated an employee of the royalist journal *L'action française.* Her deed may have inspired Breton and Aragon to celebrate in 1928 the anniversary of the discovery of hysteria by Dr. Jean-Martin Charcot. A new definition was called for. "This mental state," the argument ran, "is based on the need for reciprocal seduction, which may account for the miracles so hastily advertised. Hysteria is not a pathological phenomenon and may be considered from every aspect the supreme means of self-expression."

Hysteria was only one of the many problems that caught the attention of the editors. They rushed to the defense of Charlie Chaplin when he was embarrassed by the allegations of one of his wives. They were also, in later years, devoted to the predicament of the Papin sisters who, after being placed in a convent at Le Mans, were transferred to the custody of a bourgeois household where they were under the strictest supervision. They responded by massacring their guardians, tearing out their eyes and smashing their skulls. They then washed themselves carefully and went sound asleep. "They

were armed with one of the *Songs of Maldoror*," reported the surrealists. But their favorite heroine was Violette Nozières. The eighteen-year-old daughter of a locomotive engineer privileged to drive the trains on which rode the presidents of France, she was obliged to commit incest with her father, and poisoned him.

In a poem in her honor Breton remembered that her father was a prudent man, and not just because his savings amounted to 165,000 francs. Her first name was the psychoanalytical key to his program. "After all, the books on his bedside table have only the value of an illustration." Éluard was more eloquent. "Violette," he pleaded, "was dreaming of milk baths, of beautiful dresses of fresh bread, of beautiful dresses of fresh blood. There will come a time when there will be no more fathers in the gardens of childhood. There will be new, unknown men, ever unknown men, for whom one is always quite fresh and the very first . . . Men for whom one is no one's daughter . . . Violette dreamed of unraveling . . . she did unravel the hideous serpent's nest of blood ties." Although put away, Violette was eventually released, and no doubt to the surrealists' consternation, sought refuge in religion.

As for Breton, he was constantly seeking consolation in the most marvelous encounters. Clairvoyants he worshiped, and the hymn he wrote to them in 1929 did not forget the young girls, beautiful as dawn, whose knees were injured in the hiding place to which they were lured by the ignoble white bumblebee. His heart went out to the mediums obliged to keep their appointments on the third floors of disreputable tenements. "Don't abandon us," he cried. "We'll recognize you in the crowd with your hair let down. Give us some stones, some precious stones, so that we can chase away the infamous priests. We no longer see the world the way it is. We are absent."

Breton planned—only lack of money held him back—to

rent a thirty-room house near Paris, whose dark halls he dreamed of making darker. There he would set up a pension for three young girls, the last people you would expect to find in a scandalous or haunted house. They were to be told they were "at home." Beautiful mediums were hired to keep them company. Every room would have a great black clock that struck midnight at the precise hour. Then there would be the reception room equipped with two Merovingian chairs. The act of love would be forbidden. The penalty would be exile to the park outside.

The act of love was of course never far from Breton's thoughts, although he did pause in 1924 to fancy that he was in the hall of a fourteenth-century castle with a muffled lantern in his hand, lighting up the glistening suits of armor around him. "You shouldn't believe that I was an evil-doer," he claimed. "One of these suits of armor was almost my size. If only I could put it on and begin to recover the state of mind of a fourteenth-century man." Back in his own century Breton was positive that a charming woman, if advised of his qualifications, would have been glad to share with him what he had to offer. He was truly sorry that he could not place an advertisement in some ideal newspaper. He did relax in the company of Valentine Hugo, married to Hugo's grandson, and also with Suzanne Mussar, who stayed close to the writer Emmanuel Berl. His marriage to Simone Kahn had come to an end in 1929. It was fortunate that he happened one evening on Jacqueline Lamba, an art student earning her living diving into the pool of Le Colisée, a Montmartre nightclub. When a waiter called out "Ici l'on dîne dans le café," Breton was transfixed. What was this but a reference to the legendary Ondine, a character of whom he was quite fond. It also reminded him somehow of "Le tournesol," (or "The Sunflower"), a poem he had written in the spring of 1923. Could Jacqueline be the reincarnation of the woman crossing the Halles at summer's end, bearing in her

handbag the smelling salts which only God's godmother had sniffed? In his anxiety Breton decided that Éluard alone could properly introduce him: Éluard's mother had not only a motor car but also a chauffeur. In the summer of 1934 Breton and Jacqueline were married, and a series of adventures was initiated.

Breton was a great admirer of "Mein Feld ist die Welt," the slogan coined by the ambitious Albert Ballin of the Hamburg-America Line. But one of his own catchwords was revealing. "Irrespective of what happens or doesn't happen, expecting in itself is magnificent," he wrote in *L'amour fou*, the journal of his travels with Jacqueline. "I shall reinvent you," he said of his wife, "for poetry and life must be perpetually recreated for me." They wandered to the Canary Islands, while he murmured that he loved her by Bluebeard's beard and the diamonds in the island air. "I shall," he promised, "join you in the fascinating and fatal bloom of the datura flower." Later they explored the Breton coast, venturing to the desolate seaside resort of Le Pouldu, famous as the site where a breeder of silver foxes murdered his wife.

To the pages of *L'amour fou* Breton also confided one of the great joys of his life, the birth in 1936 of their child Aube. "Dear Chipmunk of Munkhazel," he began a letter to Aube, then eight months old, in the hope she might read it when sixteen. He detested as much as ever, he admitted, the unholy trinity of the family, the fatherland, and religion. "But you caught me by the thread which is happiness, such as it occurs as unhappiness is running its course. You were given to us as a possibility, as a certainty, at the very moment when, in the total confidence of love, a man and a woman wanted you . . . My wish for you is to be madly loved," he ended this prose poem.

Despite the coming of Aube, this decade brought no peace to Breton. His anxieties were manifest in the *Second Surrealist Manifesto* of 1930, in which he displayed his contempt for

Desnos, Masson, Soupault, and Tzara, all of whom he accused of lack of faith. He would not abandon his own faith in the Communist ideals, no matter if the official line of the party was an abomination.

"I proclaim," he announced, "the complete shutting off of all light on surrealism. The approval of the public must be shunned at all cost. The public must be refused entrance if we wish to avoid confusion. I add that we must keep it exasperated at our door by a system of defiance and provocations."

At this time a cloud, according to Breton, had come over the reputation of Baudelaire. The news had come out that he prayed for the soul of his mother and that of Poe. In Breton's eyes, Poe was the inventor of that abject department of literature we know as the detective story. Lautréamont alone remained undefiled, even if certain infamous denizens of Montmartre had named a night club after Maldoror.

One joyful discovery in these years was the work of the fourteenth-century alchemist Nicolas Flamel, who was reported alive in Paris in 1761 and again in 1819. Flamel had spoken of a king brandishing a cutlass and ordering his soldiers to kill in his presence a multitude of children whose mothers wept at the feet of the pitiless officials. The blood of the children was then poured into a vast vessel where the sun and the moon came to bathe. This, said Breton, was the perfect surrealist picture.

One ally to turn up at the end of 1929 was René Char, who collaborated with Breton and Éluard on *Ralentir travaux* (or *Slow Down: Men at Work*), a slender book of poems in which the newcomer displayed no extravagant talent. In fact, in the definitive edition of this work, the better lines are assigned to the veterans. Eventually, in 1934, Char was to move away from the surrealist orbit. Long ago he had discovered that Victor Hugo was at best an obese if majestic figure. Quite possibly the exuberance of Hugo was a frightening phenomenon. In his

finer moments Char was the careful contriver of aphorisms like "History adores moderation, which is why history is confusing rather than annoying." "Nothing banal ever occurred between us," he wrote Breton in 1947, recalling his lasting gratitude for a moment that did not admit of any farewell.

Closer by far to Breton was Benjamin Péret, an exhibitionist after his own heart. Joining *La révolution surréaliste* in 1924, he earned his living for a while correcting proof for *L'humanité,* but was soon a Trotskyite. In 1931 he was expelled from Brazil for his subversive behavior. Five years later he was fighting on the anarchist side in Spain. By 1940 he was sent to prison for organizing a Trotskyite cell in the French army. Escaping to Mexico after the fall of France, he translated one of the sacred books of the Mayas and discovered the alarming Catalan surrealist painter Remedios Varo, a woman who chose to remain in Mexico after Péret's return to Paris in 1948.

At the side of Breton and Éluard, Péret was delighted to sign a manifesto of 1931 hailing the burning of the churches of Spain. Only then, ran the argument, could the masses raise the funds to transform a merely bourgeois uprising into a genuine proletarian revolution. "A church left standing and a priest in charge"—these were serious threats for the future. Although Breton discovered that cooperation with the para-Communist editors of *Clarté* led to nothing, he hoped against hope that his variety of communism would triumph. In 1930 *La révolution surréaliste* was renamed *Le surréalisme au service de la révolution,* which lasted until 1933.

The anarchistic temperament of Péret, so completely revealed in his biography, had been captured in 1929 by Georges Sadoul, who could not resist insulting a certain Keller, just granted first place in the competition for admission to the military academy of Saint-Cyr. "If we are obliged to go to war," Sadoul informed the successful candidate, "at least

we shall fight under the pointed helmet of the Germans . . . With that cowardice so typical of Boches and Communists, we shall drive into your skin the dozen bullets you have been saving for the people whose decency is an insult to your filth—the deserters, the spies, the defeatists, the mutineers, and the Communists." This was not all. Sadoul and his friend Caupenne ordered Keller to hand in his resignation at once, submitting at the same time their letter to the authorities. If Keller failed to comply, he would be beaten up on the square of Saint-Cyr. The authorities were far from pleased, and Caupenne felt obliged to apologize. As for Sadoul, he was sentenced to three months in prison and fined 100 francs.

All this may have been exciting, but not so exciting that Breton forgot for a second that he was a poet. At one moment he might be doing his best to defend the reputation of Rimbaud's friend Germain Nouveau, infinitely preferable to the odious Verlaine. Or he might write: "We haven't forgotten that strange attempt at abduction. Look! There is a star, even though it is broad daylight. That fourteen-year-old girl, four years older than her fingers, who was taking the elevator to her parents' apartment. I can see her breasts as though she were naked. You might say they were handkerchiefs drying on a rosebush." Or he might remember that "your hands are tentatively searching for the dark needle to ward off the catastrophe. You can see the women you have loved. You can see them without their seeing you. Behind you the black wolves are passing one by one. Who are you?"

All such visions were driven out of his mind by the discovery that Louis Aragon's loyalty was not to surrealism but to the French Communist Party. He had always had his doubts about Aragon. "The only danger he runs is his overwhelming desire to please everyone," he believed, adding that "he always knew which way the wind was blowing. You no sooner make

up your mind to climb a hill than he is on top." So far as we know, Breton made no comment on *Le con d'Irène,* the dreary pornographic tale that Aragon never acknowledged but did offer to Nancy Cunard, the wild daughter of Sir Bache Cunard of the Cunard Line. He was infatuated with her. Nancy, who did not believe it was her duty to increase the human race, had her uterus removed to avert this danger, and as a rule confined her sexual escapades to blacks and homosexuals. But she did carry on an affair with Aragon while getting drunk as often as possible. Aragon seems to have taken her quite seriously, so seriously that when a check for the sale of a Braque he owned failed to reach him one day in Venice, he tried to commit suicide. Later on, when Nancy was on her deathbed in an insane asylum, he did not show up to say good-bye.

Aragon's passion was spent on Elsa Kagan, the daughter of a Jewish lawyer in Moscow. Her sister won her own reputation as the mistress of the poet Mayakovski. Elsa herself, so she claimed, was never a member of the Communist Party, but she did dedicate her life on earth to turning Aragon into a faithful Stalinist. Her first husband was André Triolet, a French observer on the Russian front in the First World War, with whom she made a pilgrimage to Tahiti. She was free of Triolet on November 6, 1928, when she met Aragon at La Coupole, a bar that Mayakovski haunted. Aragon would recall his first impression of Elsa, "Je te l'ai dit, Madame pour la seule fois de ma vie . . . Je te l'ai dit, Madame et Tu le même soir." For some reason Aragon and his Elsa were not married until February 12, 1939.

Although Breton seems to have suspected from the beginning that Elsa was a spy in the hire of the Russian government, he did nothing to prevent the departure of Aragon and Elsa in the fall of 1930 for a writers' conference to be held at Kharkov. Aragon had given the impression that he would defend Breton's point of view at the meeting. He and Georges Sadoul

revealed, however, that they were playing another game. "As members of the party," they confessed, "we realize that we should have brought about the effective control of our literary activity by the party and to submit this activity to this control. This mistake is at the very center of all the faults we committed . . . It is to be hoped that a close connection with the International Union of Revolutionary Writers and submission to the directives of this organization will allow us to avoid this confusion from this time onward." Aragon was also censured for attacking Barbusse. And Sadoul was rebuked for joking with Keller. Henceforth Sadoul should spend his time unmasking French militarism and imperialism. They noticed that Breton was going in the other direction from dialectical materialism by his interest in the idealism of Freud. Trotsky was also having an unfortunate influence: "We consider," this manifesto went on, "Trotskyism as a social-democratic and counterrevolutionary ideology. We promise to fight Trotskyism on every occasion. Our only desire is to work in the most efficient way carrying out the directives of the party, to whose discipline and control we promise to submit out literary activity."

The most violent reaction against Aragon came from Éluard, who issued a certificate on his own. "I have known Louis Aragon for fourteen years," he began.

For a long time I have had complete confidence in him. My esteem and my friendship for him have made me close my eyes on what I took to be faults in his character. When he went into "society," I thought that he had a lighter touch than I, and was more independent; when he tried to temporize with our will to exhibit our anger in public, I attributed that attitude to a critical point of view that was excessive: the language he was using seemed a trifle puerile, a trifle inoffensive; as for his mistakes, I still believed he was intelligent enough, courageous enough, and honest enough to make amends. I loved him, I esteemed him, I defended him.

A year ago he came back from Russia, having signed a text recanting his surrealist activity, and especially André Breton's *Second Surrealist Manifesto*.

When told that it seemed indispensable for him to publish this disavowal, Aragon, ashamed or pretending to be ashamed, threatened to kill himself. It was then that I lost touch with Aragon. Such a threat made me doubt he had the conscience of a revolutionary, for no revolutionary could live with such a compromise. I was worried. I was demoralized. I grew sceptical, aware of his bad conscience and his increasingly sentimental blackmail. I kept waiting for the leap he could not avoid making into the definitive night. Drawing all his strength from his denials one after the other, but putting off forever the day he would have nothing left to deny, the day when his unscrupulous ambition could no longer feed on denials, I put up with all the self-serving concessions that he was willing to make to the essence of our activity. I saw him three months ago, making use of threatrical gestures, break into tears . . .

When we proposed offering him his freedom of action, he proved to us that he would lose every reason to act. Suddenly, a victim of the fear that possessed him that we might show up the double game he was playing, he threw off his mask. He dared to ask us, he, the author of three books published under our auspices, to forbid, on the pretext that people with evil intentions claimed he was a pornographer, the collaboration of Salvador Dalí with our publications. We were stupefied. He understood that he must give up the hope of ruining surrealist activity. He seized the very first pretext to denounce us, at the very moment that Breton was studying the reaction to the protest we raised over his indictment for a poem he had written. He did not hesitate to accuse us of being counterrevolutionaries.

It is true that Dalí made no secret of his admiration for the Marquis de Sade in a reverie he published in *Le surréalisme au service de la révolution.* It is also true that while in Russia Aragon released "Le front rouge," a poem that pleased neither Breton nor the devout Stalinists. This hymn to Soviet Russia, translated for American readers by E. E. Cummings, was so violent that Romain Rolland grew alarmed. Here was a summons to murder Léon Blum and other leaders of the Social Democratic Party. "You are waiting, your finger is on the trigger," cried Aragon, "for the hour when I'm no longer the man who screams *Shoot,* but Lenin, the Lenin of the right moment."

While Aragon received almost all the publicity he could have craved for "Le front rouge," the poem did not turn out to be the inconvenience one could have imagined. He was given a five-year sentence for inciting soldiers to mutiny and for provoking murder. But the sentence was suspended. Which left him the time to contemplate Breton on this subject. Breton was quite unwilling to censor Aragon's rhetoric. What he could not forgive was the poetic aspect. It was, he considered, merely a poem of circumstance.

As for Éluard, he was disgusted by Aragon's conduct in Russia. Aragon had done nothing to protest the election of Barbusse to the presidency of the congress. He had also agreed that the surrealists should withdraw their support of Freud and Trotsky. When it came to the last paragraph of his certificate, Éluard was furious. "His incoherence is a matter of calculation," he made plain. "His cleverness is no better than plotting. Aragon has become someone else." Eliminating him forever, so he thought, he quoted a line from Lautréamont that cancelled the account: "With all the water of the sea, you can never wash away an intellectual bloodstain."

It seems likely there were moments when Aragon realized what he had done by submitting to the Stalinist commands of Elsa. "I have never done anything in my life that was so painful," he complained. "Breaking up with the friend of all my youth wasn't unbearable simply for several days. I wounded myself and the wound was never healed."

Meanwhile Breton was defending the Communist line that should have been. "The rupture," he reported, "came about from the impossibility of surrealism to keep its confidence in a man who for purely opportunistic reasons could be forced, from one day to the next, to condemn, when so ordered, all of his past activity and who showed himself from that day forward incapable of justifying his about-face in the slightest degree."

This could have hurt Aragon's feelings. He had once said of Breton that he is much more "than the writer whom you admire . . . he is a crucible burning with a fire that cannot be extinguished. Perhaps that is his essential function in our time. He carries everything off thanks to his magnificent and exceptional gifts. We alone can bring about the fission of the poems that we all bring to him. He is the man who brings about dazzling changes. You must pay no attention to his quirks or his apparent contradictions. You must be surprised by the charm which even his weaknesses and faults of character allow us to observe."

But Breton's charm did not appeal to Paul Vaillant-Couturier, the Stalinist founder of the Association of Revolutionary Artists and Writers. Vaillant was horrified to come across in the pages of *Le surréalisme au service de la révolution* a scathing article by Professor Ferdinand Alquié exposing the insipid morality of the latest Soviet movies. The day was coming when Breton's voice could not be tolerated by the Communist hierarchy. One consolation remained: the influence he possessed over *Minotaure,* the luxurious magazine launched by Albert Skira. And Breton could still publish what he pleased—in non-Communist places. In 1930 he joined Éluard in bringing out *L'immaculée conception.* Faithful to Freud and automatic writing, they shrewdly explored the anguish of the mentally disturbed. Next year came *L'union libre,* Breton's celebration of a woman with the waist of an otter caught by tiger's teeth and with shoulders of champagne. In 1934 *L'air de l'eau* was placed on sale: here was the Marquis de Sade returning to an erupting volcano, while never ceasing to issue the mysterious orders that open a breach in the moral night. So Breton could love like the first man loving the first woman—in absolute freedom like the freedom in which fire was made man.

For Aragon these poems were insults, and he declared

Breton was no better than a counterrevolutionary. The ugly climax in his relations with his former friend could not be postponed for long, especially since Breton had got himself invited in the spring of 1935 to address a meeting of the supremely Stalinist Writers' Conference for the Defense of Culture. A public humiliation of Breton was now in order, and Aragon was counting on the presence in Paris of the Stalinist Ilya Ehrenburg to raise Breton's blood pressure. Ehrenburg was notorious for denouncing surrealism as a homosexual conspiracy. Sighting him on the street, Breton immediately administered what the French recognize as a correction. So every Stalinist was ready. When the time came for Breton to speak, he was denied the floor, and his address was delivered by Éluard, under the most awkward circumstances. As for René Crevel, one of the rare surrealists with homosexual leanings, he was crushed. He went home to commit suicide.

Although Gradiva, a surrealist art gallery named after Freud's heroine, was launched in 1937, these were difficult days for Breton. In 1938 he set off for Mexico to give a series of lectures under the sponsorship of the Quai d'Orsay. Such was the ostensible reason for the trip. The real reason was the chance to meet Trotsky, then living close by the painter Diego Rivera. "I need," Breton wrote Trotsky, "a long process of adjustment to persuade myself that you are not beyond my reach." This sort of talk made Trotsky a trifle uneasy. "Your eulogies seem to me so exaggerated about the future of our relationship," he complained. He was also dismayed by the strain of mysticism that he detected in his new admirer. This did not stop him from collaborating on a manifesto for an Independent Revolutionary Art, ultimately signed by only Breton and Rivera. As you might imagine, no distinction was drawn between Nazi Germany and Soviet Russia. It was understood that Marxists and anarchists would march side by side to protest against all police states.

All very well. But there is nothing to indicate that Breton shared the passion of Dr. Wilhelm Valentiner of the Detroit Institute of Arts for Rivera the artist. Valentiner was spellbound by the murals in the museum advertising the Ford factory, claiming that they would rank with Michelangelo's work at the Vatican. Apparently Breton and Rivera were far from close friends. Of the time he spent in Paris, Rivera remarked, "I hate the town and everything it stands for."

However, Breton was fascinated by the paintings of Rivera's wife, Frida Kahlo. To his joy and surprise her canvases were so many bright flowers of surrealism. "We are allowed," he wrote, "as in the beautiful days of German romanticism, to witness the entrance of a young woman provided with all the gifts of seduction and who is used to moving close to men of genius." One of her portraits he saw hanging in Trotsky's studio. "You see me alive but I am dead," she inscribed one of her self-portraits. "Those who loved me have perished in great grief. This rose is my emblem." All these things led Breton to declare that "the painting of Frida Kahlo de Rivera is a ribbon tied around a bomb."

Breton did not attempt to describe the venom with which she so often confronted her admirers. He also ignored the morbidity with which she greeted all of her catastrophes. She fell victim to polio when she was six. When she was nineteen, the bus in which she was riding to school was demolished by a trolley car, smashing her pelvis, her spine, and her foot. And she memorized all of her troubles, her many operations, and her many abortions before she seized her brush. Praise from Breton meant nothing to her. He did his best to arrange an exhibit in Paris, in addition to writing an essay on her work for a show at the Julien Levy Gallery in New York. But he remained in her eyes merely a surrealist, "one of the coocoo lunatic sons of bitches." She was never known for her gratitude, and her great amusement in Detroit was insulting the

society matrons to whom she was introduced by Dr. Valentiner.

Breton and his Jacqueline left Mexico two years before the murder of Trotsky. Those were tense days for Breton. He was to lose the friendship of Éluard, who became the devoted disciple of Aragon. "Of all the poets I have known," said Éluard in November 1949, "Aragon has been the one who has been right most of the time, right about the monsters and right about me.

"He showed me the right path; he is still showing it today to all those who haven't understood that fighting against injustice is the same as fighting for your own life."

THE TRAVELS OF
PAUL ÉLUARD

"We are necessary," Paul Éluard proclaimed in 1939. This protest, issued after he and Breton had gone their separate ways, hints at a defiance that is difficult to reconcile with the portrait that Breton finally sketched of his longtime ally. "Éluard," Breton admitted, "was the only surrealist to be unanimously praised by the critics. The few outbreaks of violence for which he was recognized were not held against him personally, but attributed to contagion and set down against the account of his friends. The critics wished to emphasize merely his verses, which were free from the aggressive spirit of most surrealist poems and so were judged only by aesthetic standards. From this point of view, surrealism held him back, limited his freedom of action."

A more sympathetic observer might have recalled that he was shattered by tuberculosis when sixteen and never quite recovered. Breton might also have taken the time to mention his skill in providing gentle questions to the usual answers.

His questions did him no damage with his father and mother, neither of whom could be accused of opposing his career. His mother was ready with the money for the rare

editions in his library, and also for the paintings he was eagerly collecting. As for the father, he was to name the streets in the subdivisions he was planning after the gods in the surrealist mythology: Baudelaire, Lautréamont, and Rimbaud were remembered. So were Apollinaire, Nerval, and Vaché.

As the family moved from Saint-Denis to Aulnay-sous-Bois and then to Paris in 1908, he became their indulged child. In the summer of 1911, when not yet sixteen, he was sent to England for two months, where he picked up enough knowl-edge of the language to make his way in later days through Donne and Swinburne. The family frequently spent the summer in Switzerland where, one day in 1912, while chasing eagles with his camera, he came back exhausted to lunch. He developed a hemorrhage, harbinger of the tuberculosis that shipped him to the sanatorium at Clavadel where, as you have been told, he met Gala, the Russian he was to marry in 1917 and who bore him in 1918 their daughter Cécile.

Did this marriage trouble his mother? There is a hint of this in a poem of 1913. "Here's my mother and my fiancée," it ran. "They are passing by in each other's arms. The young one has slapped me. The old one has spanked me. I swear that both of them loved me. And it's not their fault that I was constantly seeking more happiness." These were the days when his father, who raised no objections to Paul's anarchistic friends, listened with more than sympathy to his complaints during the war. "We have learned divine patience," Éluard claimed, "patience in the face of evil and grief. After this, men will have more faith and confidence in the truth. And we shall be the pure ones, the veterans of the peace."

Mobilized in December 1914, Éluard was to spend most of the war in hospitals, either as a patient or as a military nurse. His heart, however, was in serving at the front. He got his wish, but after three months was incapacitated with acute bronchitis and was never again to figure in the front lines.

Incidentally, his taste in the war years was hardly surrealist. He was entertained by Maupassant and even tried Claudel.

He came alive, however, in 1921 when he ran across Max Ernst in Cologne. In the next year Ernst—minus a passport—followed him to Paris and by 1923 was living out at Eaubonne in the suburbs with Éluard, Gala, and their daughter Cécile. Gala and Max drew very close, so close that their friendship was ominous. While Max was covering the walls of the house with his paintings, this may not have been all that was on his mind. "Agile incest in a corner was turning around the virginity of a small dress," Éluard reported in a poem dedicated to Ernst.

"I've had enough," Éluard suddenly announced to his father on March 24, 1924. "I'm going on a trip. I'm leaving you all the business you put in my hands. But I'm taking with me the money I have on my person, about 17,000 francs. Don't put the police on my trail or call in any detectives. The first person to lay a hand on me I'll take care of, and that would be too bad for the honor of your name."

Obviously upset by the attentions Max was paying Gala, Éluard ran around the world to the South Seas and not even Breton could guess what had happened, even though Éluard dedicated to him his latest book, *Mourir de ne pas mourir*. "What has become of the silence surrounding him and that pair of silk stockings that was his chaste obsession?" asked Breton in *The Soluble Fish*. It is certain that Éluard was much too much alone as he headed toward Tahiti. He wired Max and Gala that they must meet him in Singapore. They accepted and the three of them returned to Marseilles on a Dutch freighter.

In the spring of 1927, while Gala was away in Leningrad, Éluard ran into new difficulties with Ernst. "I had a fight last night with that swine Max Ernst," he wrote to Gala. "He gave me a nasty blow on my eye. Just think—my best friend has

disfigured me." And in June he wrote Gala: "Don't write Max. We're through."

While the storm over Ernst was beginning to relent, Éluard confessed to Gala that "you have dictated all my poems. I dream of you every night." Off to Berlin on a trip of his own snatching primitive objects for his collection, he was making love to Frau Apfel (or La Pomme), a lesbian invariably accompanied by her friend Mops. This was not too satisfactory. "Enjoy your liberty," he commanded Gala. "You must always take advantage of your freedom."

His own freedom could be both alarming and charming, as when he recalled in *The Underside of Life* the girl with the black apron on the bench ahead of him at school. "I am always dreaming of a virgin," he kept repeating. "All virgins are different." This school girl, with her innocent eyes, turning around to ask the answer to a problem, was so confused that she cast her arms around his neck. "Always the same confession, the same pure eyes, the same caress, but never the same woman." Éluard could so easily capture the heights where "the dawn of their breasts rises to undress night."

His anger he saved for Christmas. "I hate Noël, the worst of all holidays, which tries to persuade mankind that there is something better on earth, with all that foul talk about divine children. The music of the bells is filthy, good for the necks of cows . . . I hate all holidays because they have obliged me to smile without conviction, to laugh like a monkey, and to believe that the joy of those I love is possible . . . Happiness is a surprise."

No one should be surprised that Éluard told his son-in-law that "you and I will never grow up." The bosses of the French Communist Party might have agreed. For long after his first brush with the party he found Marx unreadable.

He was his troubling self in 1932, after a winter in a tuberculosis sanatorium:

Of all I've said, what remains
I've saved fake treasures in empty cupboards,
A useless ship joins my childhood to my boredom
My games to my fatigue . . .
They no longer know me
My name, my shadow, are wolves.

Since the summer of 1929 he was reduced to sharing his
Gala with Salvador Dalí. The Éluards had come across him in
Paris, and once they promised to visit him in Cadaqués, the
promise was kept. It did not take long for her to worship Dalí,
even though he first appeared with goat dung smeared under
his armpits. "I want you to croak me," cried Gala to Dalí. This
event did not occur, but Paul and Gala were overcome by the
phenomenon they recognized as "the thinking machine." "My
little boy, we shall never leave each other," Gala decided. "I
accept Dalí as he is," Paul told Gala. "I couldn't wish that any
change should come over him." And by the winter of 1933,
Paul was positive that "I have only esteem, admiration, and
affection for him." Without Dalí and Breton, surrealism
would die. At the same time Paul could never forget his Gala.
"You must know," he confessed in the fall of 1933, "that if you
vanished, that would be the end of my life."

No one could take the place of Gala, but in December 1929,
while walking with René Char past the Galeries Lafayette, he
happened on Maria Bentz, an Alsatian girl of twenty-three
whose melancholy life endowed her with a marvelous charm.
At thirteen she was begging for bowls of soup from the French
barracks. And the day came when she tried her hand as a
performer with a traveling circus. She had been gazing
profoundly at a Miró painting in a shop window when Éluard
and Char discovered her. She was frightened and ran off, but
Char rescued her and the three of them vanished into a taxi.
Her tragedy was imperative. So was her compassion. On

August 21, 1934, Paul made her his bride. She would be painted again and again by Picasso.

Paul was still the captive of Gala when he and Nusch, as he called her, became man and wife. "The fact that I'm being married plunges me into the abyss of melancholy," he admitted to Gala. The wedding of Gala and Dalí on January 30, 1934, did not mean that Paul was losing his interest in her husband. But Dalí's new-found fascination with Hitler as a figure in the surrealist mythology was painful to Paul. "I can't pass over the almost insurmountable difficulties which Dalí's paranoia with Hitler will bring upon us," he explained to Gala. "Dalí must find some other subject for his delirium. All of us have too much in common for us to break up. And praising Hitler, even from Dalí's point of view, cannot be allowed, and will bring about the ruin of surrealism."

The problem, and it was a serious one, was whether Éluard should follow the path of Breton or that of Dalí. "Who are you, André?" Éluard was asking in 1929 in the midst of dedicating *L'amour la poésie*. "The one I can't lose unless I lose myself and my right to think and live?" But Dalí, officially excommunicated on February 4, 1934, remained an idol to Éluard. "So many brief dawns, so many maniacal gestures." Which placed him on the same level as Man Ray, incarnate "in the storm of falling dress." Or Max Ernst, "devoured by feathers and submitted to the sea."

Apparently the question of Dalí did not arise when Breton and Éluard set off for Prague to fan the flames of surrealism in the spring of 1935. The situation grew more complicated the following year when Éluard, close to the English collectors Sir Roland Penrose and Edward James, opened the great surrealist exposition that Penrose organized. Dalí could not be overlooked: his *Rainy Taxi* was on view when Éluard reviewed "The Surrealist Evidence." "There is no model," Éluard explained, "for the man searching for what no man has

ever seen. We are all on the same plane. The loneliness of poets has been erased: here they are, men among men, and now they have brothers."

Brotherhood vanished from the agenda, however, the moment Breton and Éluard came face to face in Paris in April 1936. "I have definitely broken with Breton after a relatively calm discussion in a café," Éluard wrote Gala. "My decision was brought about by his dreadful way of discussing things in front of other people. It's all over. I shan't join in any activity with him. I've had enough." By November Éluard was edging his way to the Communist Party, releasing a poem on the Spanish Civil War to *L'humanité*. "This," said Éluard to Gala, "is the first time one of my poems has had a printing of 450,000 copies. I have an idea of what Breton will think about this." "I gave my adhesion to the Communist Party in the spring of 1942," Éluard admitted. "And because it was the true party of France, I signed up forever with all my strength and my life. I wanted to be with the men of my country who were marching ahead toward liberty, peace, and happiness, which is what life is all about."

Liberty may not be the most reassuring Communist slogan, but Éluard's poem with that title became a rallying point for the French Resistance. "On my school notebooks, on my desk, and on the trees, on the sand and on the snow, I am writing your name," the poem began.

Mobilized with the declaration of war in 1939, Éluard served as a lieutenant in the quartermaster's corps until the French surrender. He was to refuse the Legion of Honor, possibly because his devotion to the Communist cause left him so little leisure. According to Aragon, Éluard's Communist poems were his greatest achievement. One sample that may be submitted in evidence is the poem he published to celebrate Stalin's seventieth birthday.

"Thanks to him we may live without ever experiencing

autumn," Éluard declared. "The horizon of Stalin is constantly being reborn. For us there is no day without a tomorrow, no dawn without a noon . . . Life itself and mankind have chosen Stalin to represent on earth their limitless hopes." This was only one of the many eulogies of Communist leaders that Éluard published with Aragon at his side. The two had become fast friends in 1943, although Éluard never succeeded in admiring the work of Aragon's Elsa Triolet. "Her writing is really very bad," Éluard admitted. "I really prefer the work of Simone de Beauvoir." But this did not prevent the two men from being active in the National Committee of Writers. Éluard would use the pseudonyms Jean du Haut and Maurice Hervent to ward off interference from the Vichy régime.

Éluard was to lose his Nusch by the end of 1946, but this did not stop him from speaking to Communist audiences across Europe. In 1948 he turned up at the Congress of Breslau in Poland. In the summer of 1949, he went to Mexico City as the French representative of the World Congress of Peace. There he met Dominique Lemor, whom he chose as his third wife in 1951.

Like many Communists, Éluard denied he owed anything to the English who fought against Hitler. In Greece in the spring of 1949, he was giving speeches to honor those opposing the monarcho-fascist invaders. Éluard was now rising to almost any opportunity. In 1950, as a delegate to the France-USSR association, he visited both Moscow and Leningrad. Then, in 1952, he participated in the ceremonies for the 150th anniversary of Hugo's death, and the centenary of Gogol's passing.

In Éluard's eyes, Moscow had become the prestigious world capital of hope, and he belabored this point in both of his addresses on the subject of Victor Hugo. By this time he was such a faithful Stalinist that he had moved far away from the influence of Breton. But Breton, on June 13, 1950, could not

help reminding Éluard of the glorious reception the two had received in 1935 from the Prague surrealist group. The painter Toyen was on hand, as was her husband Jindrich Styrsky and their friend Zavis Kalandra. Kalandra, expelled from the Czech Communist Party in 1938 for complaining about the Moscow trials, had joined the Fourth International of Trotsky and in 1939 was sentenced to a six-year term in concentration camps. Now the Stalinists in Prague had decreed his death. How could he possibly have betrayed the resistance, Breton was asking. Yet Éluard refused to raise his voice in Kalandra's favor. "I am," he wrote, "too busy with innocent people de-defending their innocence"—here he was alluding to the Rosenbergs in the United States—"to bother with guilty people advertising their guilt." "How could you," Breton ended his plea, "have the heart to stand up to such a degrada-tion of mankind in the person of someone who showed he was your friend?"

It is true that Éluard had his moments in his last years. He did write a remarkable poem on *Guernica* with a few lines worthy of Picasso's remarkable painting. And he did protest the revolting custom in France at the war's end of shaving the hair of women who had made love to their German invaders.

The end came to Éluard on November 18, 1952, with a heart attack. He was buried in the Communist section of the Père Lachaise, far from the grave of Nusch; and Aragon, who was in charge of the event, left no doubt that he was a committed Communist. "From now on," Aragon an-nounced, "Éluard will stand for the affirmation of happiness. From now on, forever. And in spite of the snow that has been falling since he died, in spite of our tears and our broken hearts, Éluard will never stop proclaiming that happiness exists."

MONTAGU O'REILLY AND WAYNE ANDREWS

Montagu O'Reilly, the fancier of fabulous pianos, was in real life Wayne Andrews, the sedate social historian and scholar of architecture. Was the closest link between them the fact that both had the elegance of exquisite manners?

"Montagu O'Reilly" sounds like an invented name but apparently it was not. Wayne told me that he came on it one day when he was going through a box of old visiting cards in a London bookshop and that the proprietor identified O'Reilly as an admiral in the King's Navy. Or more likely the Navy of Gilbert and Sullivan?

Wayne became my friend at Harvard. It would have been about 1935. He lived in Dunster House, while I lived in Eliot. The curtains of Wayne's room, of course, were black. With his friend, an undergraduate painter who called himself Lord Melcarth, he did things like renting seventeenth-century costumes and being served a candle-lit dinner in the Dunster House dining room. But Wayne was far from being a simple exquisite. A year earlier he and another friend were the first

This essay also served as the introduction to the Atlas Press (London) edition of *Who Has Been Tampering with These Pianos?* (1988).

to take a black girl to the Freshman Dance in the Union. Harvard being Harvard there was no incident, but it was a turning point. Wayne's life would be a series of modest but meaningful discoveries.

Wayne was born in 1913 in Kenilworth, Illinois, a prosperous suburb of Chicago. (There was a continuing identification with that city whose social annals and anecdotes he researched. In 1946 he would publish *Battle for Chicago,* recounting the extravagant rivalries among Chicago's plutocratic families.) The life of the Andrews was not ostentatious, but there was comfort and ease because Wayne's father did very well in printing machinery and ink. But it was not an entirely conventional household. Wayne's father was a passionate linguist who spoke four languages. Hence, Wayne's interest in French, Italian, Spanish, Portuguese, and later German. Mr. Andrews engaged a French tutor for his son who insisted that the boy model his style on that of Madame de Sévigné. The father was also very musical, which might account for Wayne's mellifluousness in the O'Reilly stories. Andrews Senior was an opera buff. Wayne attended *Die Meistersinger* at the age of four. Seats were always engaged directly behind the conductor so that the score could be followed over his shoulder.

Wayne attended the public schools of Winnetka and was "finished" at Lawrenceville, a leading prep school in New Jersey, before going to Harvard. Wayne's father died when Wayne was in his teens. From the inheritance he was able to spend summers in Paris and other countries of Europe, polishing his languages and getting to know many of the leading surrealists.

Wayne's literary career began at Lawrenceville when he and a francophile classmate, James Douglas Peck, brought out a mimeographed magazine written entirely in French, *La revue de l'élite,* later changed to *Demain.* Wayne never

showed me a copy, but it must have been lively. Brashly, the boys sent it to such eminences as Gide, Valéry, Cocteau, and Lurçat, receiving encouraging acknowledgments from many of them.

The amusing story of Wayne's correspondence with Ezra Pound has been told by Paul Hoover in the magazine *Paideuma.*

Pound's replies to the young editors were characteristic of the spiky Sage of Rapallo:*

Nothing much against the surrealists save that a lot of 'em are French and therefore bone ignorant, like the English. I believe they write, but none of 'em has ever been known to read, and it is highly doubtful if the alphabet is personally known by most of them.

I shall join the movement when they devise a form of assassinogram which will kill at once all bankers, editors and presidents of colleges or universities who approach within 1000 kilometres of its manifestations. . . .

Needless to say, *La revue de l'élite* was suppressed when the boys printed Apollinaire's proto-surrealist poem "Zone," with its Jarry-influenced line about Christ's winning the world's altitude record.

Little is known about Wayne's absorption in pianos. A friend had a baby grand in his rooms on which more jazz than classical tunes was played. I do remember one night when we had been performing with particular vim. Wayne rolled up copies of the *Boston Transcript* with which he incited us to join him in *beating* the apparently offending musical machine. Make of that what you will—but I should add that we had been imbibing a fair amount. In any case, none of the other rites of pianistic lustration described in his stories was ever witnessed by me.

But Wayne and I had more serious fish to fry. We both

*Pounds remarks are quoted more fully in Wayne's own Foreword to *The Surrealist Parade.*

wanted to write for the *Harvard Advocate,* the undergraduate
literary magazine. His first contribution came in 1934, an
excellent brief account of surrealism, a movement which was
then only a name to most Harvard students. In fact, it was not
easy to persuade the review's sedate editors that the article was
"suitable" because Wayne's critical method was rather surreal-
ist in itself:

It is the Surrealists who have saved French poetry from banquets. Very
unpleasant and impolite they are . . . they are such frenzied foes of
the monotonous they would gladly change the color of the sky of
Paris. . . . If a friend of André Breton speaks at all politely to a policeman
when he asks the direction, he is no longer a friend of André Breton.

And the writer whom Wayne wished most to praise was
one of the forerunners of surrealism, the Comte de Lautréa-
mont (Isidore Ducasse) whose *Chants de Maldoror* he found to
be "prose poems of unbearable beauty." He cited particularly
the now famous simile "beautiful as the chance meeting on a
dissection table of a sewing machine and an umbrella."

The surrealists were Wayne's literary family. He came to
know many of them well on his summer visits to Paris. But he
also had more ancient lineages. He loved the Gothic romances
with their liberating emphasis on horror and tainted emotions.
He insisted that I read Horace Walpole's *Castle of Otranto*
(1764), Mrs. Ann Radcliffe's *The Mysteries of Udolpho* (1794),
Matthew Gregory Lewis's gangrenous *The Monk* (1796), and
the Irish novelist Charles R. Maturin's *Melmoth the Wanderer*
(1820), a Faust-like fantasy which was to influence Balzac. I'm
afraid that I bogged down in the multi-volume *Les Mystères de
Paris* (whose author I have forgotten) although Wayne assured
me that "the countess Sarah McGregor [what was she doing in
Paris?] is wonderfully vile."

Inevitably Wayne was attracted to certain stars of the fin-de-
siècle circle of *l'esprit décadent.* He would have been quite at

home in such exotic cenacles as *Les Hydropathes, Les Hirsutes,* or *Les Zutistes.* Verlaine's phrase "une âme capable d'intensives voluptés" might have applied to some aspects of Wayne's sensibility. The *Oxford Companion* describes *l'esprit décadent* thus:

The spirit was one of overwhelming *langueur,* futility, distaste for any moral or religious restraint, a horror of banality, and a seeking after any novelty of sensation . . .

Only a small part of these strictures might have obtained for Wayne, and only for his writing as Montagu O'Reilly. He was a family man of good character and decorum, of impeccable respectability, and a pillar in the academic community of Wayne State University and the Episcopal Church. His only lapse of which I am aware was that he habitually astonished his blue-serge business suits by flaunting outrageous cravats. I speak of the decadents only because they were so clearly an influence on O'Reilly. He reveled in the life of Comte Robert de Montesquiou, that connoisseur of bizarre perceptions, who was a model both for Wilde's Dorian Gray and Proust's Baron de Charlus; in the books of Raymond Roussel (*Locus solus, Impressions d'Afrique*); and those of the pataphysician Alfred Jarry (the *Ubu* cycle and particularly *Le Surmâle*). Of the earlier Victor Hugo he urged me to read only the play *Les Burgraves.*

In mid-life Wayne attacked German literature and culture with the same passion he had devoted to the French. He was especially keen on Nietzsche, Hermann Hesse, Hans Henny Jahnn, and the correspondence between Rilke and Princess Marie Von Thurn und Taxis. He must surely have been one of the few people who read all the novels of Theodor Fontane. His great achievement is the book *Siegfried's Curse,* a brilliant analysis of the elements in the history of German culture which contributed to the Nazi phenomenon.

The first publication of one of Montagu O'Reilly's stories was in Number 23 of Eugene Jolas's famous avant-garde magazine *transition* in 1935. "The Evocative Treason of 449 Golden Doorknobs, Dedicated to the perilous memory of Don Luis de Gongora" gives promise of skills to come but is painfully clumsy.

Doomheavy, the innumerable headless heads of hair, billowing, evoked a Portuguese embassy. They billowed to an eccentric rhythm and the walls of the rococo room began to palpitate like melted soap.

And so on for three pages. What is more amusing is the trilingual Jolas's grandiose presentation of the piece as a "paramyth." The word-struck editor had gone into his last phase of pomposity; in the same number there were "mantic Almagestes," "hypnologues," and "experiences in language mutation."

I suggest the paramyth as the successor to the form known heretofore as the short story or nouvelle. I conceive it as a kind of epic wonder tale giving an organic synthesis of the individual and universal unconscious, the dream, the daydream, the mystic vision. . . . The language of the paramyth will be logomantic, a kind of music, a mirror of the four-dimensional universe.

Somehow Wayne managed to survive this pulverizing introduction. In his next appearance he had suddenly achieved the suavity and controlled style of his mature O'Reilly productions. A now nameless critic has written that, when at top form, Montagu is "notable for a stylistic polish—a verbal finish in which almost every word is so carefully selected for its overtones, and then so adroitly off-balanced in a suggestive cadence that it is rich in secondary meaning for the eye and ear sufficiently subtle to perceive them." "The Romantic Museum" was in the first New Directions anthology of 1936, along with work by Stevens, Stein, Pound, Cocteau, Moore,

Williams, Cummings, Boyle, Bishop, Miller, Zukofsky, and others. Montagu cleared the bar by inches in his first jump.

"Pianos of Sympathy" had the historical distinction of being the first book published by New Directions. (The earlier manifestations had been literary sections in the Social Credit magazine *New Democracy*.) The original "Pianos" was a little 7″ by 4¾″ pamphlet printed in an edition of 300 copies by the Vermont country printer who did the *Harvard Advocate*. But its unusual aroma quickly pervaded Harvard Square, and it was necessary to rush out a second printing.

Remembering Wayne's two distinguished careers, exemplary fantasist and distinguished social historian and scholar of architectural history, I resist the temptation to claim that Professor Andrews and Montagu O'Reilly were two different persons. They were not. I knew them both very well. They were one and the same.

Montagu O'Reilly was not Wayne's only persona. More like a doppelgänger was the financial genius James Wander. I suppose today we would call him a conglomerateur or inside trader in the stock markets. Surely he was a holdover from Wayne's days in banking at "Pourtales & Cie" in Paris.* I never met Wander, but now and then cryptic postcards from him would reach me from abroad as Wayne traveled or there would be news of his operations in letters. The most puzzling of these reports came in a letter of March 1968:

You will be saddened . . . to learn of the death of James Wander on July 14, 1921, in his suite at the Hotel Plaza, Buenos Aires.** At the time of his death he had decided to eschew all American steels (for which we must forgive him) and to rearrange his portfolio to emphasize his faith in Andre

* "Pourtales & Cie" was a Wanderism. After Harvard Wayne actually worked at the Northern Trust Company in Chicago for a year.
** I have been told that as a young man Wayne made a trip to Argentina on behalf of the family business.

Citroën S.A. and the Michelin works. He had already booked passage for Bordeaux on the new *Duc de Choiseul.*

Wayne was Curator of Manuscripts at the New-York Historical Society from 1948 to 1956, living in Brooklyn Heights. From 1956 to 1963 he was an editor in the trade department at Scribner's. Then in 1964 he was appointed Archives of American Art Professor at Wayne State University in Detroit. Archivist of Art? A hobby of photography had developed into a major part of his profession. Wayne went all over the country, and later around Europe, taking magnificent photographs of famous or eccentric old houses. Many of them found their way into books which are definitive in the history of architecture. But his interest in literature always took first place.

Wayne's bibliography is impressive:

The Vanderbilt Legend, Harcourt, 1941.
Battle for Chicago, Harcourt, 1946.
Who Has Been Tampering With These Pianos?
 [Montagu O'Reilly], New Directions, 1948.
Architecture, Ambition and Americans, Harper, 1955.
 (Revised edition, Macmillan, 1978.)
Editor, *Best Short Stories of Edith Wharton,* Scribner's, 1958.
Architecture in America, Atheneum, 1960.
 (Revised edition, 1977.)
Germaine: A Portrait of Madame de Staël, Atheneum, 1963.
Architecture in Michigan, Wayne State, 1967.
 (Revised edtition, 1982.)
Architecture in Chicago and Mid-America, Atheneum, 1967.
 (Now a Harper & Row paperback.)
Architecture in New York, Atheneum, 1968.
Siegfried's Curse: The German Journey from Nietzsche to Hesse,
 Atheneum, 1972.

Architecture in New England, Stephen Greene, 1973.
American Gothic, Random House, 1975.
Pride of the South: A Social History of Southern Architecture,
 Atheneum, 1979.

In 1981 New Directions published Wayne's pungent portrait of Voltaire. It is far from a full biography—only 150 pages—but as the subject himself pointed out, "the surest way of being a bore is to tell everything." What Wayne's very personal interpretation of genius may lack in laundry lists is made up in wit, learning, and an elegance of ironic style appropriate for a man who was never so ruthless as in eliminating the last trace of dust from his writing.

When Wayne died three years ago, he had completed, also for New Directions, nine tenths of his little insider's history of surrealism. Many of the leading figures of the movement were his friends, but he does not spare them in illuminating their achievements with choice examples of their eccentricities and obstinacies. Montagu is very much behind Wayne in these caustic yet admiring sketches.

POSTSCRIPT & BIBLIOGRAPHY

Wayne Andrews undoubtedly intended to provide this delightful history of surrealism with a full bibliography, calling attention to the books that supplemented his personal knowledge of the writers and artists described in these pages. His sudden death prevented this, and while it would be impossible to trace every quotation, direct and indirect, woven into the text, it has not been difficult to reconstruct Andrews's working method or to identify his principal sources. For this purpose, his daughter, Elizabeth W. Andrews, kindly provided New Directions with a list of her father's surrealist library and gave access to his working papers for the book. It seems clear from these materials that Andrews based his research on the collected works of the authors in question, often the current Pléiade edition of the Paris publishing house Gallimard. In addition, he owned a number of original editions and basic secondary literature pertaining to surrealism.

The working papers for *The Surrealist Parade* are arranged in two large alphabetical files, one of them devoted to artists, the other to writers. Under each name is found a range of materials, such as clippings, rough notes and jottings, photo-

copied articles, typed notes, and in a few cases original ephemera. The Breton section of the writers file, for instance, contains some rare broadsides originally issued by the founder of the movement. There are as well sets of reading notes on various books, neatly typed on half-sheets of paper; these undoubtedly served as Andrews's immediate sources of quotations and facts as he composed his chapters.

Since so few English translations appear among these sources, and since Andrews was fluent in French, it can be safely assumed that most of the quotations in *The Surrealist Parade* are his own translations. This is borne out by the way in which the quoted passages flow flawlessly along in Andrews's own conversational style. An exception is Raymond Roussel's *Locus solus,* which Andrews seems to have read in the English translation of Rupert Copeland-Cunningham, probably because the original French text was not easily available. Another exception is the *Secret Life of Salvador Dalí,* which is quoted in the translation of Haakon M. Chevalier, published by the Dial Press in 1942. Andrews read Giorgio de Chirico's memoirs, originally published in Italian, in the 1971 English translation of Margaret Crosland.

Andrews's files for *The Surrealist Parade* also include clean typescripts for all except the last chapter on Éluard, which exists in his own original typescript, a document that exudes the excitement and heat of composition, but which also makes it quite clear that the other chapters were copied by a typist, then proofed and corrected by the author.

The appended bibliography is basically a list of the books for which sets of typed notes were found in Andrews's files. A few of these sources served to structure sections of Andrews's narrative, among them Dalí's *Secret Life,* Éluard's letters to Gala, and Breton's famous *Le surréalisme et la peinture.*

<div align="right">THE EDITORS</div>

ARAGON, LOUIS. *Aragon. Présentation, choix de textes par Georges Sadoul.* Paris: Seghers, 1967.

———. *L'œuvre poétique.* Paris: Livre club Diderot, 1974.

ARBAN, DOMINIQUE. *Aragon parle.* Paris: Seghers, 1968.

ARTAUD, ANTONIN. *Œuvres complètes.* Paris: Gallimard, 1970– .

BONNET, MARGUERITE. *André Breton. Naissance de l'aventure surréaliste.* Paris: José Corti, 1975.

BRETON, ANDRÉ. *Entretiens 1913–52.* Paris: Gallimard, 1952.

———. *Manifestes du surréalisme.* Paris: Pauvert, 1962.

———. *Les pas perdus.* Paris, 1924.

———. *Le surréalisme et la peinture.* Paris: Gallimard, 1965.

CABANNE, PIERRE. *Marcel Duchamp. Ingénieur du temps perdu.* Paris: P. Belfond, 1977.

CARADEC, FRANÇOIS. *Vie de Raymond Roussel.* Paris: Pauvert, 1972.

CHAR, RENÉ. *Œuvres complètes.* Paris: Gallimard, 1983.

CHIRICO, GIORGIO DE. *Memoirs,* translated by Margaret Crosland. London: Owen, 1971.

DAIX, PIERRE. *Aragon: une vie à changer.* Paris: Seuil, 1975.

DALI, SALVADOR. *Secret Life of Salvador Dalí,* translated by Haakon M. Chevalier. New York: Dial Press, 1942.

———. *La vie publique de Salvador Dalí.* Paris: Centre Georges Pompidou, 1979.

DECAUNES, LUC. *Paul Éluard. Biographie pour une approche.* Rodez: Éditions Subervie, 1964.

ÉLUARD, PAUL. *Lettres à Joë Bousquet.* Paris: Éditeurs français réunis, 1973.

———. *Lettres à Gala 1924–48.* Paris: Gallimard, 1984.

———. *Lettres de jeunesse.* Paris: Seghers, 1962.

————. *Œuvres complètes.* Paris: Gallimard, 1968.

ERNST, MAX. *Beyond Painting.* New York: Wittenborn, Schultz, 1948.

————. *Écritures.* Paris: Gallimard, 1970.

LAUTRÉAMONT, COMTE DE. *Œuvres complètes,* edited by Philippe Soupault. Paris: Au Sans pareil, 1927.

MAGRITTE, RENÉ. *Écrits complètes.* Paris: Flammarion, 1979.

NADEAU, MAURICE. *Histoire du surréalisme.* Paris: Éditions Du Seuil, 1945.

PÉRET, BENJAMIN. *Œuvres complètes.* Paris: Losfeld, 1969–

RAY, MAN. *Self Portrait.* Boston: Little, Brown, 1963.

ROUSSEL, RAYMOND. *Locus Solus,* translated by Rupert Copeland-Cunningham. London: Calder & Boyars, 1970.

RUBIN, WILLIAM S., AND CAROLYN LANCHNER. *André Masson.* New York: Museum of Modern Art, 1976.

RUSSELL, JOHN. *Max Ernst. Life and Works.* New York: Abrams, 1967.

SAINT-POL-ROUX. *Genèse.* Mortemart: Rougerie, 1976.

SANOUILLET, MICHEL. *Dada à Paris.* Paris: Pauvert, 1965.

SOBY, JAMES T. *Giorgio de Chirico.* New York: Arno Press for the Museum of Modern Art, 1968.

VACHÉ, JACQUES. *Lettres de guerre.* Paris: Au Sans pareil, 1919.

WALDBERG, PATRICK. *Max Ernst.* Paris: Pauvert, 1958.

————. *René Magritte.* Brussels: De Rache, 1965.

INDEX

169